The Gods of Ancient Egypt

The Gods of

Ancient Egypt

by Pascal Vernus

photographs by Erich Lessing

translated from the French by Jane Marie Todd

George Braziller Publisher　　New York

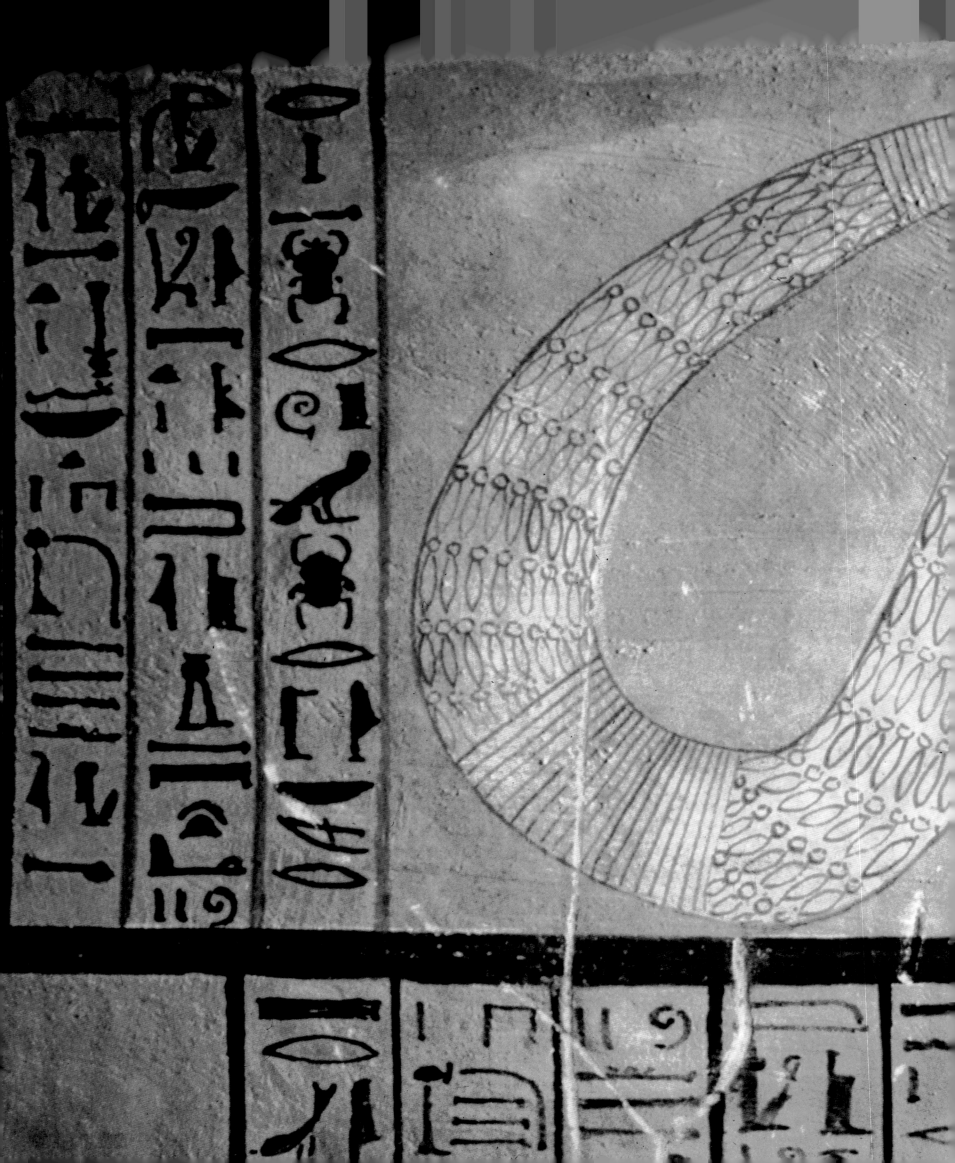

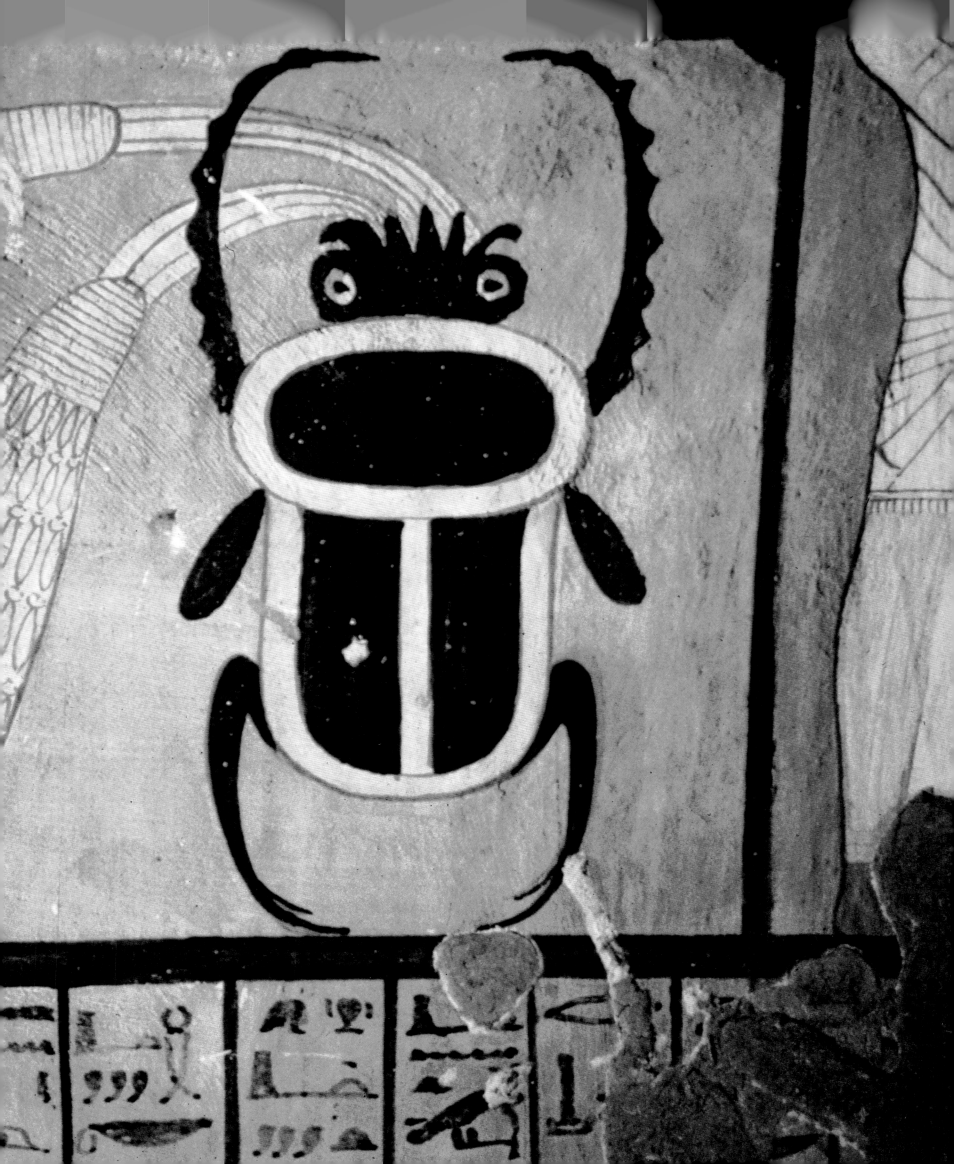

First published in the United States in 1998 by George Braziller, Inc.

Published in France under the title *Dieux de l'Égypte* by Imprimerie nationale Éditions in 1998

The maps appearing on pages 196 and 197 are from *Dictionnaire des Pharaons* by Pascal Vernus and J. Yoyotte (Noêsis éditions: Paris, 1996). Used with permission.

George Braziller, Inc.
171 Madison Avenue
New York, NY 10016

Library of Congress Cataloging in Publication Data:
Vernus, Pascal.
[Dieux de l'Egypte. English]
The gods of Egypt / by Pascal Vernus ; photographs by Erich Lessing : translated by Jane Marie Todd.
p. cm.
Includes bibliographical references.
ISBN 0-8076-1435-1
1. Egypt—Religion. 2. Gods, Egyptian. 3. Goddesses, Egyptian. 4. Art, Egyptian. I. Title.
BL2441.2.V513 1998
299'.31—DC21 98–19524
 CIP

Designed by Hélène Lévi

The paper is Consort Royal Silk 170 gsm
The text and display are typeset in Centaur MT and Centaur Expert MT
Printed and bound in France by Imprimerie nationale

First edition

Contents

Preceding pages: On this wall of a tomb in Deir el-Medina, the scarab beetle wearing a necklace, which the conventions of Egyptian drawing place beside the beetle so that the necklace will be more visible, serves to illustrate a chapter from the Book of the Dead, "Chapter for Transforming Yourself into Any Transformation You Wish." That is because the scarab beetle is used as an ideogram for the root word kheper, *associated with the notion of "becoming, transforming oneself"; it is thus the symbol for the passage from one state to another. More specifically, within this funerary context, its purpose is to attribute to the deceased the capacity to manifest himself on earth in various forms.*

Opposite: Personification of the inundation.

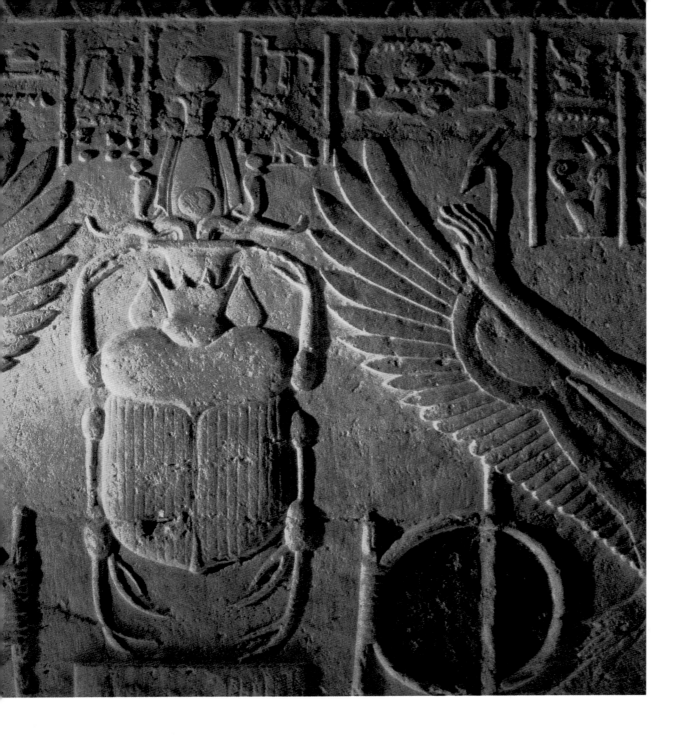

At left, the vulture goddess
Nekhbet spreads her wings
in protection of the sun,
which takes the form of a
scarab beetle wearing the
atef crown.

At right, the first of the
pharaoh's five names, the
so-called Horus name. It
is often enclosed within the
palace façade decoration, or
serekh, and surmounted
by the falcon of Horus,
here wearing the double
crown of Upper and
Lower Egypt.

An Organized Profusion

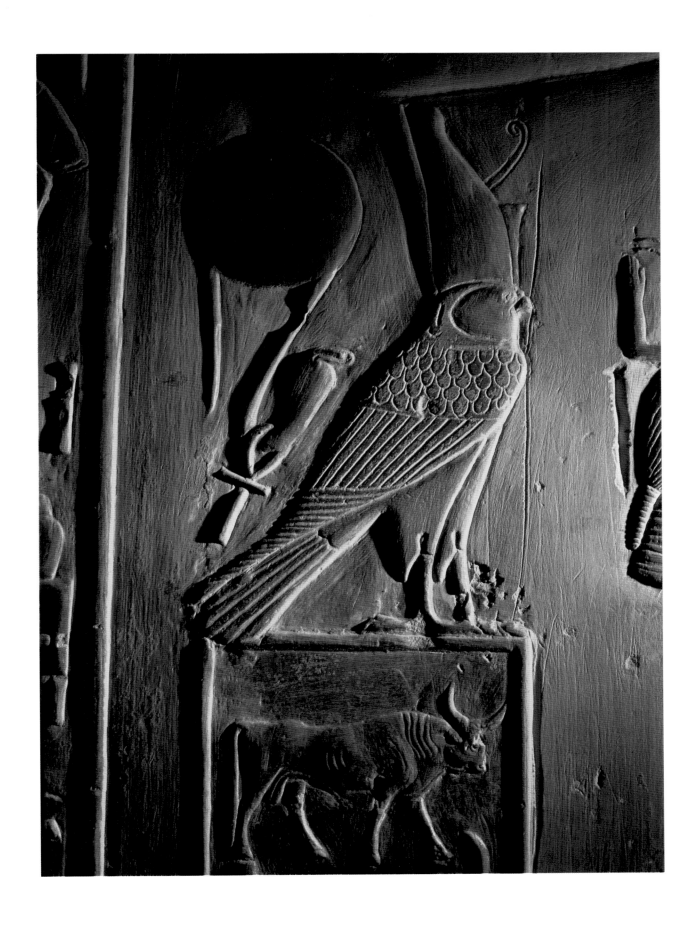

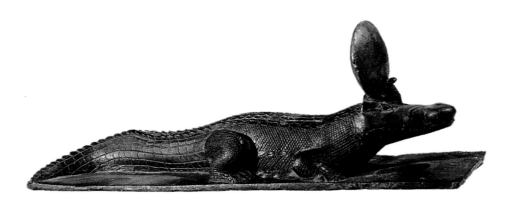

The god Sobek in the form of a crocodile bearing the sun disc.

Some landscapes invite you to dream impalpable daydreams; others seize your attention and summon you to observe, to move past what is obvious to the eyes, suggesting something beyond the visible. It is as if such landscapes were signs of hidden powers, of a supernatural force behind the things and creatures that compose them. In that respect, the landscape of ancient Egypt must have nourished the habit of observation among its inhabitants. It could not have left them indifferent.

At the Tropic of Cancer, a foaming, swirling river forces its way through blocks of granite, their backs rounded as if bracing to obstruct it. This is the First Cataract, the southern border: Aswan and the island of Elephantine. The river has arrived in Egypt. It is very narrow as it begins its course, moving between two cliffs that descend to meet it, to embrace it as it were, leaving only a few remnants of plain here and there. And yet, once past the sandstone of Gebel el-Silsila, the grip of the cliffs loosens opposite Edfu, and the valley stretches out on either side. After a brief detour to the west, the Nile resumes its northerly direction at Abydos in Middle Egypt.

Although the Arabian cliffs often still threaten the east bank, even to the point of obstructing the river, the western plain is so broad that it accommodates an arm of the Nile, the Bahr Yusef. It runs parallel to the river and into a lake of brackish water on the far side of a nearby oasis, the Faiyum. Abandoned by its tributary, the Nile pursues its course undisturbed, running into the broad plain south of Memphis and its necropoleis. This is where Lower Egypt begins. To form its delta, the Nile subdivides into several branches, which empty into the Mediterranean, crossing a coastal region whose interior is lined with a series of reed beds and large shallow, grassy lakes.

In this curious jewel case, it was nature's pleasure to play with the landscape in an astonishing manner, transforming it with the rise and fall of the Nile. Every year in mid-June, swollen by rains and the alluvium of the distant high plateaux of Ethiopia, the river began to rise, to overflow its banks, to pour onto the plains all the way to the *gebel*—the desert terrain that rises to a cliff—until the only things emerging from the inundated land were hillocks and knolls. The water gradually

began to recede in the autumn, and in winter the land seemed to rise up out of the water, or so the Egyptians thought. The land dried rapidly or slowly, depending on topography, but remained spongy from all the silt borne by the flood. This cyclical reshaping of the landscape with the rise and fall of the waters no longer occurs since the construction of barrages (particularly the Aswan High Dam) subdued the wild, though seasonal, energy of the floods.

But there is no dearth of descriptions and representations of this stunning spectacle of submerged land. In fact, the modern landscape seen by tourists, impressive as it may be, gives only a very approximate idea of the land contemplated by ancient Egyptians. The cliché—repeated incessantly in popular works—of a Nile Valley unchanged since the pharaohs is hardly accurate.

This is especially true in that one of the valley's essential components disappeared early on, namely, the marshlands and expanses of stagnant water that once dotted Egypt. They were of varying size and origin: ponds that never completely dried up after the floods had formed them, rises in the water tables located below the Nile, tributaries of the river that spread into vast shallow lakes, or depressions filled with water (the Faiyum). A luxuriant and diverse vegetation thrived in such places—rushes, reeds, and especially, the papyrus, whose stems bent under the weight of their umbels. The place teemed with exotic wildlife. Population growth and farming gradually reduced the flora and fauna to bare subsistence level, to such a degree that during the Roman Empire papyrus had to be imported from Sicily to replace the Egyptian papyrus that was disappearing. Nonetheless, the wildlife and vegetation were part of the ecology of pharaonic Egypt. We should not imagine that Egypt's territory was almost completely given over to agriculture, as it is in our own time: not only marshlands but areas of woods and brush traversed the cultivated zones here and there, especially in Middle Egypt.

In addition, the plateaux overlooking the valley were covered with savannas and traveled by populations of hunter-gatherers, who gradually moved toward the river. There they encountered fishermen-farmers established on its banks and mingled with them freely. During pharaonic times,

A snake with a human head, wearing the double crown of Upper and Lower Egypt, on a box designed to hold the mummy of a snake or eel, which was offered to deities who manifested themselves in the form of that animal.

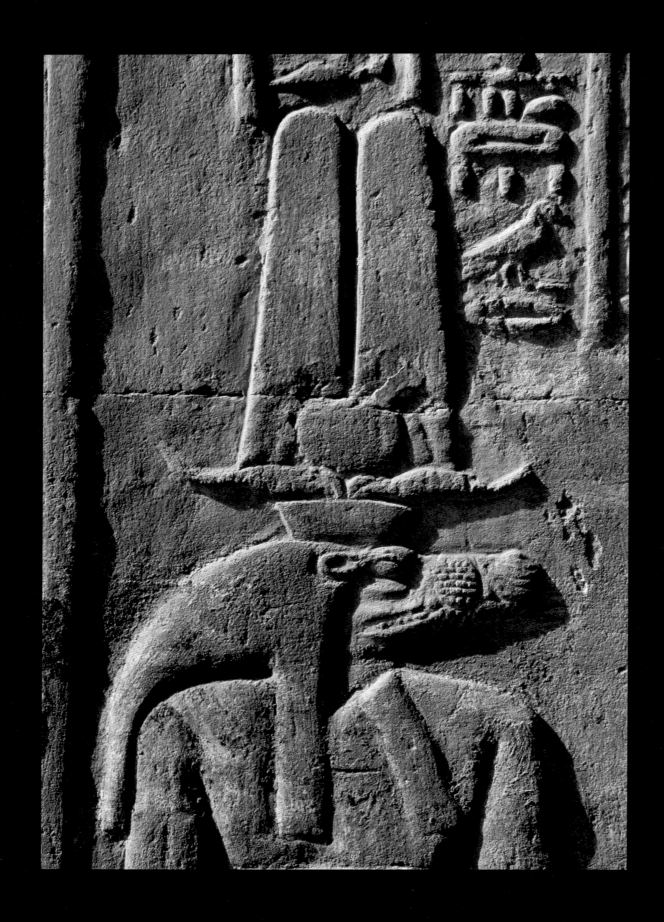

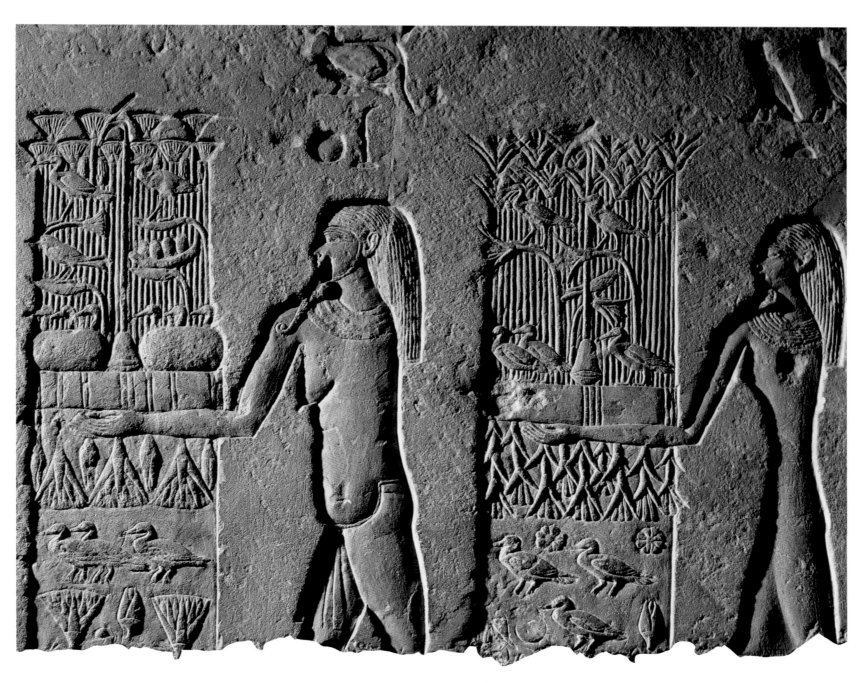

Opposite: Although crocodiles disappeared from modern Egypt in the nineteenth century—but are returning in force to Lake Nasser, upstream from the High Dam—the landscape of pharaonic Egypt was teeming with them. Is it any wonder, then, that crocodile gods were so important? The best-known was Sobek, who is depicted here as a man with a crocodile's head wearing the so-called atef crown.

The inundation and its various aspects, including its nutritional products and by-products, were person-ified throughout pharaonic civilization. The inundation was often given the ap-pearance of a very stout, bearded man with a pot belly protruding over the belt of his short kilt and his breasts hanging onto his thorax—so much so that he was often called androg-ynous. Such is the case for

the first character on this bas-relief. The inundation was also often given the appearance of a slender woman—her sex alone was an adequate symbol of fecundity—as in the second character. Both are bearing offering tables laden with symbols of the exuberant plenty of the zones where the floodwater settled: lotus, papyrus, flowers, and birds and their young nestled in their nests.

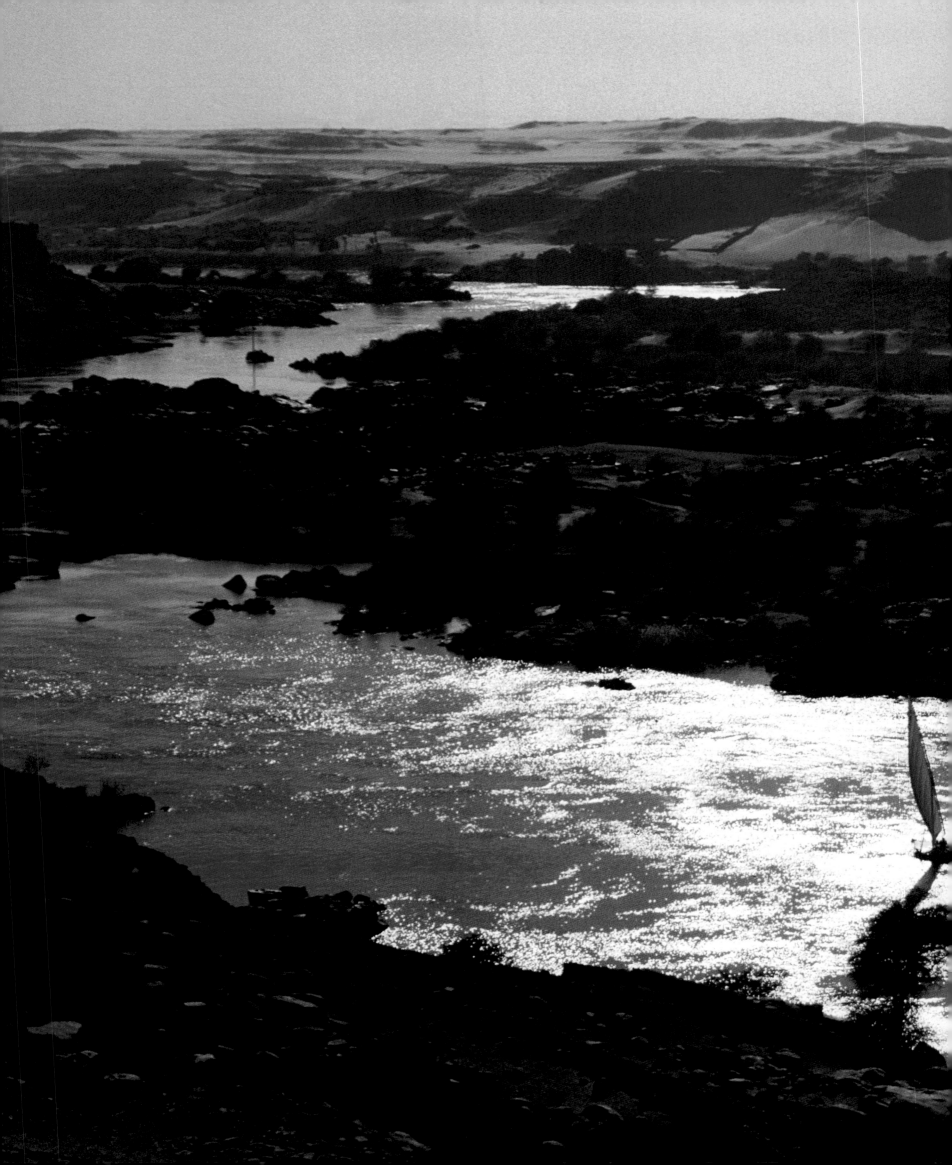

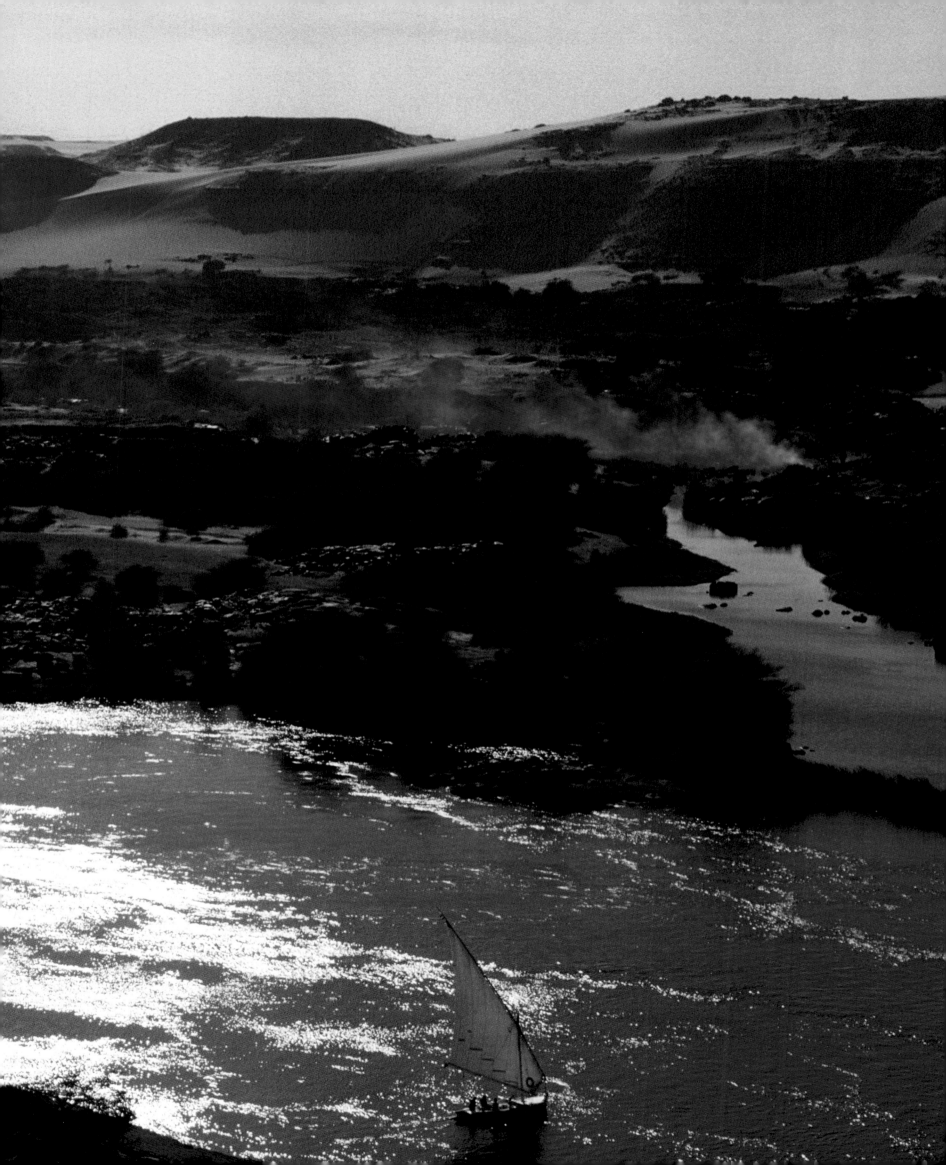

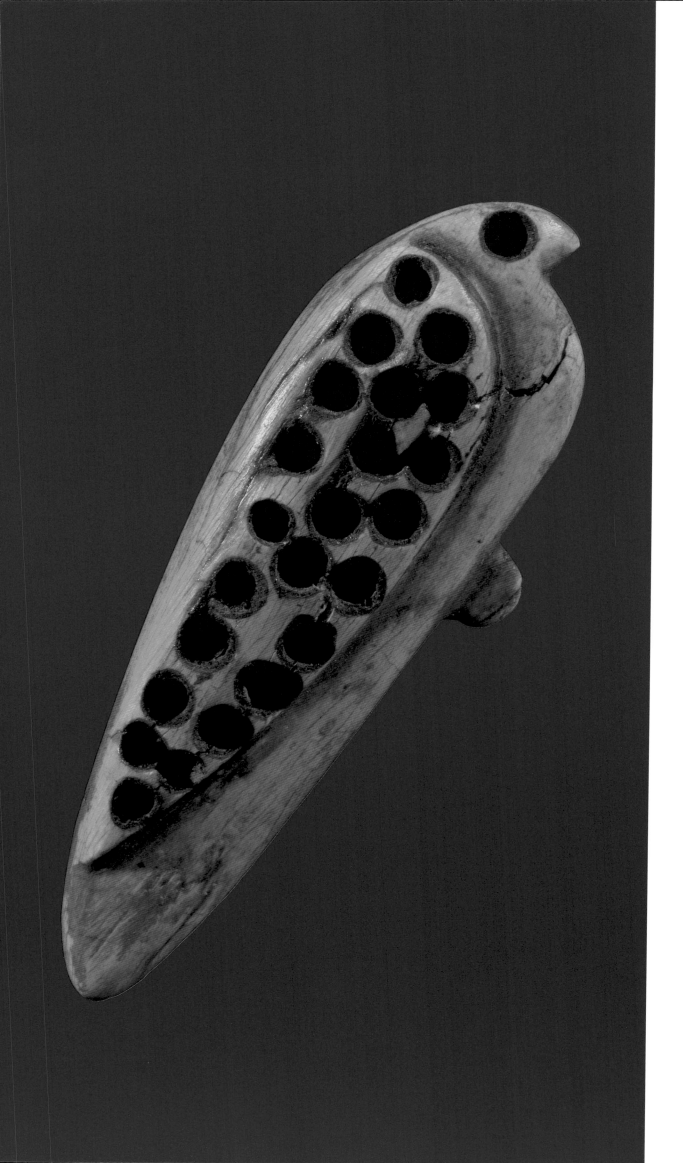

As early as the Predynastic Era, birds were considered divine manifestations. Hence this bird in ivory, probably a falcon, with an inlaid eye and wing feathers stylized with circular depressions, was probably a symbol of a solar deity such as Horus.

Preceding pages: The First Cataract of the Nile, south of Aswan.

nothing was left of this uniform environment but remnants and the cultures that had developed there, yet it still occupied an important place in the pharaonic imagination. Witness, among other things, the repertoire of hieroglyphs, which incorporated a number of signs representing animals specific to these areas, not only to designate the animals themselves, but more significantly, to indicate semantically related notions. For example, two leopard heads 🐆🐆 signified "strength," the giraffe 🦒 meant "to announce, foreshadow," and the front 🦁 and back 🦁 of a lion designated "before" and "behind," respectively. Other signs were used as pure phonograms; that is, their meaning was unrelated to the animal they depicted. This shows how fully the fauna were integrated into pharaonic civilization. It is true that the wildlife remained enclosed within the valley, since the area was isolated by virtue of its place between the Libyan and Arabian plateaux. Even the elephant, though it had already disappeared by historical times, left its trace in the Greek name "Elephantine," because the shape of the island of that name suggested the massive back of a pachyderm! Generally speaking, pharaonic flora and fauna were very broadly African, similar to those still in existence thousands of kilometers farther south.

There are two major representations of the divine falcon: first, the complete bird, standing on its legs and balanced on its talons; and second, as here, the recumbent mummified bird, with an envelope hiding its talons. Figurines of this second type, linked especially to Sokar, god of the Memphis necropolis, were often placed at each of the four corners of sarcophagi or coffins.

Ecologists of the Divine

Very early on, inhabitants of the valley were inclined to discern behind that extraordinary environment the activity of higher powers, and to choose from its profuse wildlife what seemed to be the most revealing and exemplary manifestations of the gods. Accidental topographical features were believed to be haunted by a supernatural presence. Thus, certain impressive peaks along the desert cliffs bordering the Nile were reputed to be sites treasured by goddesses. For example, "the Great Peak of the west" was an epithet for a rocky hill in the shape of a pyramid, which overlooked

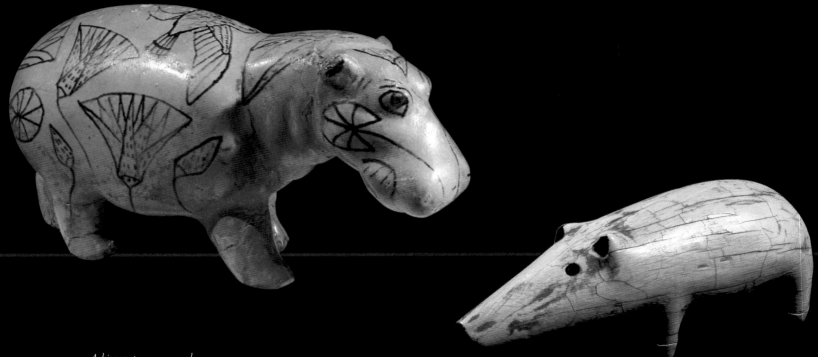

A hippopotamus covered with aquatic plants (Middle Kingdom). Egyptians saw the emergence of the animal from the flora in the marshes as an illustration of rebirth, hence the custom of placing this sort of statuette in tombs.

Figurine of a sow carved from the tip of an elephant tusk, dating from the so-called Naqada I Period (early fourth millennium B.C.), during the Predynastic Era, that is, the era preceding the birth of pharaonic civilization. The body of the animal, probably a variety of African warthog, is treated in a streamlined style that agrees perfectly with the material in which it was carved. Although its precise meaning eludes us, this object may have been invested with an unknown religious meaning. In pharaonic Egypt, the pig was an animal of ambiguous symbolism. Often the object of hatred, it also had a positive aspect. Thus, the sky goddess was sometimes considered a sow that swallowed her young in the evening and gave birth to them again in the morning.

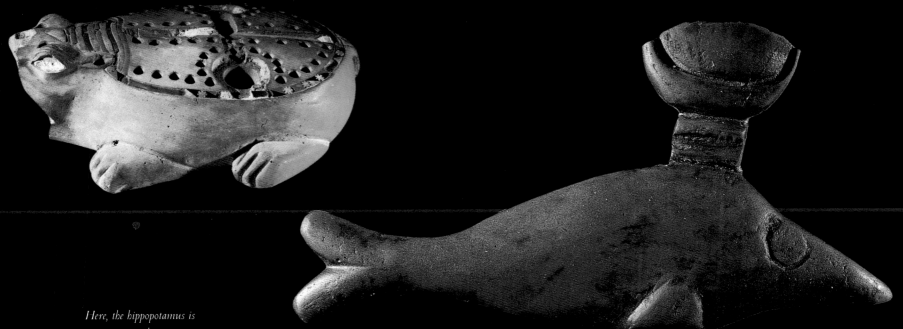

Here, the hippopotamus is a game piece; the game probably had religious connotations.

Like the pig, certain fish had an ambiguous status. Although the predynastic nomad hunters had rejected all fish as an abomination, some fish, such as the perch, later had divine manifestations. In addition, there was a goddess, Hat-Mehit, whose name means "the foremost of fish." This amulet represents the Oxyrynchuss fish (**Mormyrus**), which supposedly swallowed Osiris's phallus after he was dismembered. The cult of this fish later enjoyed great popularity in the region of Oxyrhynchos in Middle Egypt. The attribute of the sun disc between the cow horns reflects a link to Hathor.

the Theban necropolis. Isis, Sekhmet, and a cobra goddess called Meretseger—"she who loves silence"—manifested themselves there.

Beginning in predynastic times, a narrow space between the massive rocks of Elephantine was believed to be permeated by the divine; there, archaeologists have uncovered superposed sanctuaries composing a stratigraphy of three millennia! Although the sea was only slightly deified, in very ancient times, the fertilizing inundation was imagined under the name "Hapy" as a very stout creature with pendulous breasts, its potbelly hanging over a belt pulled too tight, and a clump of papyrus on its head. Certain landscape features explain symbolism that seems enigmatic at first glance. For example, the cow, which, covered with papyrus, emerges from the mountains, was identified with the goddess Hathor. In the New Kingdom, that association led to the formulation of a hope for life after death. That is, here and there, the ground dropped away near the cliffs bordering the valley, and as a result, the water table rose and marshy pockets of luxuriant vegetation formed. The contiguity between the wasteland of the *gebel*, set aside for necropoleis, on the one hand, and the rich pasturelands that these residual wetlands offered cattle on the other seemed an eloquent declaration that a sepulcher dug into the desolate mountain could be the beginning of a hearty rebirth. This accounts for the popularity of the cult of Hathor-of-the-west in the Thebes region.

On occasion, the plant kingdom also indicated the powers that governed the universe. A few poorly identified trees, erected as fetishes and made emblems of the provinces (nomes) of Egyptian territory, can be traced back to the origins of pharaonic civilization. Others, because they were particularly abundant or, conversely, because they stood out in an otherwise desolate landscape, were considered signs of a divine presence. Thus the *Ziziphus* (Christ's-thorn) was the tree of the hawk-god Sopdu in the Wadi Tumilat, on the eastern border of the Delta, because its thorns resembled the bird's talons. The same tree was associated with Thoth in Nubia, because the baboon, the animal of that god, was fond of it (see below). In the cool shade—so welcome in the torrid summer—offered by the lush foliage of the sycamore, one of the best-loved trees, the ancient Egyptians discerned the gracious hand of the goddesses Nut and Hathor. In their germinating cycle, grains displayed the influence of a power personified under the name "Neper." And was not the blue lotus (*Nymphea coerulea*) the most eloquent of plants? On the surface of the water its buds opened as soon as the first rays of the sun touched them, then closed again when darkness fell. For Egyptians, this

Because it appears to be born from the water, the frog, like the hippopotamus, became a symbol of rebirth. In later periods, the hieroglyph representing a frog signified "to be reborn."

The sow was not only a manifestation of the sky goddess Nut but also of Isis in later periods as the inscriptions on this statuette indicate. Although in cosmological representations the divine sow swallows her young, here she merely suckles them, indicating a benevolent evolution in beliefs.

During the Predynastic Era, many theriomorphic (animal-shaped) palettes were used to grind eye make-up. Often the palettes were elegantly stylized. Motifs of ostriches, birds, turtles, and, as here, fish, animated the palettes. The eye was modeled either by an inset material or by a hole for hanging the palette.

As strange as it may seem, the Egyptians believed that certain deities manifested themselves as vultures. Foremost among them was Nekhbet, tutelary goddess of Upper Egypt. In later periods, she protected the dead.

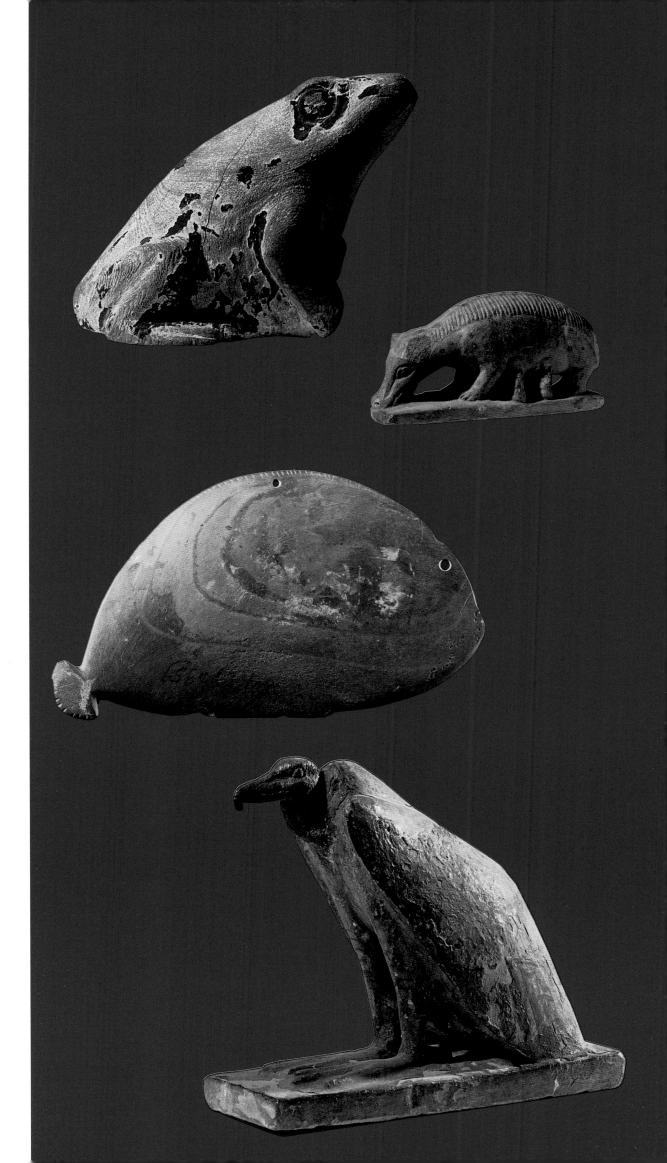

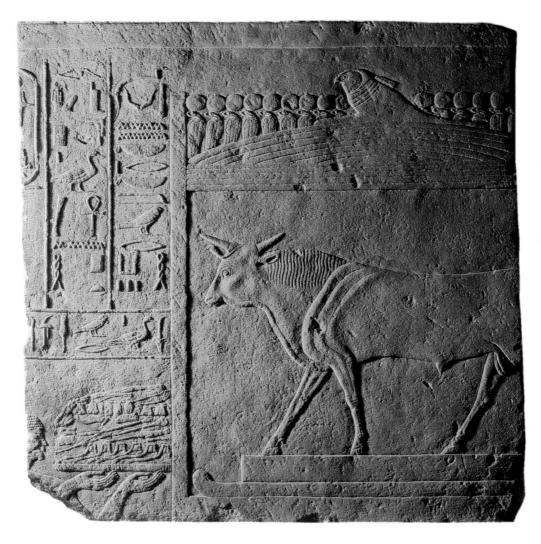

Statue of the god Apis, set on a cart inside a naos, receives the Opening of the Mouth ritual. The officiant is none other than the most illustrious of the many sons of Rameses II, Khaemwaset, a scholar with a passionate interest in antiquities and an expert in religious texts; he did a great deal of work in the Memphis necropolis. This bas-relief probably came from Serapeum of Memphis, that is, the cemetery of the Apis bulls.

Below: A highly symbolic representation of Hathor appears on this bas-relief for Ramose, scribe of the royal tomb workers. The goddess Hathor in the form of a cow crosses through a papyrus thicket on a raft with a prow shaped like a flower. Around her neck is a necklace called menat, whose counterpoise rests on her back, while the main part encircles the neck of the pharaoh Rameses II. Thus, the regenerative power of the exuberant vegetation eaten by the animal envelops the king.

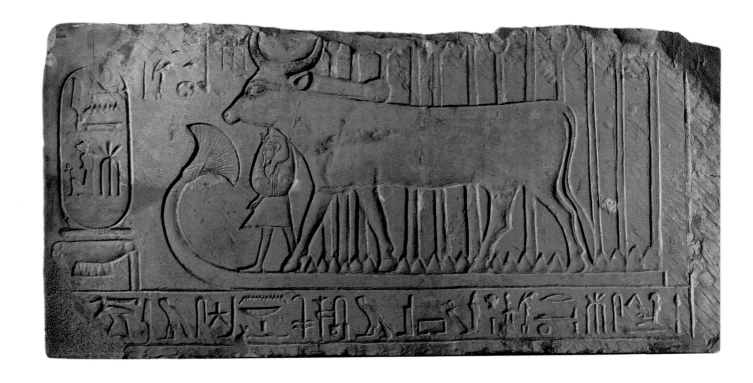

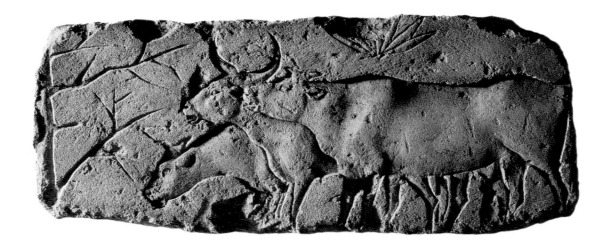

symbolized the creation cycle: the sun emerged from the primeval ocean, then sank back into it at the end of its diurnal journey. Moreover, that symbolism existed at several levels: as it opened, the flower gave off a sweet fragrance, and fragrances were one of the sensible signs of divine epiphany. As if in counterpoint, the white lotus opened at night, signifying that the sun continued its activity even after it had set. The lotus was both aesthetic and rich in meaning. It certainly deserved its deification in the form of the god Nefertem at Memphis and gave rise to a sophisticated theology.

Even more than the flora, the rich and diverse fauna of pharaonic Egypt signified the divine in many ways. Ancient Egyptians were clear-sighted and perspicacious observers, to such a degree that modern zoological studies have explained and confirmed animal behaviors that Egyptians transposed into their mythology.

Take the universe of tiny creatures. Areas near the river and the marshes teemed with various species of scarabs, the most spectacular of them the black (*Scarabeus sacer*) and the green (*Kheper aegyptiorum*) beetles, which had a semicircular head equipped with six radiating denticles. The female insect fashioned a ball of dung, which she pushed backward to a hole, where she buried it and laid her eggs. Ancient Egyptians, playing on analogies of morphology and of process, saw this behavior as a particular manifestation of the sun's power. In its morphology, the ball of dung suggested the sun disc. Entomologists call the scarab beetle's semicircular denticles, "radiating." That is a perfectly apt description since the ancient Egyptians saw them as a microscopic reflection of the first rays that appear on the horizon at sunrise, stylized in the hieroglyph �. In addition, the scarab beetle's pupa suggested a mummified body. In terms of process, the sun reappears in the morning after spending the night underground; in the same way, a young scarab beetle emerges from the dung ball buried in the earth, after passing through the larval and pupal phases. Consequently, the sun was frequently represented as a disc borne by a scarab beetle, and the scarab god Khepri was often depicted as the

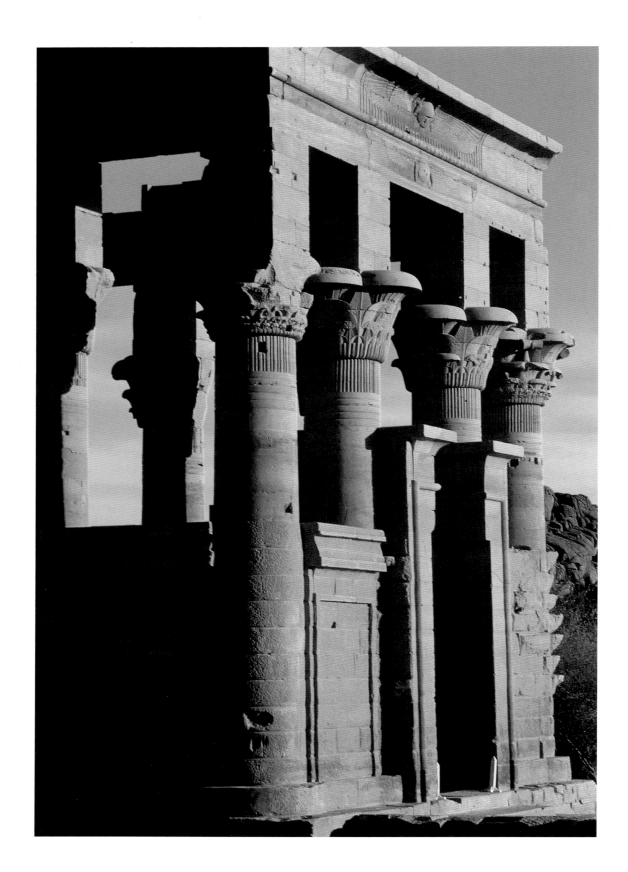

The Kiosk of Trajan,
island of Philae.

Opposite: Colonnades of
the Temple of Isis, island
of Philae.

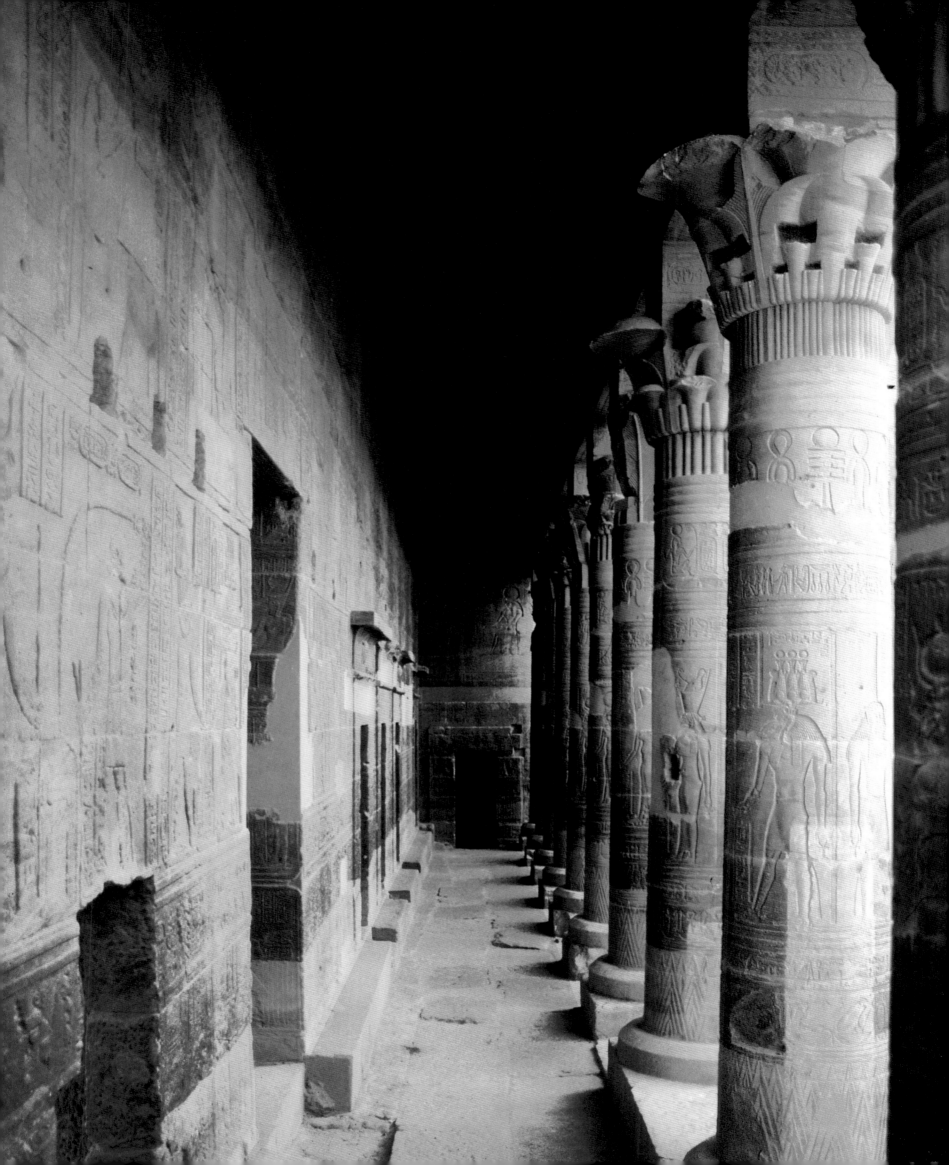

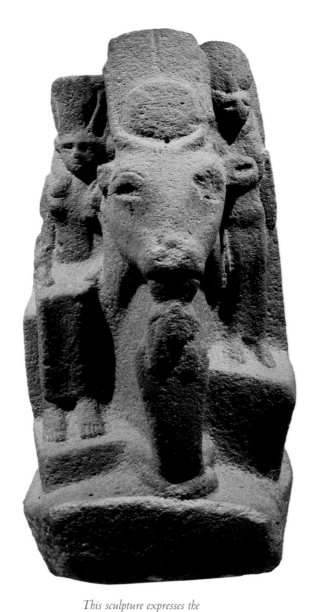

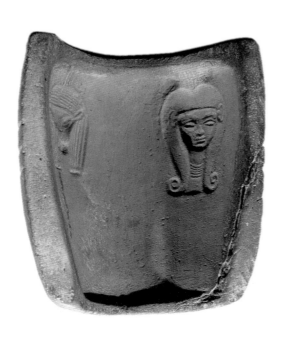

This sculpture expresses the theological complexity of the goddess Hathor by linking four of her manifestations. Dominant by its position and size is a cow's head bearing the sun disc between its horns, the primary depiction of Hathor. The human form on the left suggests her function as goddess of love and of festivals, which complemented the cow's role in fertility and nourishment. In front of the human figure stands a third manifestation of Hathor, the menacing cobra, which was the uraeus on the forehead of the sun god and his son, the pharaoh. They are associated with the representation of a lioness, Hathor's fourth manifestation, on the right, to emphasize the formidable destructive potential contained within most goddesses.

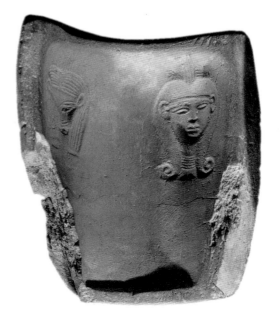

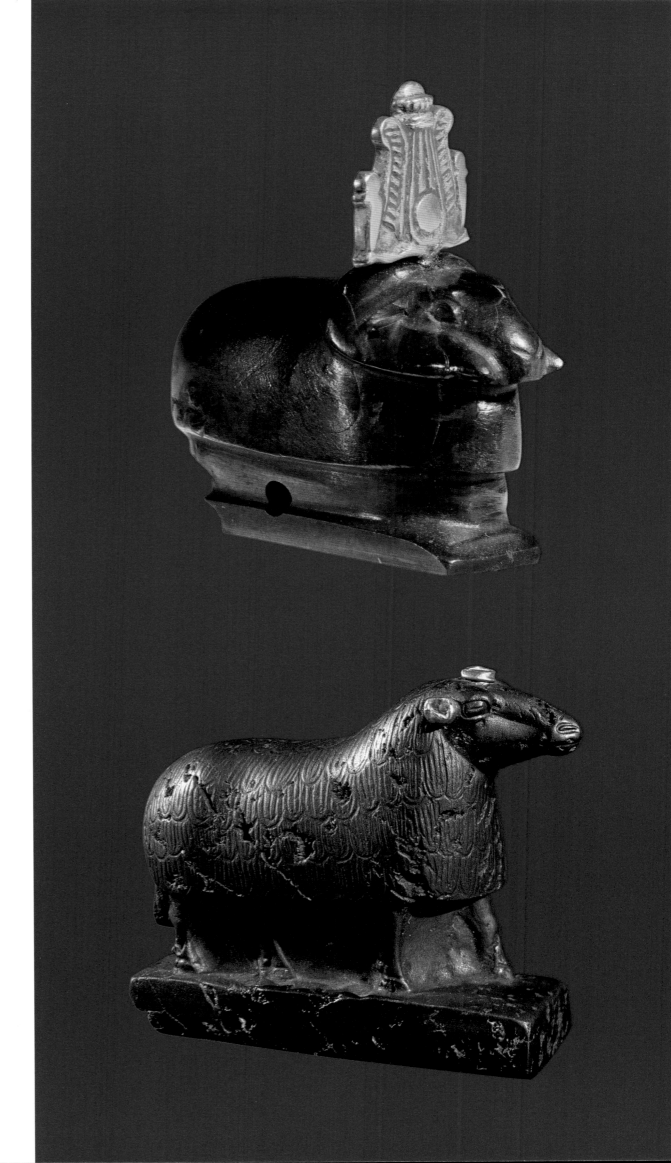

There were several species of rams in Egypt, each distinguished by the shape of its horns. This ram has curving horns that come forward parallel to its forehead; that was a trait characteristic of the newer species, Ovis platyra. Therefore, this is probably the animal of Amun, a god that acquired importance relatively late. This effigy is made of hematite, and the atef crown on the animal's head is gold. It was a ring setting or part of a piece of jewelry.

The horns have disappeared from this ram, whose heavy fleece falls like a mantle, but the way the horns are positioned in the head suggests this is the ancient species Ovis longipes paleoaegyptiaca.

Opposite: Mold with four images of Hathor, two each with bovine heads and with human faces. The latter are differentiated: one is the face of a young girl, the other of a full-grown woman. An eminent Egyptologist has coined the term "quadrifons [four-faced] Hathor" to denote the complex personality of the goddess.

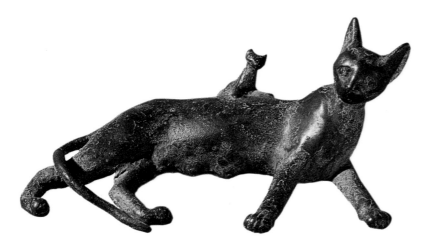

In the ninth century B.C., the popularity of the cat goddess Bastet increased, and her sanctuaries multiplied. Her suppli-cants offered statuettes or cat mummies. Over time temple chapels filled with these objects. In our own time, cat statuettes are particularly sought after by collectors. This is easy to understand: the cat, a naturally elegant animal, is even more so as rendered by Egyptians, who captured its long straight ears and supple body in the bronze piece above.

rising sun. The name of the scarab beetle, *kheperer*, was formed from the root *kheper*, "to come into existence, to evolve, to be transformed."

Another astonishing observation accounts for the place occupied in the divine bestiary by an animal we would not have expected to encounter: the baboon. All Egyptians wanted to attain after death the fabulous status of these baboons, who accompanied the sun god in his bark and welcomed the sunrise with dance, song, and jubilation. These joyful sounds were uttered in the gods' own tongue, to which only initiates had access. Although it is easy to understand how the gesticulations of baboons, excited by the rising sun, might have been considered as expressions of glee, it is bewildering that an articulated language, incomprehensible to mere mortals, was attributed to them. And yet, that idea permeated pharaonic civilization and even Greco-Roman magic. It might have remained enigmatic to us had not a recent study of certain baboons from the Ethiopian high plateaux—the baboon has long since disappeared from Egypt—demonstrated that the cries made by these animals very closely resemble certain phonemes in human languages. Ancient Egyptians made that observation long ago. This explains why the baboon was one of the animals of the god Thoth, master of language and writing. His other animal was the ibis, apparently because its measured, regular steps were perceived as the manifestation of a deity who, through language and writing, controlled metrology, cultural norms, and natural cycles.

Another animal symbol that is surprising at first is the vulture, which was the manifestation not only of the goddess of kingship, Nekhbet, and of the goddess Mut but also of the protective power of Isis. This bird certainly does not evoke such pleasant virtues for moderns! And yet, if we observe the vulture, we come to understand the Egyptians. The extraordinary span of its wings when spread to shade its young cannot fail to impress: they impart the idea of protection and of breadth, like the pharaoh's power over Egypt.

The means by which other animals came to signify the divine is more immediately obvious. If

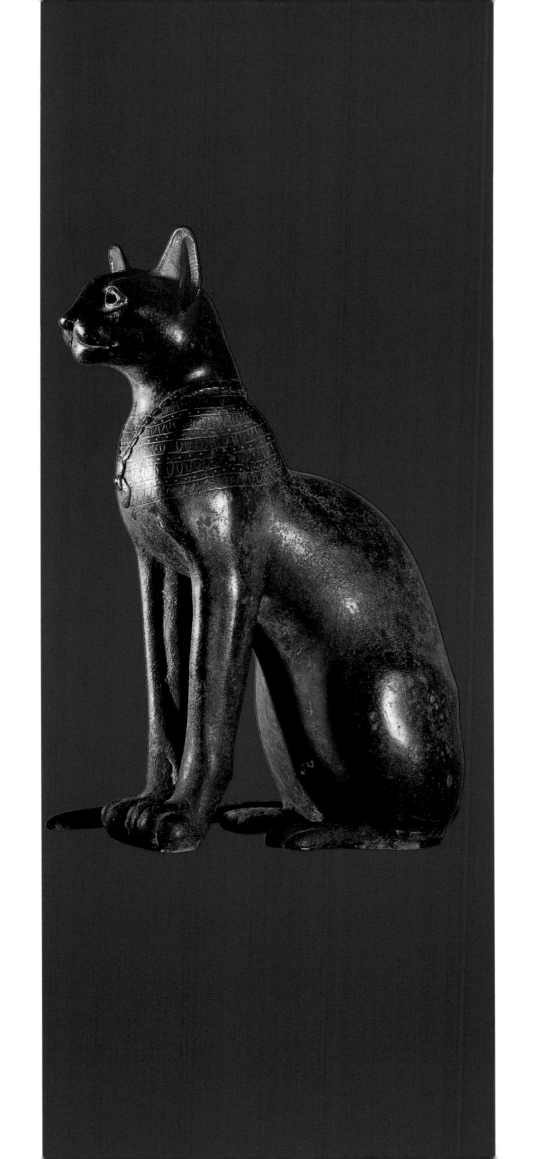

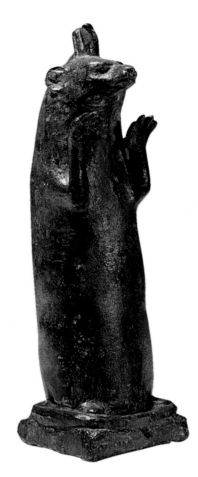

Two otter statuettes. The otter chases fish in the dark, muddy water, then emerges into daylight and fresh air to devour them. In addition, it stands on its hind legs in an attitude that evokes a prayerful posture. That explains why it was associated with the sun, as indicated by the sun disc borne by the animal on the statue shown at right. It was one of the sacred animals of the cobra goddess Wadjyt (Hellenized form, "Uto").

we follow a hawk in its heavenly ascent, we can easily understand not only why the Egyptians saw this majestic flight over the earth as a metaphor for supreme power, but also why they used the ideogram of the hawk, 🦅, for the name of Horus, god of kingship, that is, "the higher power," "the distant." Is it any wonder that savage ferocity was incarnated by a lioness, Sekhmet (Hellenized form, Sakhmis)? Or that floodwaters, serene when in abeyance but abrupt in their rise, were believed to be the work of Sobek (Greek, Suchos), the crocodile god, an animal with the capacity to attack with a suddenness that his near immobility and imperceptible movements do not seem to warrant? Was it not fitting to give Anubis—guardian of funeral ceremonies, at which the corruptible part of the corpse was separated from the incorruptible—the form of a carrion-eating canine, the product of repeated crossbreeding between dogs and jackals? It is also easy to understand why gods representing the power of generation, which, via reproduction, was part of the driving force behind the creation cycle, should take the form of a bull, such as Kamutef, or of a ram, such as Khnum or Heryshef (Hellenized form, Arsaphes).

A single species could manifest the divine in various, even contradictory ways. Such was the case of the hippopotamus. Grouchy and irascible, it is quick to charge anyone who passes too close to its aquatic territory or who seems to stand between it and the river. Its curved teeth and impressive girth, powered by a strength entirely proportionate to its size, makes it a formidable beast. It was considered one of the manifestations of Seth, god of uncontrolled violence. In addition, however, the enormous corpulence of the pregnant female, her flanks bent outward and her belly distended, was such a powerful image of fecundity that she became a goddess, the benevolent Thoeris, who protected women in childbirth.

Similarly, the snake could represent either nonbeing, which constantly threatened creation (Apophis, for example), or the cyclical rhythm of creation, by virtue of the well-known image of the snake biting its own tail. In addition, mythology promoted the snake to the rank of warrior's companion, in the form of the cobra goddess Wadjyt, called a *uraeus* when placed on the pharaoh's forehead to spit fire at his enemies. The cobra, as we know, not only bites but projects its venom into the eyes, which produces temporary blindness, made even more unbearable by a horrible burning sensation. Finally, like many other peoples, ancient Egyptians saw the snake as the power ensuring fertility of the soil. Thus, the cobra goddess Ermuthis protected crops, granaries, and supplies.

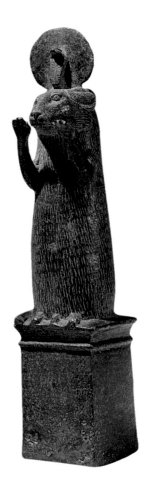

Bestiary Pairings

Even more striking are the zoological observations at work in myths linking two animals. Such is the case for the goddess Serket (Hellenized form, Selkis), which has led to massive confusion among Egyptologists. A protective goddess, often in the company of Isis, Nephthys, and Neith, she was often invoked in formulas and remedies for scorpion stings (Egypt teemed with scorpions in the past as it does in the present). Most often, she was represented as a woman with the head of an animal, which, quite naturally, scholars wanted to see as a scorpion. But further research has revealed that it was a nepid (water scorpion), a small, harmless insect that lives in marshes. Was this simply a crude approximation on the part of ancient Egyptians? Not at all. It was rather a sophisticated symbolic system. The water scorpion, emblem of the healing goddess, was paired with the scorpion as its positive counterpoint. They are so closely related morphologically that some eminent Egyptologists mistook the water scorpion for a scorpion; yet, at the same time, their behavior is completely different. A scorpion's sting produces shortness of breath, obstructed respiration; the water scorpion, on the other hand, possesses one of the most extraordinary respiratory devices nature has provided animals, a long tube of sorts with which it seeks air at the surface of the water. The scorpion's tail and its stinger cause asphyxia; the water scorpion's appendage brings life. Serket was thus the goddess of breathing. In Egyptian, her name is an abbreviation for an expression meaning "the one who causes the throat to breathe."

There are other animal pairings of the same kind. One example is the astral god Mekhentyirty who moves from blindness, when the sun and moon are not visible on the last night of the lunar month, to clear-sightedness, when the sun and full moon appear together in the sky. This god was represented as a hawk, but the ichneumon (a kind of mongoose) and the shrew were closely related to him. Even though they belong to different species, and the ichneumon is much larger than the shrew, the tapered silhouette of each animal unites it morphologically to the other. Thus the two could be paired as opposites: the nocturnal shrew is opposed to the ichneumon, a great destroyer of snakes, just as the sun is the relentless and stubborn destroyer of the serpent Apophis, incarnation of the darkness of nonbeing that continually threatens fragile creation. After all, the sun must begin its work over again every day.

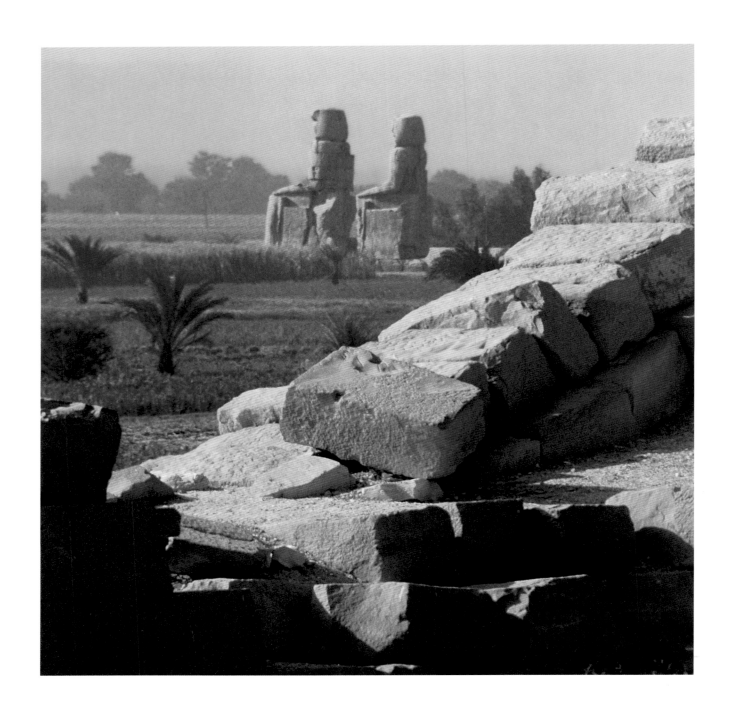

From the collapsed pylon of
the Ramesseum, the
mortuary temple of
Rameses II on the west
bank of Thebes, the famous
"colossi of Memnon"
are visible. They stood at
the entry to the mortuary
temple of Amenhotep III.

Opposite: View of the
sanatorium of the temple
of Dendara dedicated to
the goddess Hathor.
Having flowed over statues
and been permeated
with the magic of their
inscriptions, water was
directed by a network of
channels from the sacred
lake to a chamber. There
the afflicted could drink the
water and be healed by its
potency.

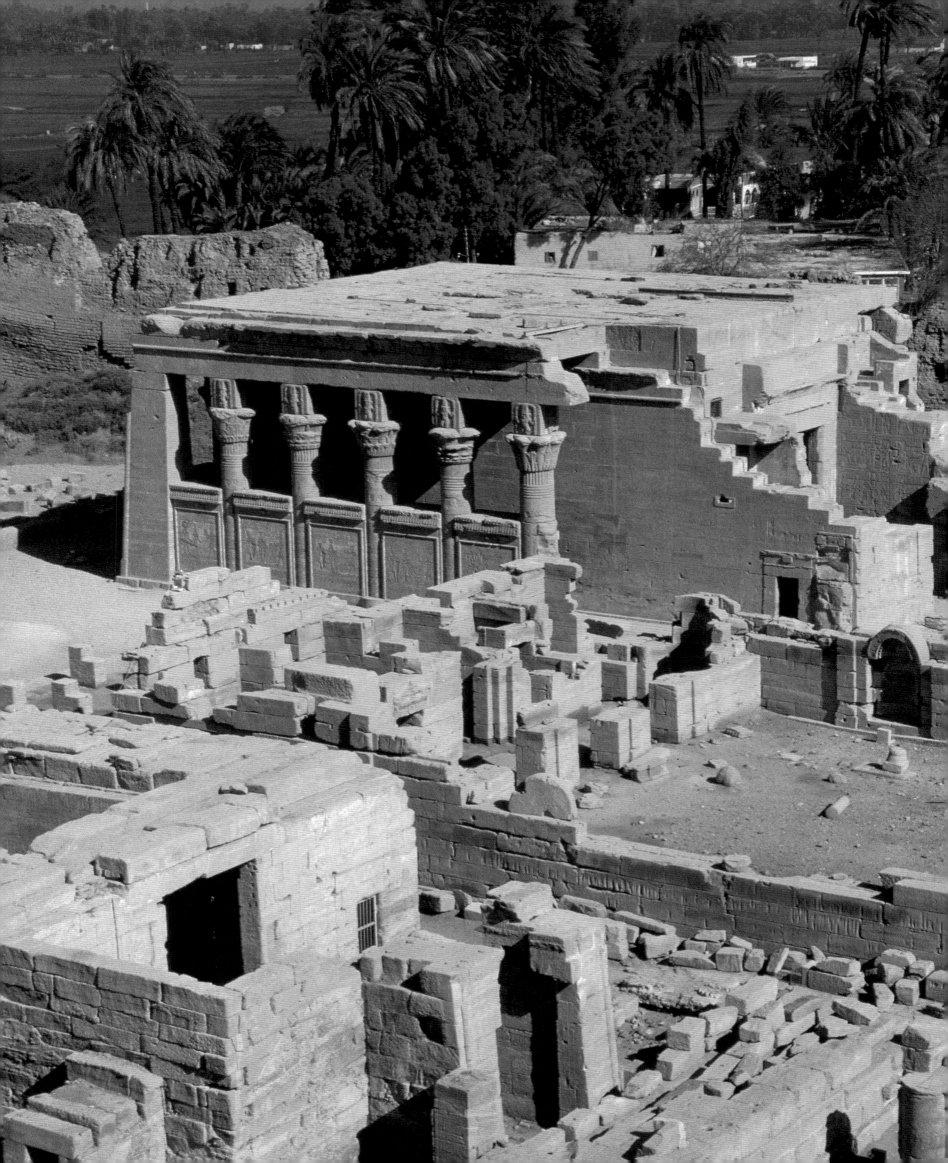

Because trees offer benefits such as fruit and cool shade, they must be inhabited by the gods. This assumption is expressed in these two representations of the goddess Nut, who gives the deceased a platter laden with fruit and pours water from a libation vessel.

But the most spectacular pairing in religious mythology was between the female cat and the lioness: for example, Bastet, cat goddess of Bubastis in Lower Egypt, and Sekhmet the lioness. Are they not both felines? That morphological analogy united them as a pair of opposites. It is easy to surmise the kind of opposition involved: the cat's gentleness was understood as the counterpoint to the lioness's ferocity.

That antithesis, like those mentioned previously, expressed a dynamic process, which was also depicted in a colorful myth. The sun god reigning over the earth had to quell a revolt among human beings. He immediately sent his executioner, the formidable lioness Sekhmet, who went about massacring poor humanity with such gusto that the sun god himself was terror-stricken and decided the carnage had to end. How to calm the raging beast? The sun god devised a ruse. An alcoholic beverage, colored red to look like blood, was offered to the lioness. Sekhmet greedily drank it up. The alcohol had its effect. When she woke up, the ferocious beast was calm. Linked together, the lioness and the cat represented the appeasement of the brutal forces of nature through offerings and feast days. They gradually came to be considered manifestations of almost all the goddesses, since irrepressible savagery and joie de vivre were thought to compose the ambivalent structure of feminine deities.

Even more astonishingly, animals were sometimes paired with human gods. The crocodile, as we have seen, incarnated the power of the flood. But for ancient Egyptians, the flood itself emanated from the primeval ocean sweeping over creation. Thus, the goddess Neith, mistress of the primeval ocean, was represented suckling two crocodiles. As a nurse, she certainly carried professional conscientiousness to an extreme!

Ubiquity and Coherence

The forces of the universe manifested themselves not only in natural elements but also in certain artifacts. Pharaonic civilization did not emerge from a void. As original as it may have been, it was the direct or indirect heir of various cultures, which passed on many fetishes, emblems, and symbolic motifs. Many disappeared or were gradually forgotten, while others were reinterpreted. The motif of the sun disc held between the horns of a bovine belongs to a very old Nile-Saharan

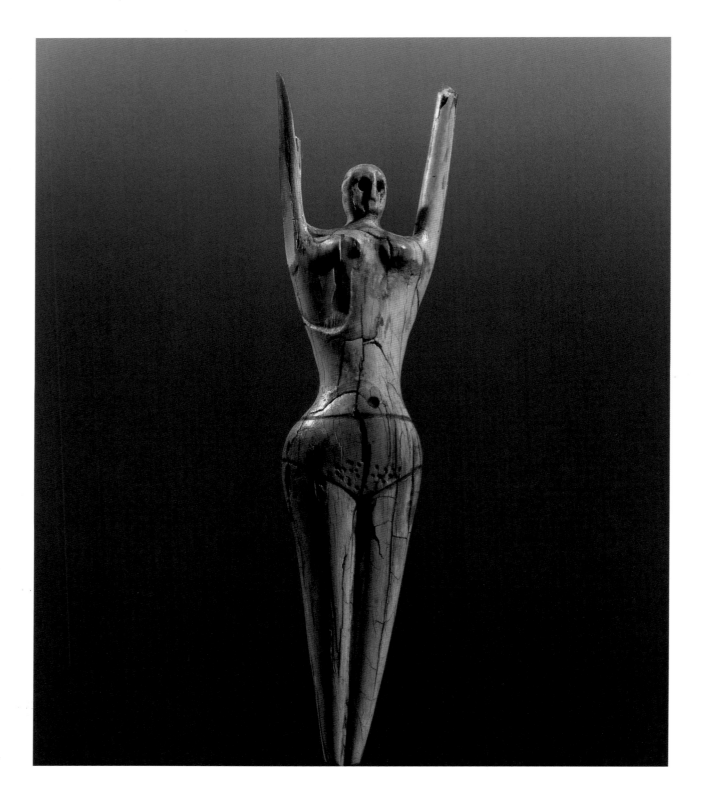

Carved in hippopotamus ivory, these two statuettes, date to the most ancient phase of the Predynastic Era, the so-called Naqada I Phase (early fourth millennium B.C.). At left, a woman with her arms raised; her heavy midsection is emphasized by an incision (height: 6 7/8 in., or 17.5 cm). At right, a man bearing a phallic etui; on his head are holes designed to hold a plumed headdress (height: 9 1/4 in., or 23.5 cm). Of unknown symbolism, these figures, which are also found as images painted on pottery, probably came from tombs. Although the woman may have been a dancer in a ritual, her shape and the emphasis on her pubic area suggest beliefs and practices related to fertility.

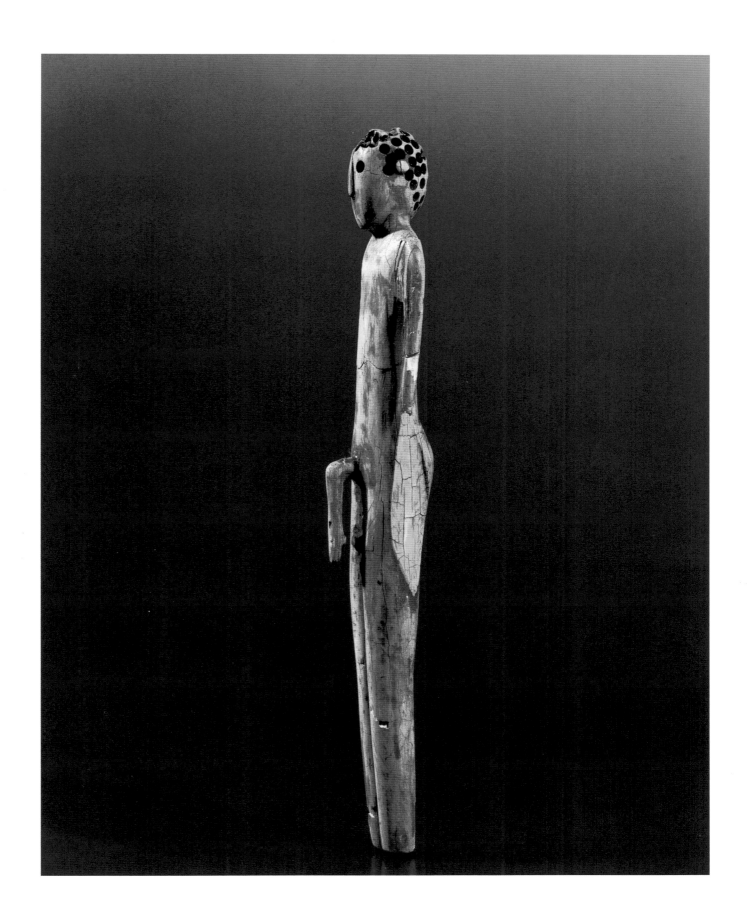

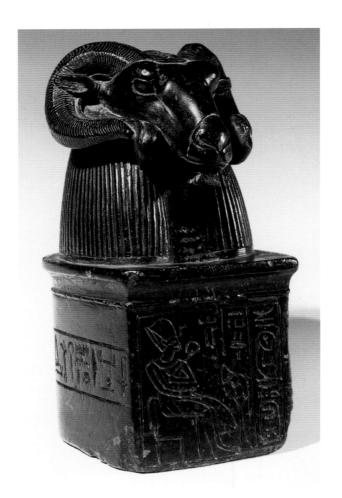

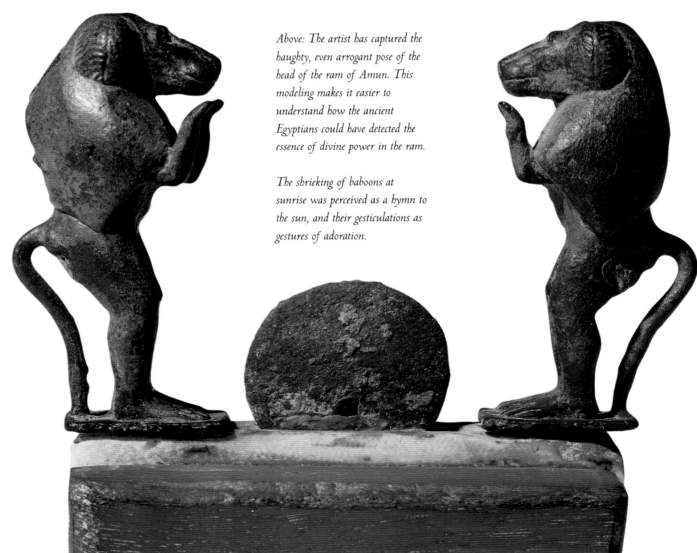

Above: The artist has captured the haughty, even arrogant pose of the head of the ram of Amun. This modeling makes it easier to understand how the ancient Egyptians could have detected the essence of divine power in the ram.

The shrieking of baboons at sunrise was perceived as a hymn to the sun, and their gesticulations as gestures of adoration.

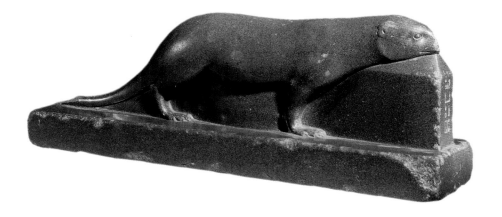

cultural tradition; in Egypt, it gave rise to cosmological and mythological representations of a celestial cow bearing the sun. This was the original role of the goddess Hathor, whose name means "house of Horus." Ancient sacred coats of arms from the area around Sais in the Delta were composed of a shield and two crossed arrows, or of two bows in a case. They acquired a new meaning when they were assigned their own warrior—or more exactly, their own woman warrior. As we have already noted, and as we will have occasion to do again, femininity was often perceived as bellicose. So here was the goddess Neith brandishing bows and arrows, but in the cause of righteousness!

Certain animal manifestations of divinity were imaginary creatures, for example, the animal with a curved and tapered snout, long rectangular ears set deep into the head, a slender, elongated body, and a straight tail. Bearing the name Ash or more often Seth, it incarnated the wild forces haunting the deserts. It was troubling if not terrifying for the old peasant stock that predominated in pharaonic culture. The cleverness of naturalists, captivated by that enigmatic animal, was put to the test: they proposed by turns that it was a greyhound, a giraffe, an okapi, a wild boar, an orycteropus, a donkey, an oryx, and so on. Then, one day, they finally admitted it was a fabulous beast, sometimes depicted in the company of species as disheartening for taxonomists as winged griffins and snake-headed quadrupeds!

Even in the products of human labor, believers sometimes perceived a divine presence. The Great Sphinx of Giza, for example, was carved from a rock and annexed to the funerary complex of King Khephren (about 2509–2484 B.C.). A millennium later, the pharaohs of the Eighteenth Dynasty took great pains to clear away the sand, which had almost buried it. Since its original meaning had been completely forgotten, it was now considered to be the hawk god Horemakhet, that is, Horus

A predator of snakes, the ichneumon, a type of mongoose, must have been appreciated in a country teeming with reptiles. Because the sun god confronted an evil snake in its daily course, the Egyptians made a connection between the deity and the animal.

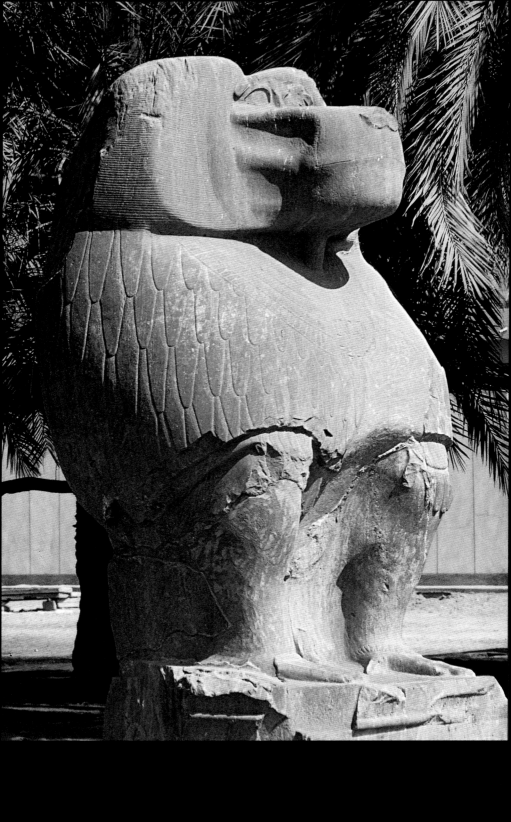

in the horizon, a manifestation of the three phases of the sun: Khepri at sunrise, Ra at midday, and Atum at sunset. Under the influence of Asians who had settled in the sector, it was also assimilated with the Canaanite god Hauron.

Even cities and economic communities were likely to be conceived as divine manifestations. A sector of the city of Thebes, Khefethernebes—"she who faces her master," a term that undoubtedly designated the east bank as a whole—was deified and represented as a goddess. But the most astonishing case is that of Thebes itself. Through the chance events of history, twice, at five hundred years' distance, strong dynasties originating in Thebes reunified Egypt. First, at the end of the Eleventh Dynasty, a Theban, Mentuhotep, ended the schism within the country, which had begun during the First Intermediate Period (between about 2130 and 2022 B.C.). Then, in the early part of the Eighteenth Dynasty (about 1539 B.C.), the lineage of Theban princes expelled the Hyksos rulers, who had held the country under their sway. The city, now called "Thebes the Victorious" because it incarnated national unity in the face of separatism and resistance in the face of the invader, was deified as a woman armed with bow and arrow and with a spear or a bludgeon equipped with a blade. As such, she was integrated into local theology.

The Egyptians' inclination to identify manifestations of the divine extended even to abstract concepts. Thus, Hu incarnated the word of creation, Sia personified discernment, Heka, magic, and Maat, depicted as a woman wearing an ostrich feather, represented justice, equity, and the essential harmony uniting the elements of creation. Under such conditions, is it any wonder that Egyptians freely welcomed foreign deities, even integrating them into their theological elaborations? Astarte, sometimes on horseback, Qadesh, perched on a lion, Reshef, and many others arrived with the flood of voluntary and forced emigrants who poured into Egypt, especially during the New Kingdom.

Hence, from north to south, divine manifestations perceived in the landscape, in flora, in fauna, and even in certain artifacts paraded past. But that profusion of deities was no lawless proliferation. The multiplicity and diversity of gods did not entail a radical heterogeneity. Far from a mere juxtaposition of irreconcilable cult and belief systems within the same geographical region, the sacred tended to form a mosaic of varied but homogeneous elements. Throughout Egypt's history, in fact, the unifying and organizing principles of pharaonic culture were at work.

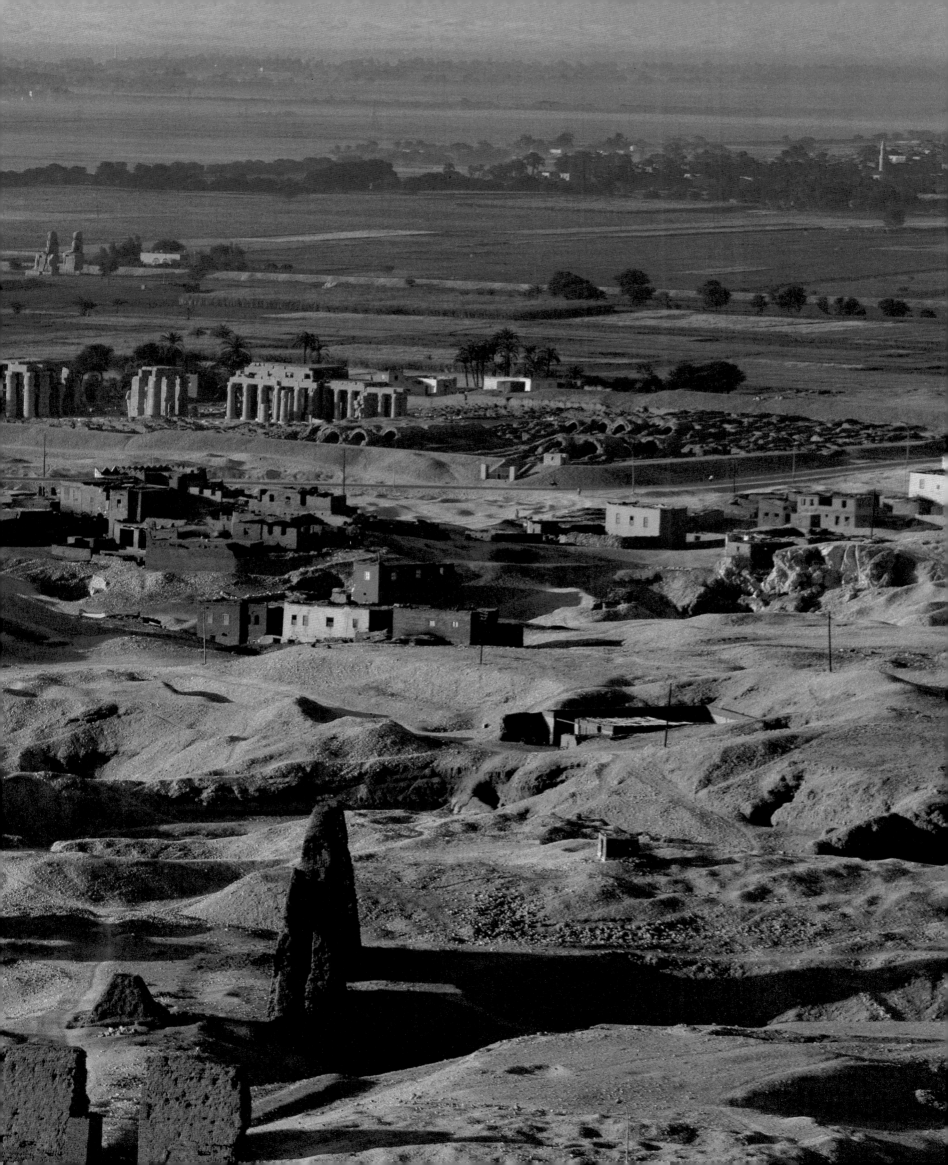

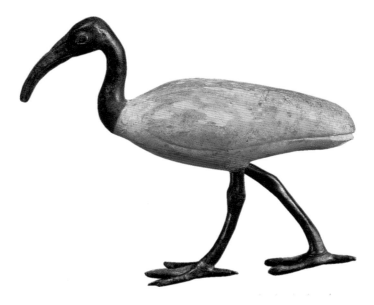

Although one might be justified in distinguishing several components present from the beginning—we have already mentioned a culture of hunters obliged to comingle with fishermen-farmers—once constituted, pharaonic culture imposed coherence beyond the chance events of history.

Let us cite one striking illustration of that permanence across the centuries: the scene representing the pharaoh massacring the enemy was handled in fundamentally the same way (once stylistic variations are taken into account) in the early dynasties at the beginning of the third millennium B.C. as in a temple built under Roman emperors in the second century A.D.! That astonishing stability is a challenge thrown in the face of history, with its endless and irresistible change.

That unity of time corresponds to a unity of space. With the anecdotal exception of a few foreign enclaves, occasionally imposed or agreed to, the same culture extended uniformly across the entire Egyptian territory, jealously holding to its view of the world across geographical terrain and historical time. How could religion, which was one of the major expressions of that culture, not have reflected its coherence? Especially since religion was one of the living forces that shaped the country's destiny. It is an understatement to say that Egyptian religion was a state religion; in fact, it was a constituent part of the pharaonic state. In ancient Egypt, there was no separation between civil and religious powers. One and the same person, the pharaoh, both governed the country and oversaw cults. The temples where these cults were practiced, like the administration and the army, belonged to the state apparatus. As such, religion was inevitably designed to serve the unifying and—let us admit—more or less totalitarian function of the government. As a result, religion constantly worked to integrate originally disparate material into systems which, if they were not perfectly coherent, were at least homogeneous. These efforts occurred at both the local and the national level.

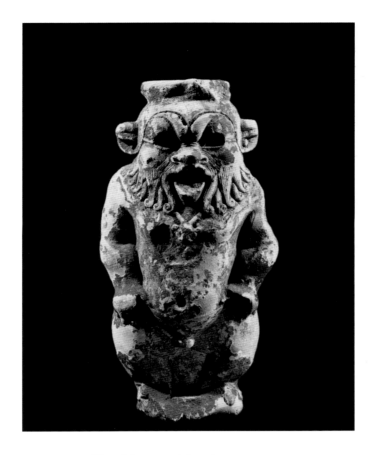

The god Bes was a deformed
dwarf with twisted legs and a
grimacing leonine face. Paradox-
ically, it was his forbidding aspect
that made him one of the most
popular deities of Egyptian
civilization. Supposedly he
frightened away evil or destructive
forces. Headrests were adorned
with his effigy to prevent
nightmares.

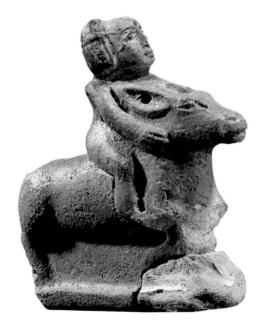

At left: Harpocrates, the child
Horus, riding a donkey. The object
symbolizes the victory of Horus
over the god Seth, murderer of
Horus's father, Osiris. Seth is
represented by the donkey. The cult
of the child god became widespread
in the first millennium B.C. This
statuette may have been one of the
first manifestations of the new
vogue.

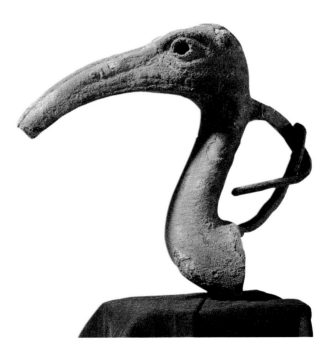

At right: An ibis beak, originally
mounted on a wood statuette. The
ibis was the animal of the god
Thoth.

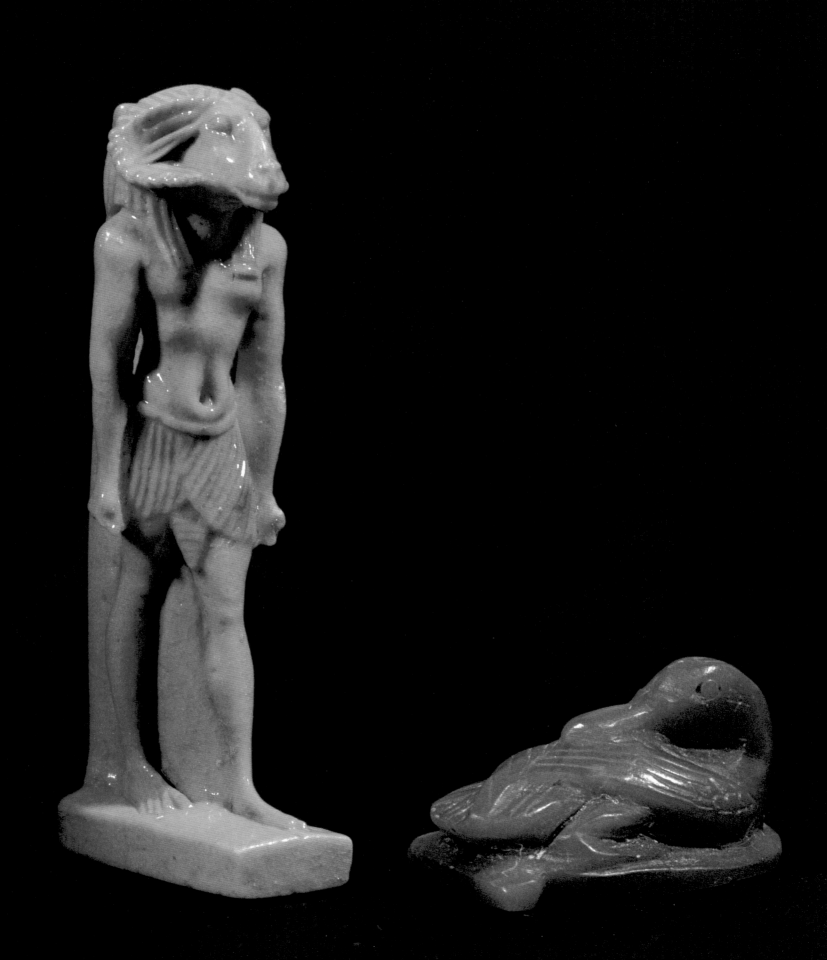

Cult Organization at the Local Level

Each of the two parts of Egyptian territory, Upper Egypt and Lower Egypt, was subdivided into provinces or nomes, as they were called in Greek. Theoretically, Lower Egypt had twenty nomes and Upper Egypt twenty-two, but additional nomes or districts were occasionally created to adapt to historical changes. The original territory of these nomes seems often to have been delimited as a function of geographical features. Thus a nome might correspond to a brief broadening in the space located between the Nile and the desert plateau, to a plain into which important waterways flowed, to a zone defined by two tributaries of the river, or even to the border country near Asia or Libya. In any case, these nomes were not only administrative districts, tax bases, for example, but also dioceses of sorts among which the cults were distributed.

The division into nomes supposedly came about when the world was made, and it reproduced the plan of god the creator. Nomes thus formed the basic territorial units of a sacred cosmography that ordered creation as a whole. Moreover, the very manner by which they were designated betrayed their religious function: each nome possessed its own insignia, composed of a standard ⌐⊤, upon which a fetish (a type of magical object) was placed. Within the framework of that nome, religious science had to organize the original proliferation of beliefs and cults by designating a major deity, for which the city served as metropolis, and an increasingly extensive set of cult entities, which were gradually codified: consorts, Osirian relics, snake spirits, trees, sacred places and spaces, feast days. An enormous task of hierarchization and reinterpretation was thus carried out.

In accordance with a hierarchical process of which we can usually see only the results, the territory of a province welcomed a number of varied and concurrent deities, one of which necessarily had to come forward as the nome's chief god within the overall representations of Egypt and the created world. The choice was obviously motivated by power relations between cults of different ages and origins, as the fate of the nomes' heraldic fetishes suggests. These fetishes could justifiably be

This snake coiled into a figure 8 is on a casket that contained the mummy of a snake. Together, the box and mummy were an ex voto, which a believer placed in the sanctuary of one of the deities for whom the snake was a sacred animal.

Opposite: Amulet of a ram god. This small object (height: 1 ¹/₂ in., or 3.8 cm) is remarkable for the intricacy of the workmanship. Saite Period (664–525 B.C.). At right, a ring setting in the shape of a duck. It is inscribed underneath with the name of Princess Neferura, daughter of Hatshepsut and Thutmose III.

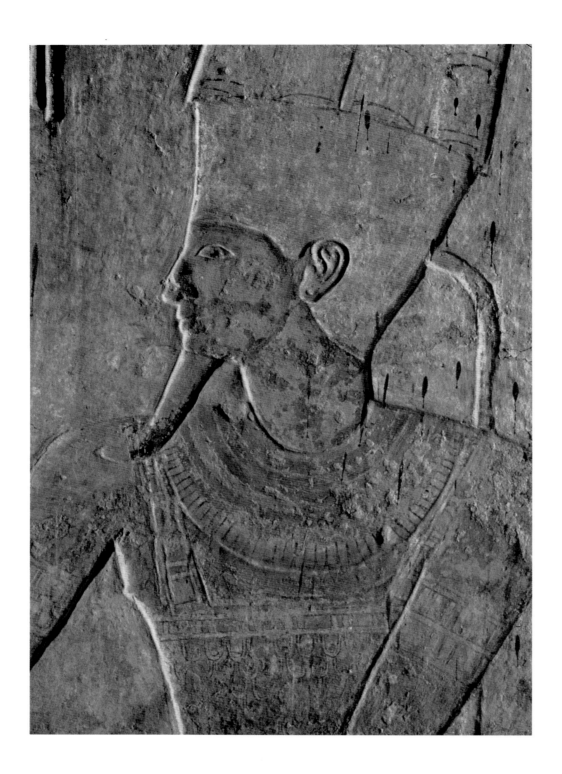

The god Amun. Bas-relief from the temple of Beit el-Wali in Nubia. Rameses II built a series of temples in Nubia, the most famous of them at Abu Simbel. They were dedicated to major gods—Amun, Ra-Harakthy, and Ptah—who were associated with the divine aspects of the pharaoh himself.

Opposite: The goddess Isis on a bas-relief in her temple on the island of Philae. Although the workmanship is extremely fine, the overall style shows a rather labored mannerism characteristic of the Greco-Roman Era.

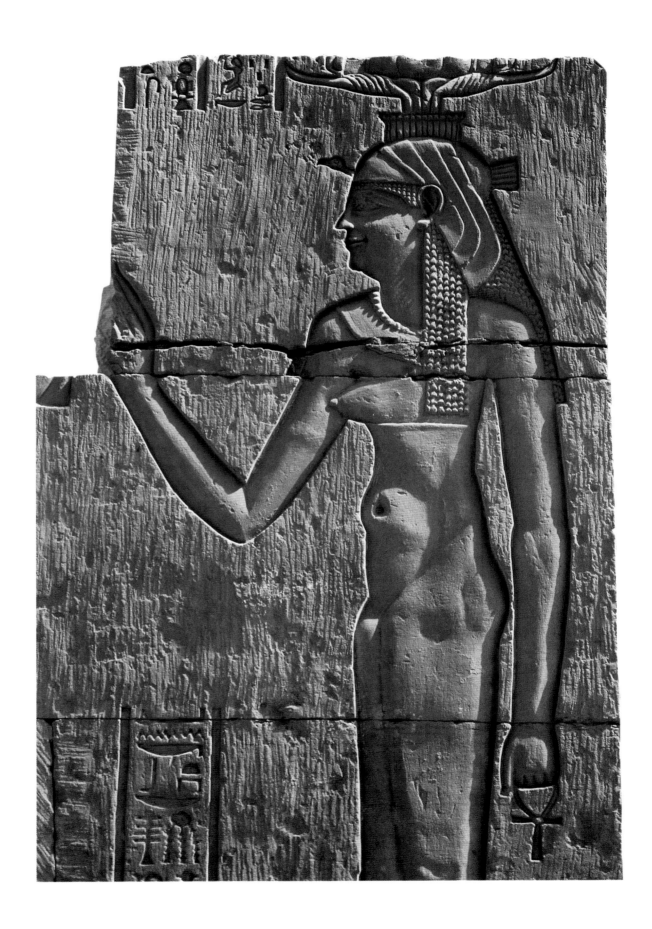

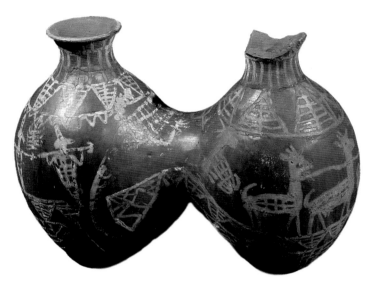

This double vessel has a white pattern on a brownish red glaze that is characteristic of the so-called Naqada Period, in the early Predynastic Era (fourth millennium B.C.). Framed by geometric motifs is a series of figures, which are difficult to distinguish from the stylized geometric shapes. Depicted are a crocodile and a human silhouette with a harpoon (?) on his shoulder; at right, the tag end of a herd of oryx, which are attached to a rope. Whenever the archaeological context of vases of this kind is discovered, it is found to be a tomb. Thus, these motifs are possibly inspired by religious beliefs.

considered relics of very ancient cults. Many of them disappeared without a trace from the religious traditions of their province. Some survived very marginally, as if overwhelmed by another deity. Thus, the crocodile god Iq from the nome of Tentyris (Dendara) was in some sense reduced to bare subsistence level by the goddess Hathor. Surprisingly, the tree god Naret from the nome of Herakleopolis resurfaced from time to time in the first millennium, though it had been believed condemned to oblivion, given the omnipotence of Heryshef, the great local god.

Other fetishes, though supplanted, retained a place of honor. For example, Kemur the black bull, emblem of the nome of Athribis in the center of Lower Egypt, had a personality so strong that he was integrated into different developments in the cult of Khenty-khety, who became the god of the city. In a few cases, the nome's heraldic fetish was promoted to the rank of major deity, undoubtedly at the price of reinterpretation. The second nome of Upper Egypt, whose emblem was the perch (?) of a hawk, had Edfu as its metropolis. The city's temple, still almost intact in our own time, was dedicated to the hawk god Horus. The fetish of the ninth nome of Upper Egypt, ⟨⟨⟩⟩, which Egyptologists have not yet definitively identified, was assimilated by the god Min, and it remained his ideogram (insignia).

The process of hierarchization did not simply establish the status of heraldic cults, but also concerned itself with all the deities in a nome. Those who became secondary gods after the major deity was promoted were not necessarily eliminated. Often, they were integrated into the mythico-religious entourage of the major deity, becoming his consort or child. For example, on Elephantine Island, capital of the first nome of Upper Egypt, two minor goddesses, Anuket and Satis, were linked to the primary god, Khnum, to form a triad. In Memphis, another triad brought together the originally independent cults of Ptah, Sekhmet (promoted to Ptah's wife), and Nefertem (who became their son). Thebes was not far behind, grouping Amun, his wife, Mut, and their son, Khonsu, into a nuclear family.

In addition, the cult of secondary deities could develop independently in one part of the nome,

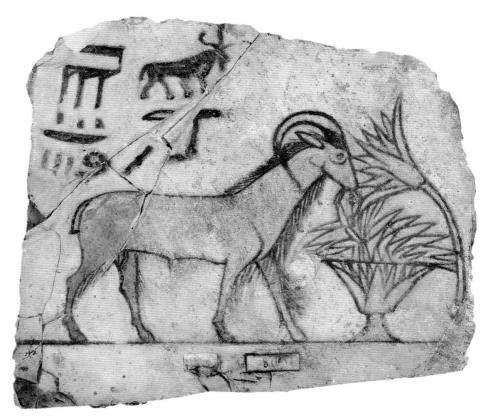

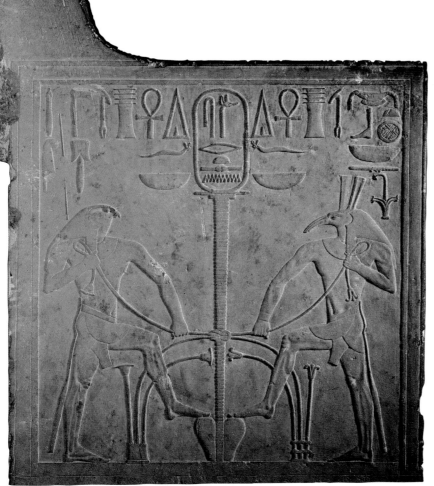

At left: One of the most common means to express the pharaoh's power was to assert the union under his rule of Upper and Lower Egypt. That symbolism is found in this scene on the side of a throne on the statue of Sesostris I. To the hieroglyph for "to unite," two gods join the heraldic plants of each of the two parts of Egypt that were placed under their respective control. The central heiroglyph has been enlarged to make it a graphic element. At left is Horus, with a falcon's head, and at right is "he of the city of Ombo," that is, Seth, recognizable by his phantasmagorical head.

Above: This ostracon illustrates the problem raised for the ancient Egyptians by the disappearance of certain species of sacred animals. The animal depicted is a goat, but the hieroglyphic legend above it designates it as a ram, using the ideogram of a sacred ram belonging to a species that had disappeared nearly a millennium earlier.

Following pages: Farming along the Nile.

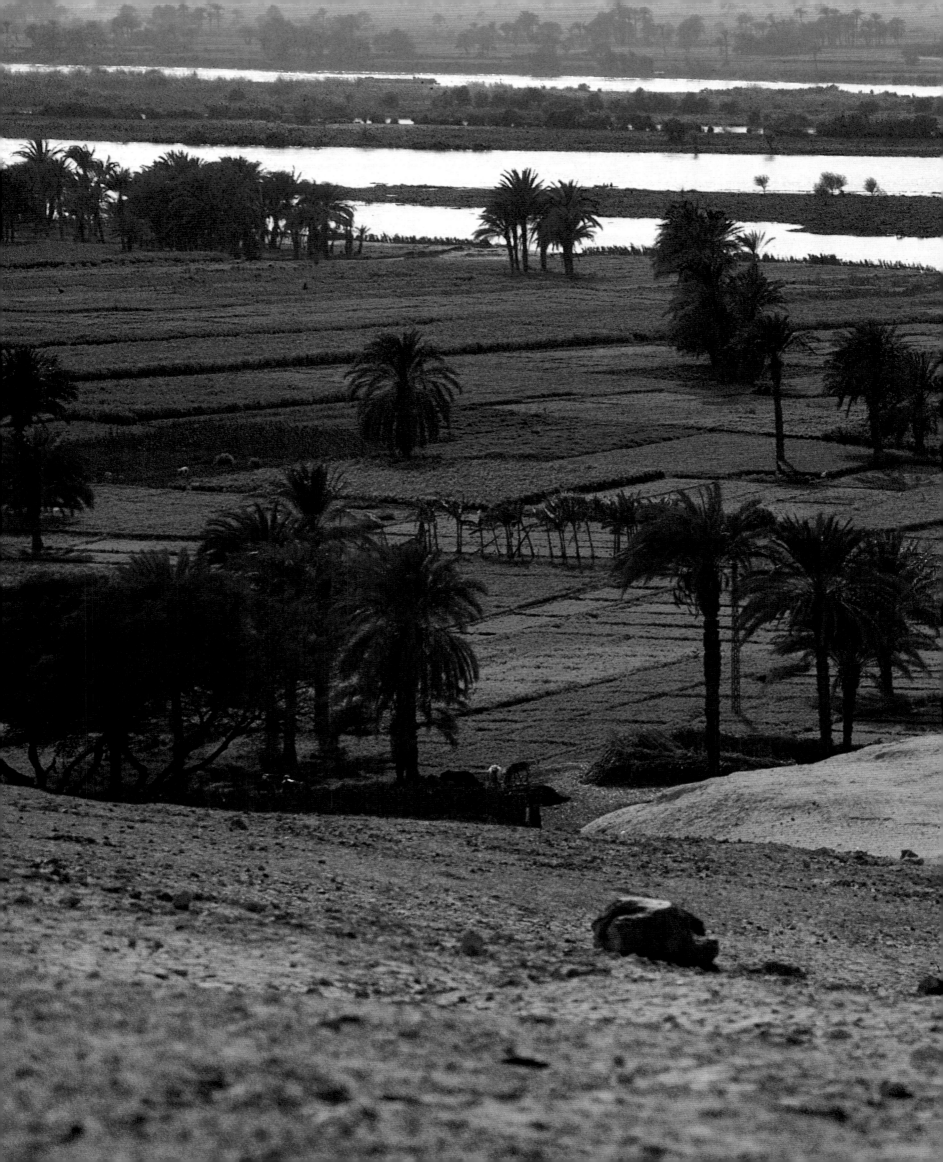

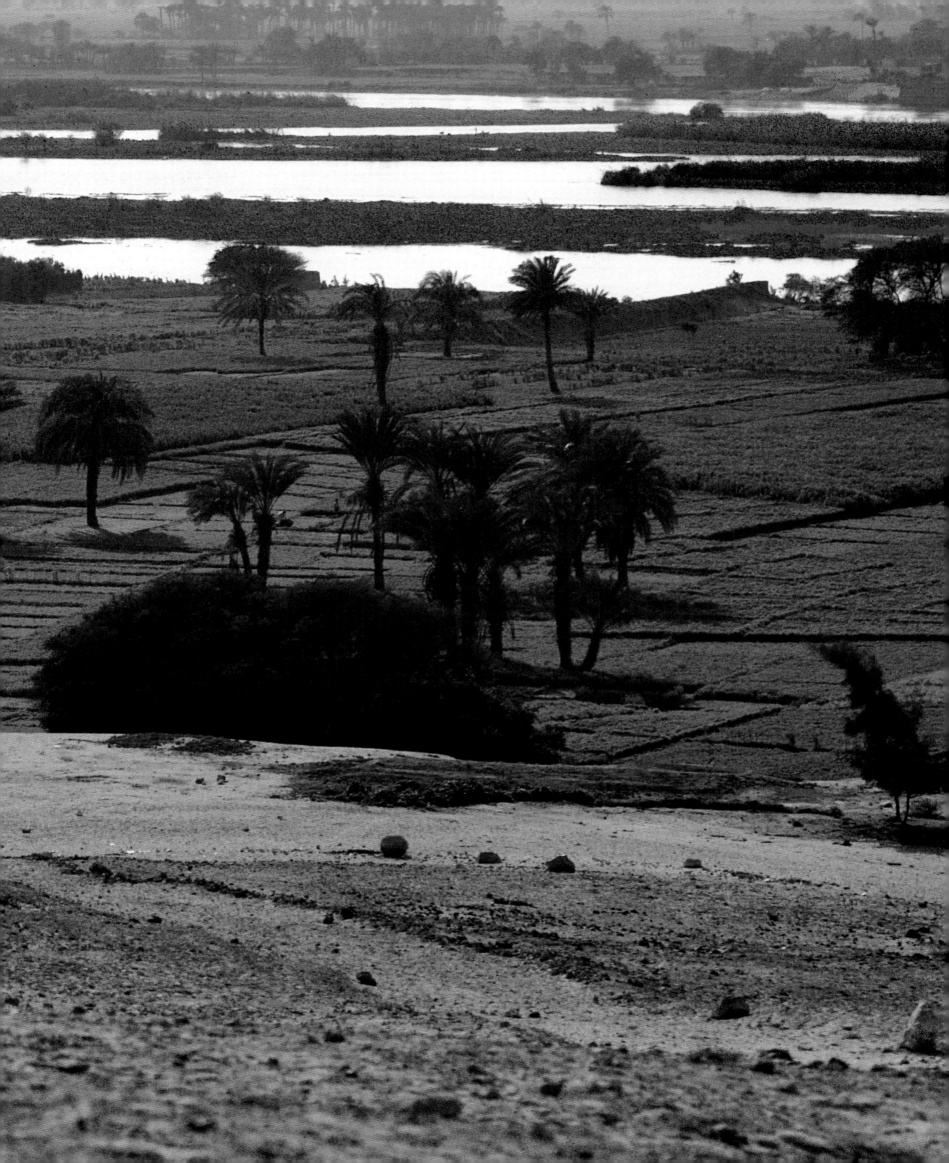

Two so-called concubine statuettes. Placed in the sanctuaries of goddesses or in tombs, they supposedly ensured fertility to the living and the recovery of sexual potency to the dead. The legs were cut off, no doubt to make the concubine ever available. The pelvis is accentuated, and the nudity of the body is underscored by a belt and beaded netting.

sometimes until that part was recognized as an autonomous district. This is demonstrated in the fate of Hermonthis, a locality originally within the Theban nome, but which attained the status of independent nome, territory of Montu, after that god was supplanted in the Theban hierarchy by Amun. The city of Nubyt, rendered in Arabic "Ombo" in the modern name of the site, Kom Ombo, was an exceptional case in this process of regional hierarchization. Originally belonging to the nome of Elephantine, it gradually formed into an autonomous district with not one but two associated major gods, the crocodile Sobek and the solar hawk Haroeris. The fact that they were considered on equal footing is marked by the very architecture of the temple of Kom Ombo: it is arranged around two sanctuaries placed symmetrically in relation to the central axis.

That hierarchization was also a reinterpretation. The vast number of religious texts that were once part of temple archives systematically listed all the cults and holy places of a province, assigning them a meaning based on etiological myths and thus homogenizing their original disparateness. One significant example occurred within the territory of the nome of Cynopolis in Middle Egypt. A vineyard was attached to a "castle," which no doubt housed men and materials relating to wine making, like the castles in the Bordeaux region of France. The entire complex was part of the property of the "divine adoratrix," a priestess incarnating the feminine erotic power that stimulated the generative powers of the demiurge of creation. There is good reason to believe that the castle was established there during the New Kingdom, a period when the institution of the "divine adoratrix" was developed.

In the late period, that geographical particularity, an accident of history, was integrated into the religious traditions of the region. A lengthy myth told how the vineyard, the grapes, and the wine came, respectively, from the sockets, pupils, and tears of the god Horus, who had the castle built so that Isis could stand on its terrace and solicit Ra's protection by directing signs of adoration toward him.

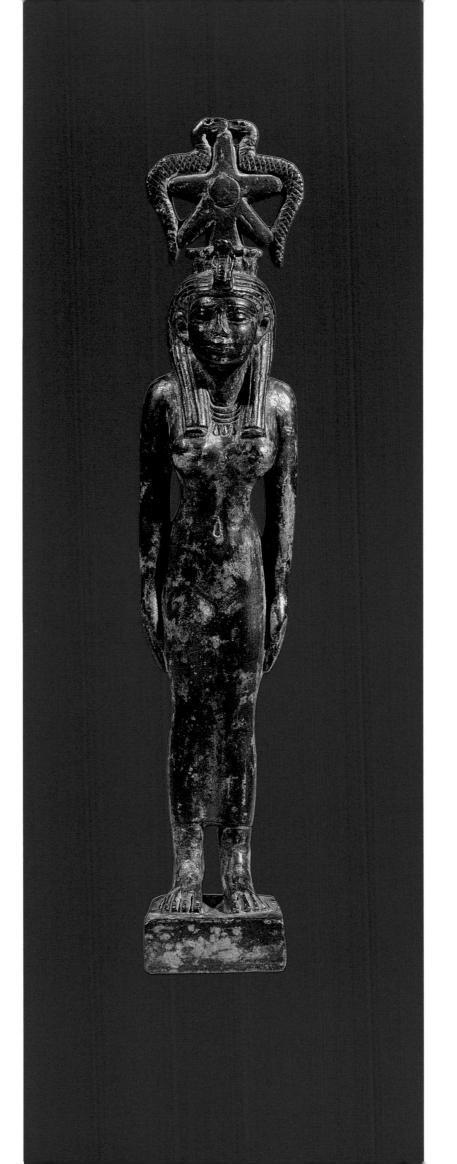

A bronze statuette of the goddess Seshat, mistress of make-up, adornment, and drawings. By the latter association, she was the consort of Thoth.

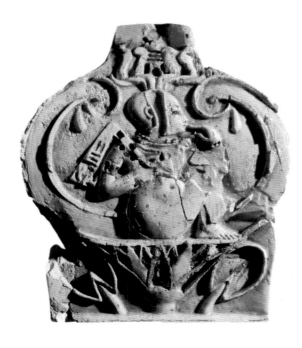

In pharaonic Egypt, the first millennium B.C. was the era of child gods. Both the myth of the young Horus, who was saved from Seth's fury in the dense marshland, and the myth of the sun's birth as a child emerging in a cloud from lotus petals, enjoyed great popularity. That is the theme of this illustration. To indicate the god's youth, the artist has followed the Egyptian convention of positioning the deity's finger at his mouth.

Opposite: The child god Horus, wearing a composite hemhem *crown composed of three* atef *crowns.*

That hierarchization and reinterpretation, which organized the traditions specific to a nome, illustrate what was in some sense the original foundation of religious thought in pharaonic Egypt: local cults. A good number of deities first distinguished themselves in the cult devoted to them in some province, or even in some place within a province. In addition, this cult often reflected the particular topography of the place. For example, both Satis, worshiped on the southern border, and Sopdu, master of the eastern marches leading to the Asian world, were war gods who repelled enemies. The god Min of Koptos, a city located at the entrance of the Wadi Hammamat, a passageway to the Red Sea and the Sudan coasts, was the lord of far-off countries and their treasures. The notion of local god was attested in very ancient times in the expression *netjer niuty*, "god of the town," frequently used as a sort of empty signifier, which inhabitants filled with the name of their local deity.

Throughout pharaonic history, cults were unerringly attached to a place of origin. Although that attachment manifested itself in a particularly visible manner during periods when the central power had weakened or collapsed (during the First Intermediate Period, for example), or had fallen into the hands of foreigners (the Greco-Roman Era), it did not disappear even when a pharaoh with uncontested authority imposed a unifying and centralizing policy. Witness the attitude of Amenhotep son of Hapu. Trusted adviser to Amenhotep III (c. 1391–1353 B.C.), at the height of the pharaonic state's power and prosperity, he was ordered by the king to oversee the colossal construction projects in Thebes, the gleaming capital. Even after he had, in essence, been promoted to the prestigious rank of vizier to the pharaoh, the provincial man did not forget Athribis, his city of origin. He used his credit to advantage to make renovations in the temple of the city's god, Horus-Khenty-khety, and received, no doubt, the title "overseer of prophets," that is, head of the local clergy.

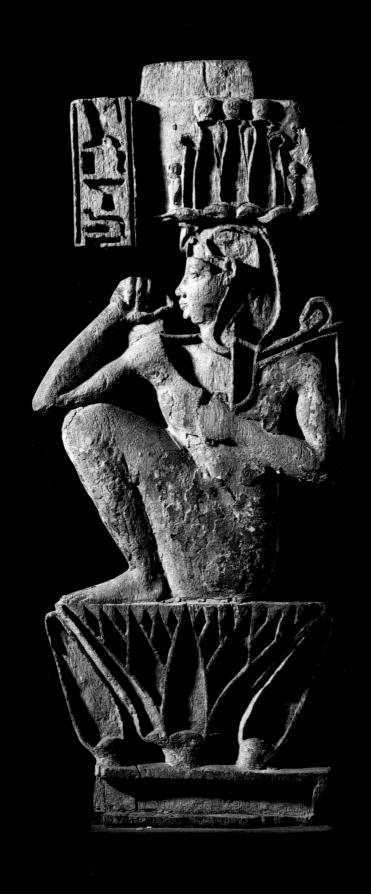

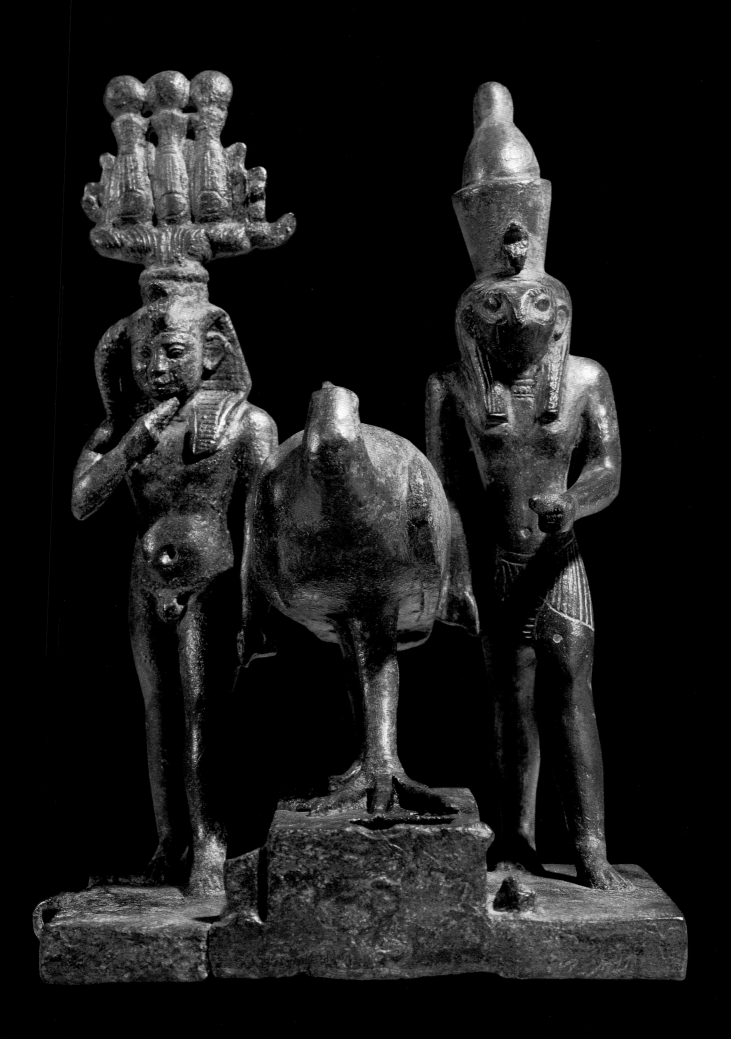

Opposite: Bronze group statuette. Front and center is an ibis, flanked on the left by Horus as a child and on the right by Horus as king, wearing the dual crown of Upper and Lower Egypt.

Statuette depicting Imhotep, the architect who designed King Djoser's funerary complex. More than two millennia later, Imhotep was considered a demigod, son of Ptah and a mortal woman. Here he has placed a partially unrolled papyrus on his knees.

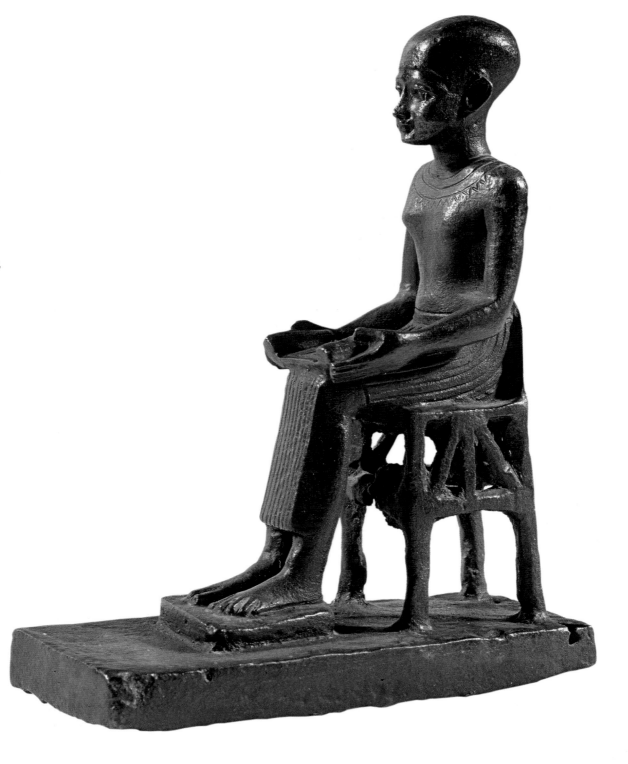

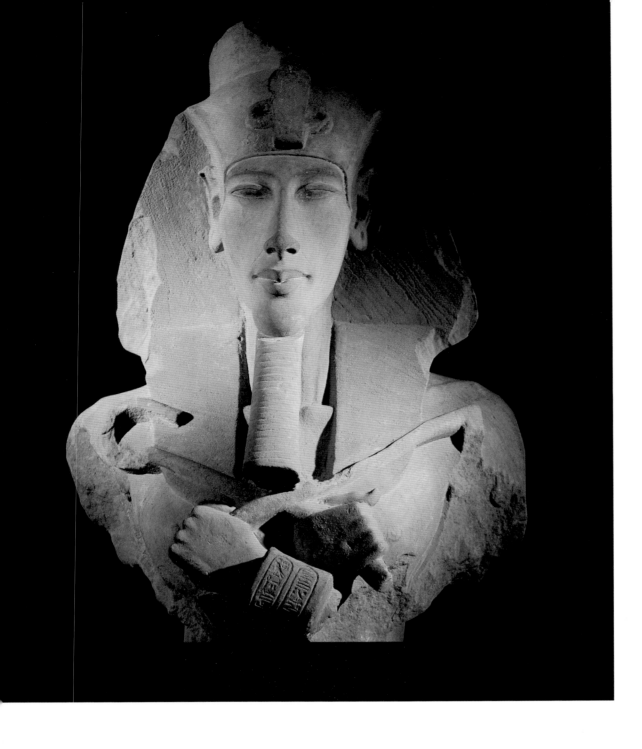

Head of a colossal statue
of the pharaoh Akhenaten.
On the wrist of his right
sleeve, two cartouches
surround the names that
theologically define the god
Aten.

Opposite: The goddess Isis
holds a sistrum, the base
of which is a woman's
head with cow's ears.

The World Order

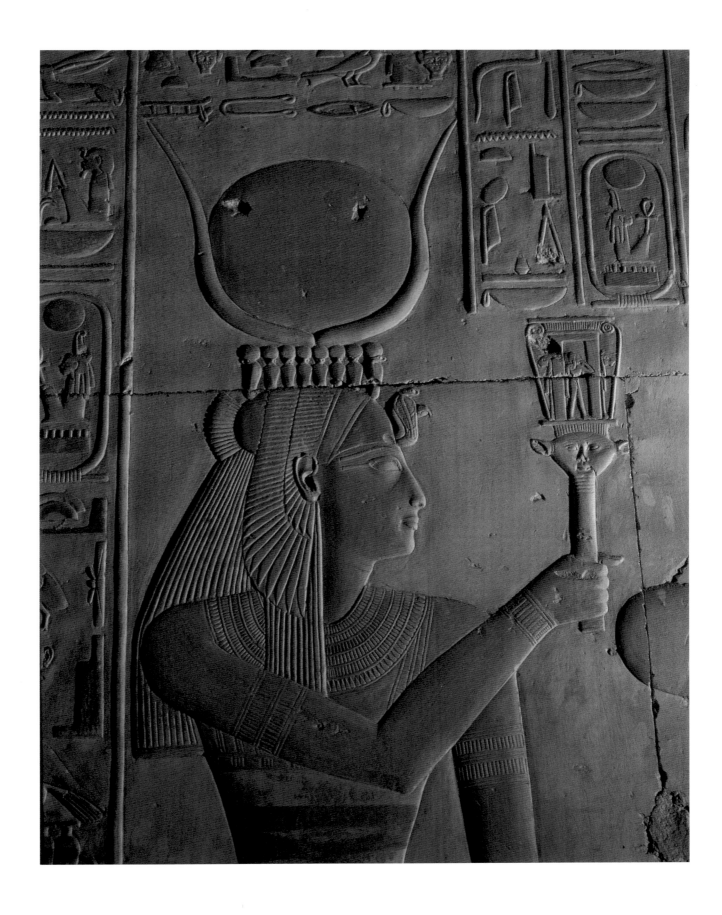

The ideology of the pharaoh's relation with the gods was also expressed in sculpture in the round, in groups such as this one. It was erected by Horemheb, the last pharaoh of the Eighteenth Dynasty, who definitively annihilated the Amarna heresy by dismantling Akhenaten's temples. Horemheb is seated next to Horus avenger of his father (Greek form, "Harendotes"). Horemheb was originally from Hut-nesut, a city in Middle Egypt, whose major deity was Horus; this sculpture may seem to be a tribute to his local god, to whom he attributed his accession to the throne, but Harendotes is not necessarily Horus of Hot-nesut, and there are two other analogous groups showing Horemheb beside other gods.

The profusion of deities was thus divided into an intricate network of about forty nomes. Yet the multiplicity and diversity of these local deities did not entail a radical heterogeneity. In fact, although cults were organized initially at the local or nome level, the nomes themselves were only subdivisions of a centralized state with a totalizing ideology and a uniform culture. As a result, these local beliefs, far from developing in a totally autonomous manner, were integrated into a system of thought and practices shared by Egypt as a whole.

The Pan-Egyptian Sensibility

There were several reasons for that unity transcending diversity. First, the same god was sometimes venerated in different places within Egypt, since his cult was often linked to topographical or ecological conditions existing in more than one spot. Of course, historical evolution played a role in blurring such geographical determinism, which must not be overestimated. Nonetheless, lioness cults are often attested at entrances to wadis, the dried-up streambeds linking the infertile savannas of plateaux and the valleys, where easy prey grazed. Similarly, wherever there were lakes, marshes, or tributaries, there were crocodile gods.

Second, the individuals and even the groups who relocated at the whim of administrative and economic necessities ,or political vicissitudes took their native gods with them to the places where they settled, temporarily or permanently, thus spreading deities throughout the entire territory.

Third, from its advent in the so-called Thinite Era (First and Second Dynasty, between 3000 and 2630 B.C.), the central government worked to establish homologies between regional deities and those representing the person of the pharaoh. Hence, Bastet, the goddess who oversaw the royal ointment, was identified with a lion goddess in a city located on the eastern Delta. That city was later called "Bubastis," a Hellenized form of an Egyptian name meaning "home of Bastet." In addition, each of the pharaoh's two principal crowns, symbolizing the two parts of the kingdom, was identified with a god. The white crown of Upper Egypt was associated with the vulture god of the city of Nekheb south of Thebes. The red crown of Lower Egypt was identified with the cobra goddess Wadjyt, or Uto, from a city on the northern Delta. That city was later called Buto, a Hellenized form meaning "home of Uto." In general, the religious ideology associated with the pharaoh, propelled by the

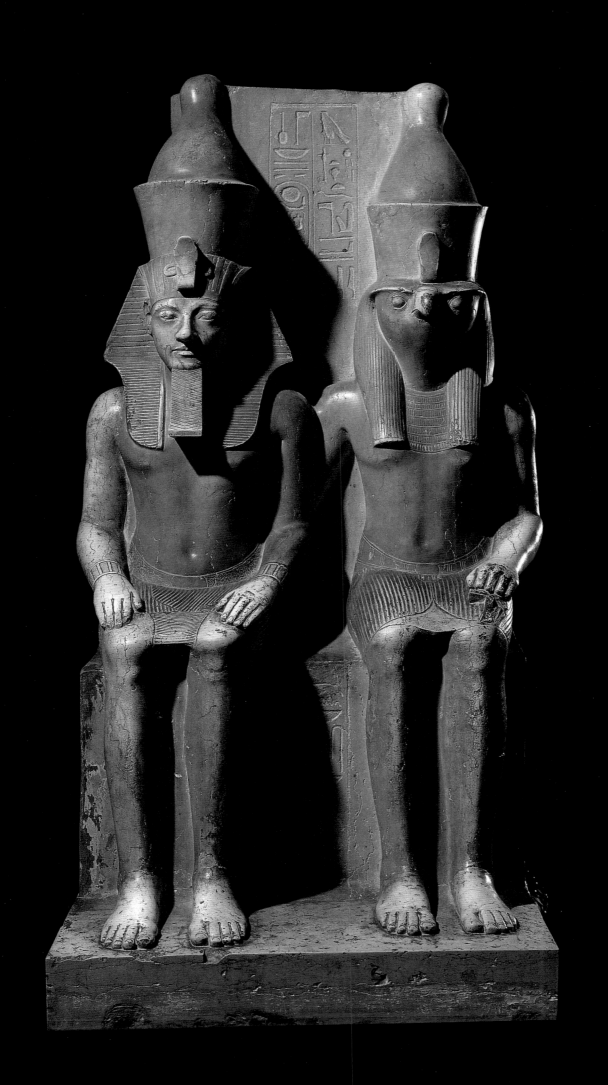

An "epsilon" ax, so named for the shape of its blade. Widespread elsewhere in the Near East, it was introduced into Egypt during the First Intermediate Period.

prestige and power of his office, spread throughout Egypt. Local beliefs were adapted or adjusted to fit the overall picture, beyond the variations required by partitioning.

Fourth, the pharaohs, in favoring cities for which they had a special fondness, either because they were the cradle of the pharaoh's dynasty or because of their cultural, historical, economic, or strategic importance, promoted gods from these cities to the rank of national or pan-Egyptian deities. Such was the case in the Ramesside era, when the extraordinary stature of the major gods Amun-Ra of Thebes, Ptah of Memphis, Ra of Heliopolis, and Seth of Piramesse was proclaimed in ideology through a series of signs. For example, each of these gods gave his name to one of the four corps composing the Egyptian army.

Fifth, other deities transcended their local roots and were shared by the country as a whole because of the particular function they incarnated. Thus, Thoth was universally the god of scribes; Montu was the god of warriors; and it was Hathor who secretly promoted love affairs.

Finally, from time to time, religious currents with a national dimension accelerated the irresistible mingling of cults and beliefs across Egypt by submerging, or more precisely assimilating, local particularities. For example, in the early third millennium, a craze developed for the child god, based on the model of the young Horus, who, despite much trouble and persecution, managed to take the place of his murdered father. As a result, a cult of the child god was elaborated in every province, either spontaneously or from a marginal aspect or mere potentiality of a deity. That cult was then integrated in one way or another into local traditions. Later, inside every temple, a particular sanctuary was built; called in Arabic a *mammisi* (derived from the Coptic word for "birthplace"), it was there that rites and rituals specific to the birth and suckling of the child god were celebrated.

Similarly, some time later, the popularity of Osiris, though already long established, became so widespread that, next to its fount of traditional beliefs, every city systematically made a particular place for the Osirian mythico-cultural complex and its local interpretations. Hence, a treatise of the nome of Cynopolis in Middle Egypt, copied into the Jumilhac papyrus, includes, in addition to an exposition of ordinary cults, a special section on the Osirian traditions of the site. That practice was

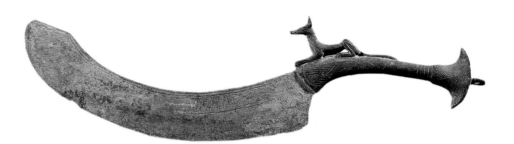

also expressed in monuments: six chapels dedicated to Osiris were built on the roof of the temple of the goddess Hathor in Dendara; these chapels operated independently from the rest of the building. The architecture of other sites, such as Philae, also included divided sanctuaries.

All these factors served to promote the proliferation of cults over the entire expanse of Egypt. Their number never fails to astound us, whenever the available documentation gives an overview of some site or region. During the New Kingdom, within the small community of royal tomb workers, located on the site of present-day Deir el-Medina, the following gods were venerated: Ra, Harakhtes, Amun (in different forms), Ptah, Thoth, and the moon god Yah, Suchos, Min, Soped, Osiris, Anubis, Isis, Nephthys, Harsiesis, Hathor, Meretseger, King Amenhotep I and his mother Ahmose Nefartari, Thoeris, Ernuthis, and deities of foreign provenance such as Qadesh, Reshef, and Anat, not to mention gods introduced from neighboring regions, no doubt as a result of relocation or migration (the Elephantine triad Khnum, Satis, and Anukis, Montu of Hermonthis, Seth of Kom Ombo, Onuris-Shu of This, and so on).

Under the Thirtieth Dynasty, an inventory of the cults of Athribis, a mid-sized city, listed no fewer than sixty-eight minor deities, not including the major ones. And even that was only a selection. A text from a temple's archives lists thirty-six cults in Duan-auy, probably the township of Harday, a few acres wedged between the Arabian cliffs and the Nile River in Middle Egypt. Inscribed on the walls of the surviving Ptolemaic and Roman temples, the lists of deities is enormous. In general, these pantheons include specific deities, some honored only sporadically, others quite widespread, even pan-Egyptian.

Their status varied. Some were the objects of formal cults, with appointed clergy, regularly celebrated rituals, and feast days and agricultural property to provide for them. Others were evoked as mere personifications to complement the symbolic array of a theological assembly. Still others were deities who, lacking their own cult, had to share the services of a collective priest with other dieties who were just as bad off. Specially in charge of the rejects, this member of the clergy was called "servant of god [i.e., priest] for gods who have no servant of god"!

Because the jackal—suggestive of the god Anubis—appears on its hilt, this knife may have been used for mortuary preparations, perhaps mummification.

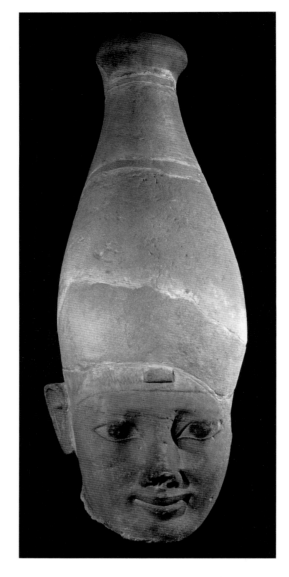

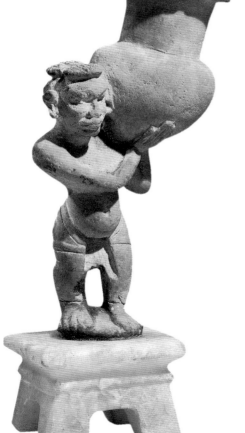

In temple architecture, pillars were sometimes merged with colossal statues depicting pharaohs in the aspect of Osiris, that is, enveloped in a large winding sheet with only the hands and head show-ing. The head was covered with a type of miter. Here is the head of one of these "Osirid pillars," which dates to the early part of the Eighteenth Dynasty.

Two unguent vases are carried by as many servants, a Nubian at left and an Asian at right, that is, the two peoples neigh-boring Egypt to the south and northwest, respectively.

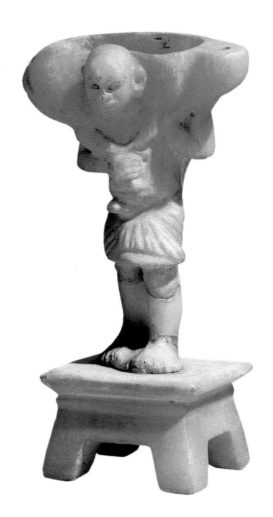

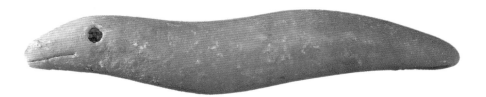

Divine Osmosis

Hence, ancient Egypt was populated by a dense and compact crowd of gods. That overcrowding was not unpleasant: everyone seemed to get along together, and their human servants accommodated themselves to the proliferating diversity. Conflicts between worshipers of different animal species, a topic Juvenal poked fun at with some sarcasm, came about only with the final decay of a dying civilization. In the times of the pharaoh, exclusion was not practiced among Egyptian gods; on the contrary, the ease with which they mingled, coexisted, and even joined together can be disconcerting. Witness the incessant and ecumenical activity of theologians, who always favored the affinities that united their deities with others, some of them very remote.

At an elementary level, gods were paired as couples or dyads, not only within a single locality, but also between distant cities. Consider the wedding ceremonies celebrated every year with pomp and merrymaking between the goddess Hathor of Dendara and the god Horus of Edfu. More than a hundred kilometers of waterways separated them; but, after all, who could resist Horus? Thus, the statue of Hathor left its dark sanctuary to travel far to the south and there to remarry.

But the most common procedure among Egyptians was to consider all deities in other places who shared traits with a local god as particular manifestations of that god. They fastidiously strung gods together in endless litanies. The tendency to assimilate one god to another was at work throughout pharaonic civilization and greatly contributed toward reinforcing the national dimension of a religion that was apparently scattered into a myriad of local cults, disseminated across the territory. This process is called "syncretism," and the identification it posited did not imply an exact equivalence. The personality of one god was simply recognized as an aspect that was particularly developed in another.

Hence, the crocodile gods Suchos of Shedyet and Khenty-khety of Athribis were renamed, respectively, Suchos of Shedyet-Horus-who-lives-in-Faiyum and Horus-Khenty-khety (Hellenized form, Harchentechtai), because, as beliefs evolved, these gods displayed a personality trait for which Horus was the prototype. Were not these crocodiles, who had the habit of dragging their prey

Known as "the great of magic," this implement was used in the Opening of the Mouth ritual. Often shaped like a snake, in later periods, it sported a ram's head.

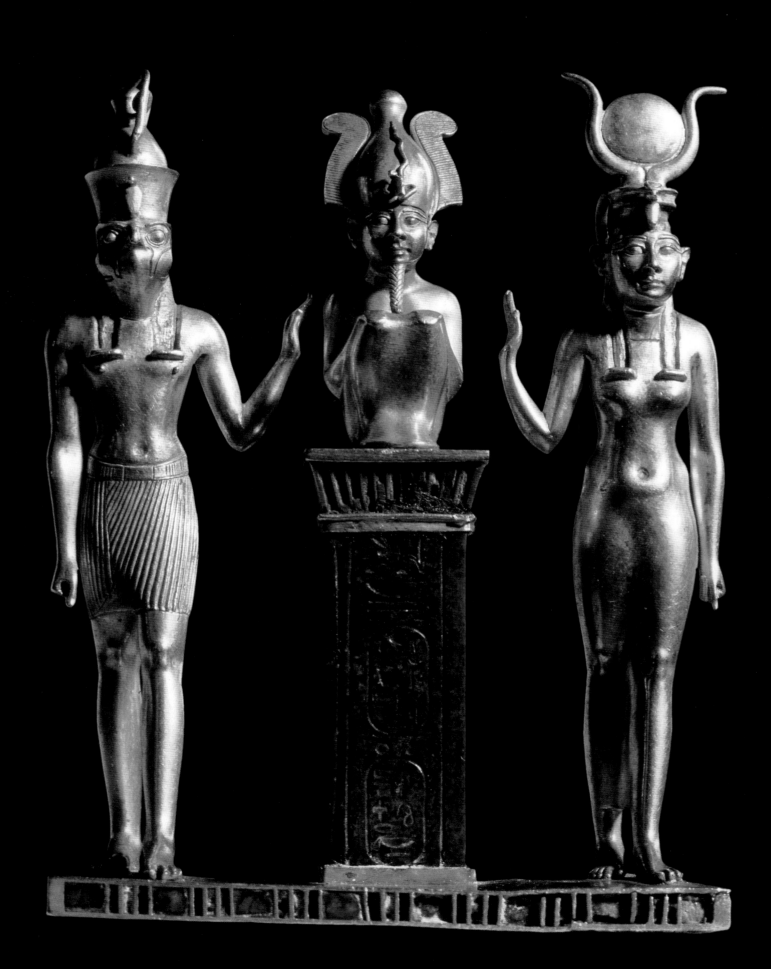

underwater, capable of going to look for the body parts of Osiris, father of Horus, which had been dispersed along the length of the river by Seth, his brother and murderer?

Similarly, the tendency of theologians to highlight solar qualities, and thus affinities with Ra, the sun god par excellence, in Horus, Khnum, Sobek, Amun, and so on, was consecrated by the creation of "syncretist" forms such as Horus-Ra, Khnum-Ra, Sobek-Ra, and Amun-Ra. Sometimes, more than two gods were involved: thus, the Great Sphinx of Giza, already mentioned, was sometimes given the fourfold name Harmachis-Khepri-Ra-Atum. That is, it took the name of the sky god Harmachis (Horus in the horizon), and was envisioned more specifically as the three phases of the sun in its daily journey: Khepri at sunrise, Ra at midday, and Atum at sunset. In the Late Period (660–330 B.C.), speculation went so far as to unite syncretically a god and a goddess!

Such associations were fluid and did not affect the independence of the deities composing them. The two partners continued to live separate lives, always prepared to establish other unions of the same type. Even when he manifested himself as Khnum-Ra, Khnum was still Khnum, and also appeared in the form of Khnum-Shu. At the same time, Shu was joined to, among others, Khonsu, under the name Khonsu-Shu, and Ra formed alliances with many other gods. To be sure, the Egyptian deity was neither the only god nor a jealous god, and the pantheon seems to have existed in a state of osmosis.

Divine Ontology

That is what is so disconcerting and, in the end, perhaps even amusing. We should not take such syncretism too lightly, however. In fact, behind the appearance of a game of theological musical chairs, an open and original conception of divine ontology was at work. Gods were the dynamic principles that governed the order of creation. Their place was in heaven, but they could, by extension in some sense, come to earth, temporarily occupying anything that bore some analogy or homology with them. Yet they were never completely bound to that thing. They could thus manifest themselves in many different ways. In that sense, the ideogram of a god clumsily traced by an apprentice scribe or the physical sound of a god's name in someone's mouth was a receptacle as likely to receive the divine substance as was a sacred animal, selected according to very strict criteria, or the most perfect cult statues made of precious metals.

The grouping of deities into triads occurred gradually. Although certain triads were a bit artificial, others reflected widespread mythological beliefs. Such is the case with this triad that reunites Osiris, Isis, and their son Horus. It is an exquisite piece of jewelry, made of gold and lapis lazuli, and it is one of the masterpieces of Egyptian decorative arts in miniature (height: 3 9/16 in., or 9 cm). It was made for pharaoh Osorkon II of the Twenty-second Dynasty. This triad is unique in that Osiris's status is ambiguous. Although he is preeminent as father and husband, he owes his fate to the other two. He is beholden to Isis, who gathered up the pieces of his body scattered by Seth and thus saved him from complete annihilation. Osiris is also indebted to Horus, who avenged his murder and succeeded him for the perpetuation of his work. This item of jewelry expresses the complexity of the situation; the dominant figure is passive and vulnerable. Osiris is at the center, and his eyeline is slightly higher than that of the other two figures. That superiority results not from his stature, however, but from the pillar on which he is seated. Enveloped in a winding sheet, Osiris is supported on either side by the hands—open in a gesture of protection—of his wife and son.

Pharaoh Sety I makes offerings of globular pots to Amun and his consort Mut.

Of course, if the hypostasis concentrated within itself several homologies with the thing it stood for, it was all the more likely to attract the god to it. Even so, however perfect that hypostasis, it was always only one possible form of the deity and was never coextensive with it. The divine always transcended the form in which it manifested itself and the words that signified it. It was only partially bound to its earthly presence. The divine could be drawn to something, but not circumscribed by it; it occupied a form, but was not confined to it; it had extension but was not comprehended, unfolded but was not enclosed. It could be articulated but not delimited.

As a result, the list of its manifestations, of its possible hypostases, was always limitless. Unable to grasp the deity in its totality, Egyptians could only set forth new aspects or develop virtualities that had remained latent until then, by multiplying the signs designating it, endlessly accumulating and enriching written descriptions and images. Theology is a science of signifiers, and that fact accounts for the variation in divine representations. Many took the form of an animal or, in the case of sacred animals, a particular representative of the species. Others had a completely human form. Still others were a strange combination of the two, an animal head on a human body. Such amalgams form a significant part of the mystery and attraction of ancient Egypt. Pharaonic art managed to present as self-evident something that was, in fact, a monstrous hybrid.

But, beyond the technical tour de force, that artifice had a purpose: its aim was to represent the god in the form of an animal that visibly displayed the principle the god incarnated. At the same time, that technique pointed out the god's accessibility to human beings. Thus, anthropomorphic representations of animal deities frequently appear in the thousands of ritual scenes illustrating the "dialogue" (in the broad sense) between humanity and the god, a dialogue mediated by the pharaoh, who performed the rite. That was the essential point: the gods always concealed themselves from men even as they manifested themselves, maintaining a kind of reserve. Yet they were still joined to men by the solidarity required to maintain fragile creation. Both gods and men, though to different degrees, participated in being, which, in the Egyptian view, was always threatened.

The World's Creation

That view was rooted in the cosmogonies that accounted for the birth of the world. Beyond numerous variations, all of them rested on a shared foundation. In the beginning, there was the primeval ocean, Nun, where inert water in its limitless expanse, darkness, and the absence of purpose—which Egyptians expressed as wandering—reigned.

The process of creation began with the emergence of difference from within that indifferentiation. The demiurge, virtually present in the ocean, floating unawares, woke up and became conscious of himself. That marked the first phase of creation, characterized by "autogenesis." The demiurge, generally called Atum, "he who brings himself to completion," and designated by the epithet "he who comes into existence by himself," first manifested himself in the form of the sun. A mound emerged from the waves, like the banks of earth suddenly uncovered by a shift in the Nile. On this mound was a pyramidion, the *benben* (probably "that which takes on volume"); at its apex was the sun disc, that is, the demiurge, the only one to possess being in the midst of an absence of being.

Since he did not intend to remain in that solitary state indefinitely, he entered the second phase of creation, the transformation from the one to the many, that is, the creation of other beings. To do this, he drew from his own substance, which contained in virtuality the world to come, just as the primeval ocean had contained him in virtuality. The mythic tradition expresses this process in very explicit terms: first, the demiurge masturbated, his hand standing in for the female partner missing by force of circumstance; and, second, he spit. "So I made the male with my fist, I copulated with my hand, from my own mouth the spittle fell, when I emitted Shu, when I expectorated Tefnut."

Some of the variants hierarchized the two: the sperm gestated in his mouth before being spit out. Others preferred breath or even sweat to the previously mentioned secretions. In any case, the result was the sexually differentiated couple Shu and Tefnut. Shu represented the space separating sky from earth,

This extraordinary monument to Pharaoh Nectanebo of the Thirtieth Dynasty is a circular libation table, an unusual shape for this type of object. Its purpose was to radiate the benefit of libations outward to all the divine effigies of the sector at whose center it stood in a sanctuary in Athribis, Lower Egypt. These effigies are listed on the periphery, according to their position in relation to the table, somewhat like our orientation tables.

The notion of physical performance, a venerable tradition within royal ideology, was developed extensively in the New Kingdom with the glorification of the pharaoh's exploits both in war and in sports. This bas-relief illustrates the hunting prowess of Rameses II, bow in hand and a lion at his feet. The show of vigor rendered by the impressively broad shoulders and the swagger is all the more significant because the king is a child, as indicated by the characteristic sidelock. He was not just the heir apparent at the time, however, but the co-regent, since he sports the uraeus on his forehead.

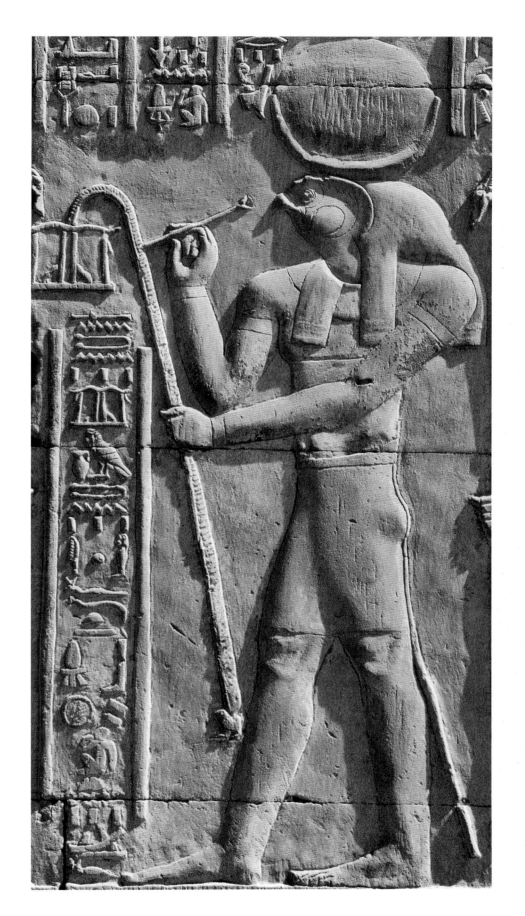

The sun god delegates
earthly power to his chosen
pharaoh and determines the
length of his reign by
recording "jubilees,"
that is, the festivals that the
pharaoh celebrates periodi-
cally to renew his power.
Here, Haroeris records the
"jubilees" with notches
made in a palm stalk.
Thus, the sign ⌠,
depicting a notched palm
stalk became an ideogram
for the word "year."

The incense burner was a basic implement of the cult. Incense was placed in the bowl, which was held by a hand represented at one end of the object. The other end was often shaped like a falcon's head. Many of these incense burners were merely replicas offered as ex votos.

Tefnut perhaps the lower spaces. Along with Atum, they formed the basic triad from which the rest of creation developed. Shu and Tefnut created the third generation, the couple Geb, god of the earth, and Nut, goddess of the sky, who in turn had four children: Osiris, the principle of a natural cycle of death and regeneration; his sister, Isis, with whom he was paired; Seth, the principle of chaos needed to supply energy to creation; and his sterile sister, Nephthys, with whom he was paired. These nine gods, who represented the fundamental principles of the cosmos, composed a collegium called an *ennead*. This *ennead* was deified and was often considered an entity autonomous from the very beings that composed it.

Variations on an Obligatory Myth

Such is the minimal cosmogonic scheme, which is recognized as a doctrine originating in the city of Heliopolis (north of present-day Cairo), the great religious and ideological center of the monarchy and its inspiration. Of course, motivated by various factors—most often, a concern to give local deities the foremost role—theologians elaborated a dense thicket of variations on this schema, proposing a new way of envisioning one episode or another, or further developing some phase of the cosmogonic process.

For example, in place of a mound rising from the waters, a Memphis tradition preferred an earthquake; another tradition, elaborated in Edfu, chose instead a floating bundle of reeds, bearing a hawk god, mysteriously rising to the surface of the primeval waters. The creator could manifest himself not only as the sun disc at the apex of the *benben* but also as an egg set down on earth, either by a collegium of primeval spirits or by a gander whose honking, breaking the original silence, noisily announced the apparition of being.

According to a particularly poetic view elaborated in Hermopolis, a lotus appeared mysteriously—that goes without saying—and broke the surface of the water. Assisted by the eight

primeval gods, the flower opened its petals to reveal the sun in the form of a child. When the child opened his eyes, there was light. Then, with the gold dust that surrounded him and with his fragrance, the lotus child created the ennead and gave life to the gods and to human beings.

As we have seen, the fact that the demiurge performed this task by himself was a fundamental principle, but there were several ways to formulate it. A doctrine concerning Ptah of Memphis substituted a more intellectual view for the masturbation and spitting: the creation was planned in the god's mind, then realized through his word. In addition, the key role in creation could be displaced from the demiurge himself to those who followed him. Hence, an ancient tradition attributed the principle of life, by which beings became animate and the world developed, to Shu, son of Atum. A reverse tendency divided that responsibility between the demiurge and the very medium from which he differentiated himself. Thus, the primeval ocean or Nun was called father and mother of gods, and the traits defining it were personified, if at all possible, as a collegium of eight deities, the Ogdoad, which were attributed an active role in the demiurge's apparition.

Certain local theologies mentioned a primeval cow, Meheturet ("the great floater," later associated with Neith), who was immersed in the ocean. She served as a platform for the demiurge when he drew himself out of the water, or she established a set of conditions, based on seven formulas, that favored the birth of the world. These versions would seem to give a foremost role to the feminine element, except that this element was also bisexual. Thus Neith, "born of Nun before what exists had come into being," was both "the mother who had being, though no one gave birth to her," "the first mother," "the great parent," but also "father and mother of the gods," "the divine being, both god and goddess," "the mother and father at the origin." That is only natural: the autogenetic demiurge and its predecessors were, by their very status, necessarily ambiguous or undifferentiated, since they preceded the establishment of sexual differentiation.

In general, the role of primeval deities, of "protodemiurges," took on growing importance in the later periods; far from being confined to myths, they took on concrete form, even becoming the

This incense burner has a more sophisticated design. The incense was placed in a pan in the middle of the object. A small figure of the pharaoh, who acts as officiant, kneels before the basin. The king wears the crown of Lower Egypt. The end of the incense burner is shaped like a bark's prow.

Following pages: Sacred lake of the temple of Karnak, fed by the waters of the Nile via subterranean canals.

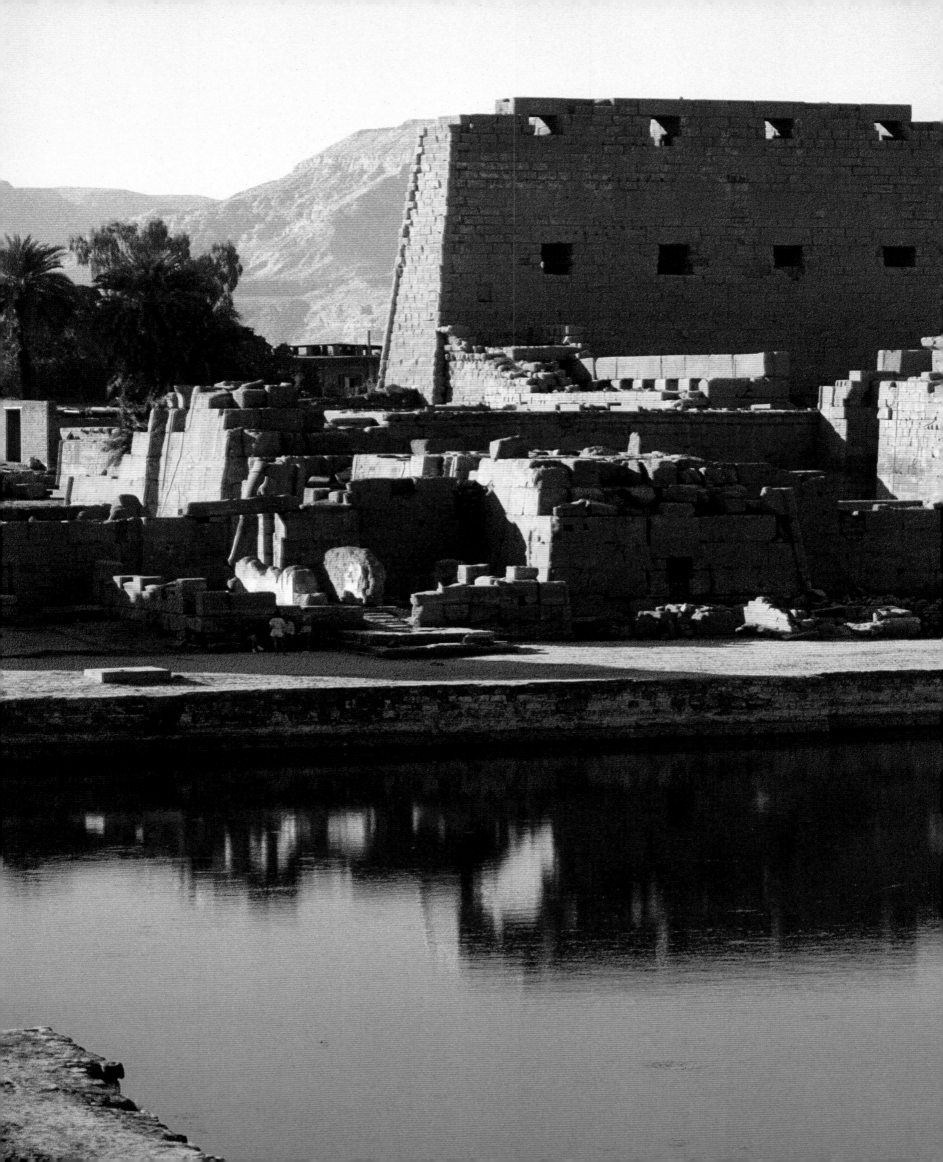

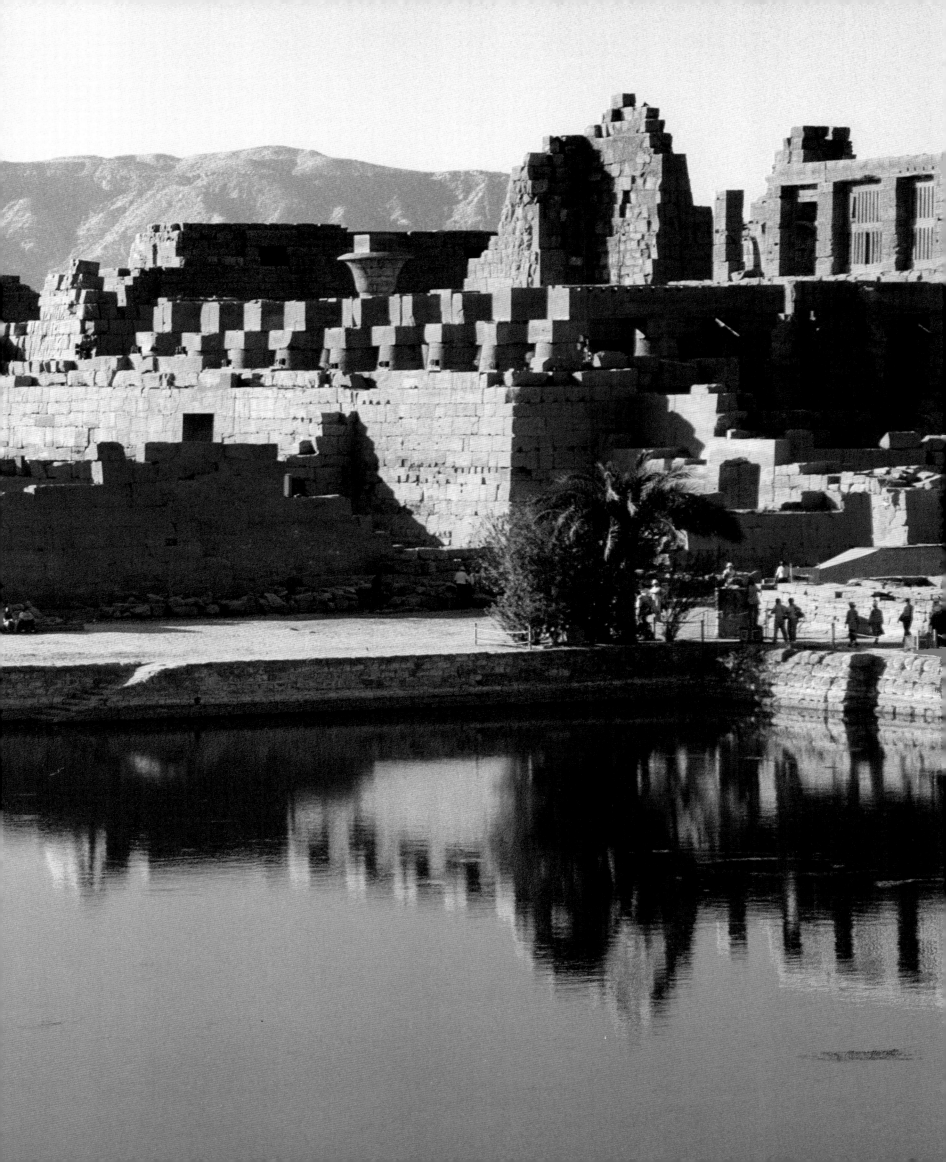

Situlae *were water containers used for cult libations and were often donated by individuals. The object depicted here has religious scenes with the ithyphallic Amun and, above him, the solar bark.*

object of cults. Every region dedicated a special cemetery to these deities, whose myths required that they die. In Thebes, the processional statue of Amun Kamutef, the ithyphallic Amun, veiled in its reliquary, left its sanctuary in the temple of Luxor every decade, crossed the Nile and, after several stops, arrived at the Djeme knoll, present-day Medinet Habu. There the god himself performed funeral rites on behalf of his Ogdoad.

Human Beings and Creation

However diverse the forms of the demiurge, his activities were not limited to his separation from Nun and the formation of the ennead. He populated the world with living creatures, human beings included. The particular status of humans is proclaimed in myths in which they emerge from the demiurge's tears. At an elementary level, that origin was based on a play on words, which was granted an etiological function—a fundamental mythological procedure—since the Egyptian word for "men" was similar in sound to the word for "tears." At a more profound level, it indicated that men were born directly from the very substance of the demiurge, just as Shu and Tefnut were born from his semen and spittle, and other gods from his sweat. This situated human beings among the most basic elements. Finally, it indicated that their creation was accidental: tears welled up in the eyes of the demiurge and separated from him. By that very fact, he was absolved from men's predisposition to do evil, which he of course had not wanted. That said, the demiurge made the best of a bad situation and worked to ensure human beings a preponderant place in the earthly world.

Men, the herd of god, are well provided for.
For them he created heaven and earth
After repelling the greedy water.
He made breath so that their nostrils could breathe,
[For] they are his replicas, born of his flesh.
For them he rises in the sky.
Plants, cattle, birds, and fish
He made to nourish them.
For them he killed his enemies.
For them he destroyed his children, because they

82

planned to rebel.
For them he makes light,
He journeys to see them,
Having fashioned a cabin [in his bark] away from them.
When they cry, he is always listening.
For them he made a ruler with [his] fragrance,
A support to shore up the back of the feeble,
For them he made magic as a weapon
To repel the blows of fate.

This extraordinary passage, the conclusion of a wisdom text written by a pharaoh for his son Merykare, probably at the dawn of the second millennium B.C., illustrates the anthropocentric turn of the demiurge's policy. Rather than exterminate a race he had created without really wanting to, he preferred to reconcile with men by fashioning the world for their use because he found it in his own self-interest. In fact, he ended up entrusting to men the task of maintaining and perfecting creation.

A myth tells how the sun god, tired from his long earthly reign and the rebellions he had had to quash, decided to live in heaven, renouncing the task of governing the earth directly. For a long time, power was passed from hand to hand among other gods and demigods, then among "spirits" and "followers of Horus"; finally, it fell to men, that is, to the pharaohs. That mythological foundation of history gave rise to hybrid chronologies linking the list of historical rulers to the time of the gods. The fact that they were used for administrative purposes, quite simply because, in the absence of an absolute dating system, a king's reign had to be situated in relation to those that came before him, shows that these chronologies were taken seriously. In fact, they reflected a fundamental principle of Egyptian ideology, the necessary solidarity between gods and human beings.

The Collaboration between Gods and People

Why was this solidarity necessary? Because the created, vulnerable world could never be taken for granted. It had separated itself from the chaos of the primeval ocean, from nonbeing in the sense of the undifferentiated, but it had not abolished nonbeing. Far from it. The primeval ocean, the Nun, continued not only to surround the world on every side, bathing the subterranean region of

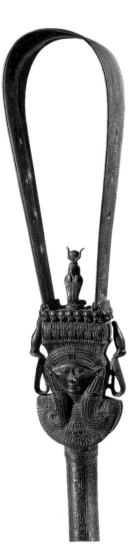

The sistrum *was a rattle, whose sound was made by vibrating circular metal plates. On the object depicted here, the plates have disappeared, but the holes into which they were inserted along the hoop are visible. The* sistrum *was a basic instrument in the cult of the goddess Hathor, where music was more important than in the cults of other gods.*

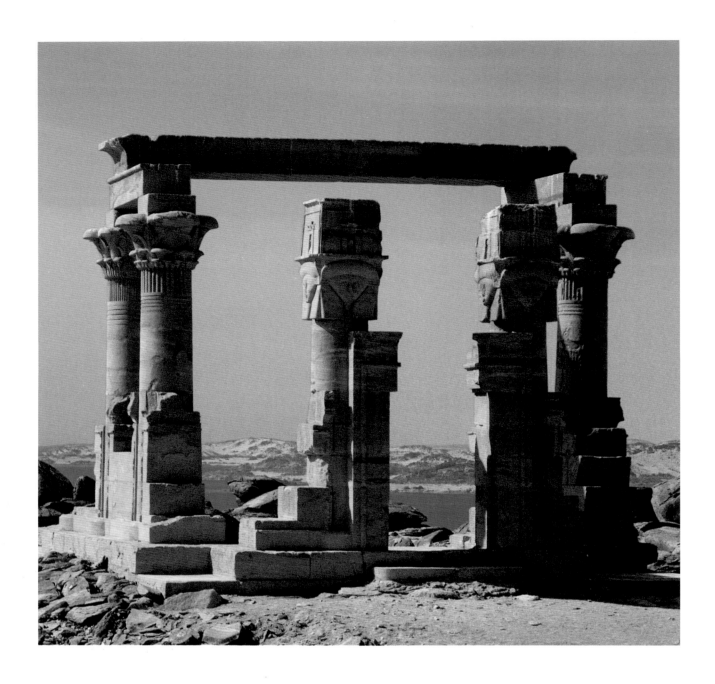

The temple of Hathor in Kalabsha, Nubia. The pillars have "Hathoric" capitals, so called because they are decorated with images of the head of the goddess.

Opposite: Colonnade of the temple of Sobek and Haroeris in Kom Ombo.

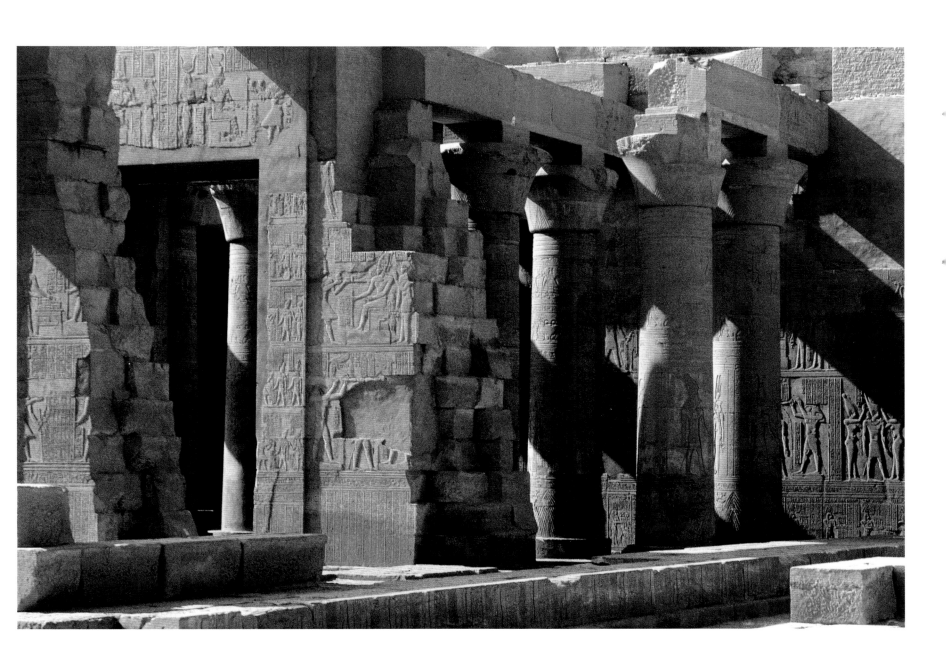

the Duat and the upper reaches of the sky, but even to penetrate it. In addition, the world was not fashioned once and for all; even on earth, many spaces were still unknown, beyond the control of the pharaoh who pursued the work of the creator, and thus under the sway of the undifferentiated. For Egyptians, history consisted precisely of continuing this act of creation.

The world, moreover, was porous. Were not the floodwaters of the Nile themselves fed by the primeval ocean? Sleep and death were leaps into primeval nonbeing, and all the regular cycles marking creation included a phase of contact with it. For example, during its nocturnal journey, the sun approached nonbeing and faced down its peril, represented by the snake spirit Apophis. The result was that this primeval nonbeing was both frightening and indispensable; its ambiguous status lay in the fact that it was indifferentiation. It was frightening because it always threatened to reabsorb being, which had had so much difficulty separating from it. Yet it was indispensable as well, since the forces of the world were regenerated in it, having diminished following a crisis. Was not grain reborn from the seeds buried in the silt of the flood, which surged forth from the Nun? Did not life after death presuppose a descent into the underworld, the border zone between the created universe and this same Nun?

In other words, the order of creation required that the undifferentiated be carefully tamed wherever it emerged. The vital energy that animated it could not be left to itself; it had to be informed by an ordering principle. That principle was deified under the name of Maat, literally, "she who governs," and took the form of a seated woman wearing an ostrich feather, 𓆄. As daughter of the demiurge, she was paired with her son, Life (the noun is masculine in Egyptian). Maat was the norm by which the course of things and the conduct of creatures had to be regulated. That included both cosmic and natural cycles and the operation of human society through institutions, hierarchies, and collective and individual ethics.

Far from established once and for all, order had to be constantly reaffirmed and imposed through dynamic processes, since creation was intrinsically prone toward disorder, comparable to entropy in thermodynamics. As a result, Maat governed all sorts of natural and human phenomena. It governed the sun, which rises anew every morning after subduing the forces of indifferentiation, incarnated by Apophis, during its journey through nocturnal places; the moon, which becomes full again after phases when it is only partially visible, like the eye of Horus torn to pieces by Seth, then reconstituted by Thoth; the pharaoh, who repels foreign tribes from Egypt's borders and ensures the proper operation of the state; the magistrate who performs the duties of his office; the individual who gives bread to the

A sphinx, a hybrid form with the body of a lion and a human head, was originally an expression of the omnipotence of the pharaoh who, though a man, possessed physical powers superior to other men, comparable to those of the lion. The reinterpretation of the sphinx as a divine manifestation did not obscure its original meaning, which is obvious on this object made of bronze and encrusted with gold. Here the pharaoh is certainly transfigured, serenely assured of his domination over the world. He is identified on a cartouche by the name Menkheperra and he wears the nemes headdress. He is recumbent on a pedestal on which are inscribed nine arrows, the traditional designation of the peoples of the inhabited world. On the front of the pedestal, two lapwings, symbols of Egyptian commoners, face each other. Above is a star, an ideogram meaning "to adore." The image as a whole constitutes the frequent rebus, "he whom all men adore." This sphinx was a decorative element of a cult object, perhaps a sacred bark. Menkheperra does not refer to the famous Thutmose III, but to a later pharaoh, perhaps the high priest of the Twenty-first Dynasty, who claimed the right to inscribe his name on a cartouche.

hungry and water to the thirsty, and who protects the weak and poor. Maat was therefore equivalent to morality, justice, social and cosmic order, in short, to the balance and harmony of the universe.

Everything went together: the homology between the cosmic order and the earthly order was not just formal but consubstantial, because both orders followed the same principle. When the cosmic order was disrupted, catastrophes immediately ensued for humanity; and, correlatively, a disturbance in the proper operation of human society—for example, the death of a pharaoh—was likely to have repercussions in the heavens. Celestial anomalies or even disruptions in the sun's course might occur. As a result, the collaboration between god and humankind was obligatory, and each was committed to the other. The gods controlled the active principles governing the world order in heaven, while human beings ensured their application on earth.

The Cult

That is the significance of the rite of all rites, the pharaoh's offering of Maat to the gods. After receiving life and the dynamic principles of creation from the gods, he returns these gifts to them in some sense, once he has given them an appropriate and adequate form, that of the earthly order, which he secures for the gods. As this example shows, the solidarity uniting the gods and people as they maintained and managed creation had to be constantly reaffirmed by the practice of a cult. Cults were not only manifestations of personal piety, but were also a state concern, since the authorized officiant of the cult was none other than the pharaoh; it was he who was depicted performing rites on scenes decorating temples and monuments.

Of course, in reality, the pharaoh could not be present in all the temples of Egypt at the same time and therefore delegated his power to the clergy. In the case of an important god, there were often many members of the clergy, arranged in a strict hierarchy. At the top of the hierarchy was the "servant-of-god," or the "first servant-of-god" when there were several of them. "Servant-of-god" is the literal translation of a title designating the major priest in charge of a deity, a term Egyptological tradition has rendered as "prophet," taking its cue from Greek authors. For the Greeks, the term was used in its literal sense, "he who speaks for," that is, the person who conducts the oracular ceremony during which the god is supposed to speak; it did not have anything to do with biblical prophecies.

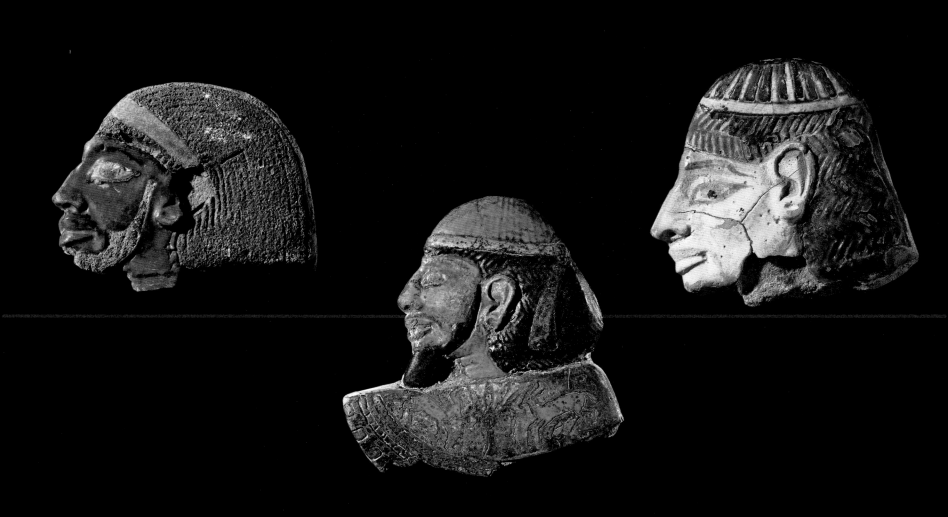

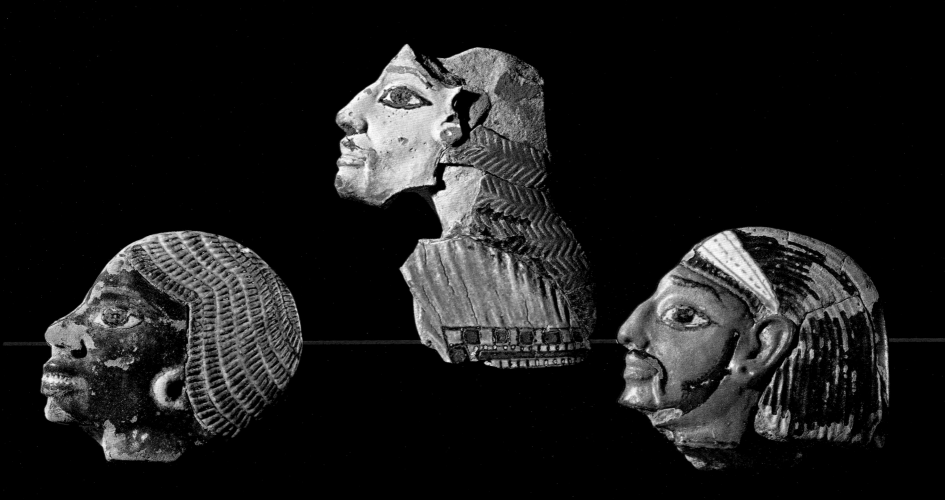

Decorations in the royal
palaces often alluded to the
pharaoh's omnipotence by
illustrating on faience tiles
the panoply of tribes
supposedly doomed to
defeat and submission. The
facts did not always
correspond to royal
ideology.

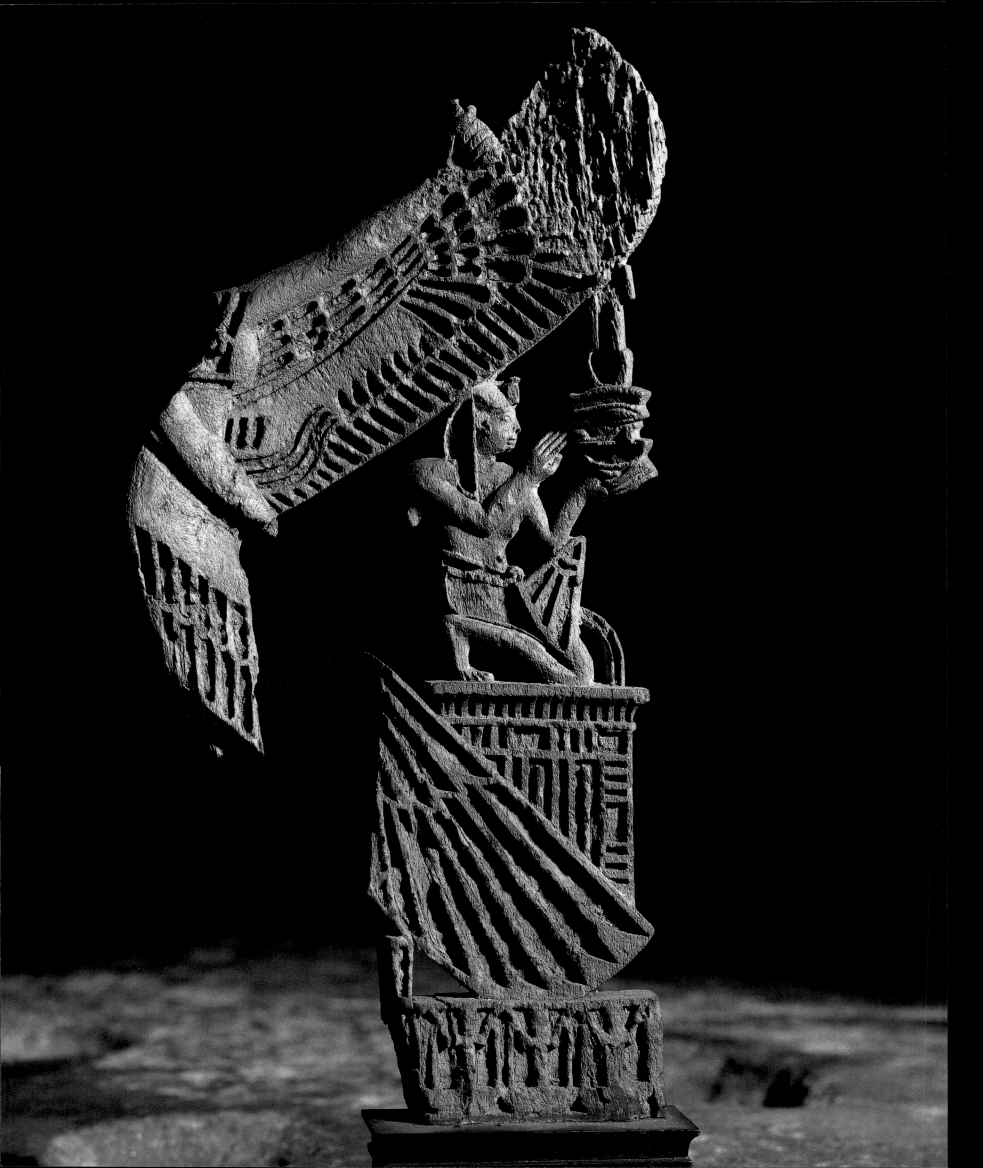

The temple was understood as both a microcosm and replica of heaven, home of the gods. Its architecture combined symbolic requirements and practical necessities. A pylon with massive piers stood at the entrance, followed by a series of spaces lined up in such a way as to move progressively toward darkness: first an open-air courtyard, sometimes lined with colonnades, then a hypostyle hall, that is, one covered by a roof supported by row upon row of columns with vegetal motifs, and lit by clerestory windows. Finally, as the ground rose, the ceiling lowered and came to rest on walls that did not allow daylight to pass through. A series of rooms arranged around the axis of the holy of holies followed; there, a *naos*, a sort of stone chest, enclosed the most sacred object, the cult statue.

There were two major modes of temporality to this cult. First, the daily cult was practiced by the very few priests authorized to enter the private part of the temple. Every morning, the statue was awakened with hymns, washed, anointed, perfumed, dressed, censed, and supplied with libations and offerings of all sorts. A similar service was repeated until evening in a meticulous but insular ceremonial. Second, many feast days occurred throughout the year, when the statue, placed on a bark and borne by clerks proud to be given the privilege, was brought out of the temple with great ceremony. It wended its way through the jubilant throngs, stopping at each station along its sacred itinerary. This occasion was the opportunity for everyone to contemplate, or more exactly, catch a glimpse of, the god, which stood under a canopy that shielded it from the vulgar gaze of the crowd. It was also a chance for people to direct their petitions to the statue and to question its oracle.

Beyond their extraordinary richness and astonishing variety, all these rites, rituals, ceremonies, and feast days, endlessly celebrated in the long string of temples spread across Egyptian territory, had the same purpose. They were designed to maintain the momentum of creation by appropriately regulating the vital energy that animated it, to continue the demiurge's work by developing what he had left incomplete or in a state of potentiality. This they did quite simply by integrating the achievements of human history into creation.

The Sect of Akhenaten

The view of the world just described prevailed almost unchanged not only throughout the national period, from the origins of Egypt (about 3000 B.C.) to the conquest of Alexander the Great (331

A goddess spreads wings suspended from her arms to protect the kneeling pharaoh, who is making an offering.

Following pages: The sacred lake of the temple of Hathor in Dendara. Ptolemaic Period.

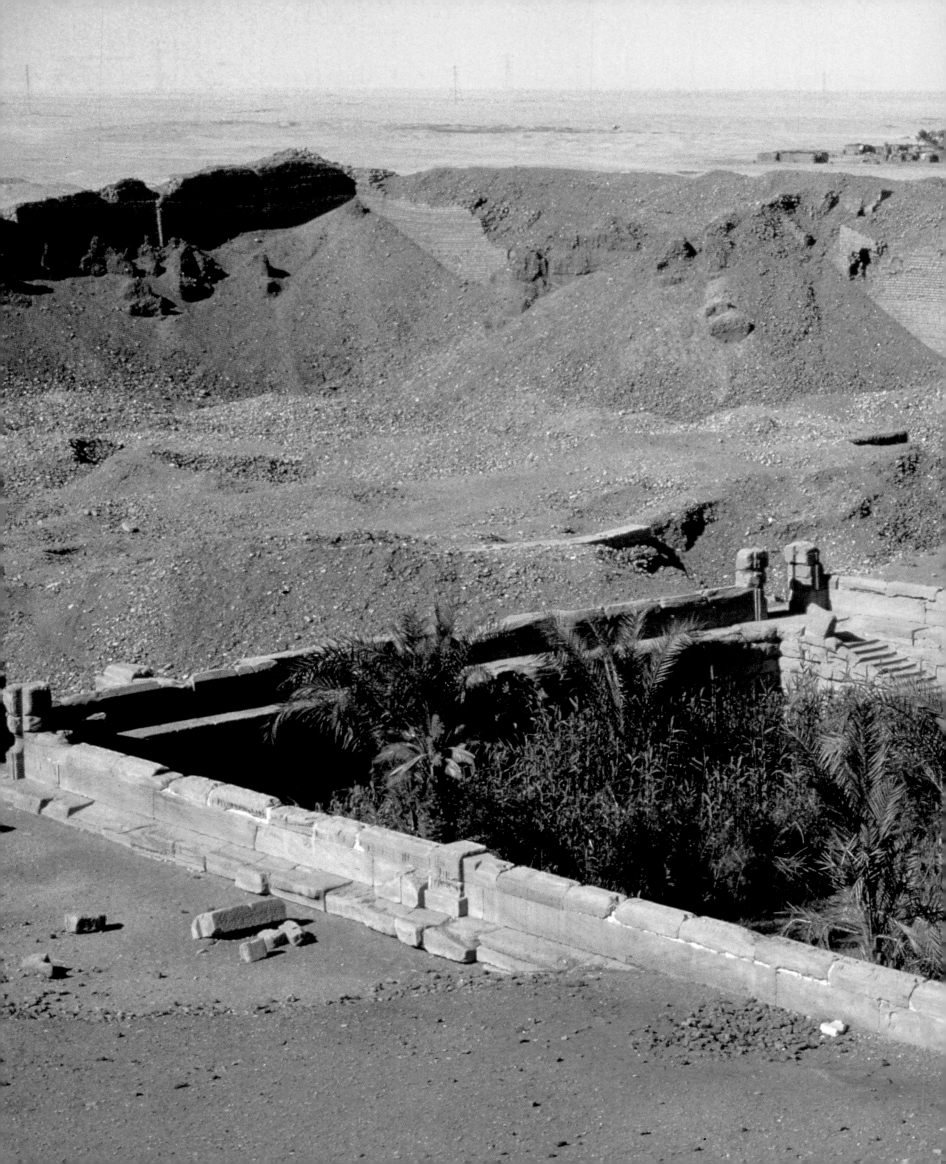

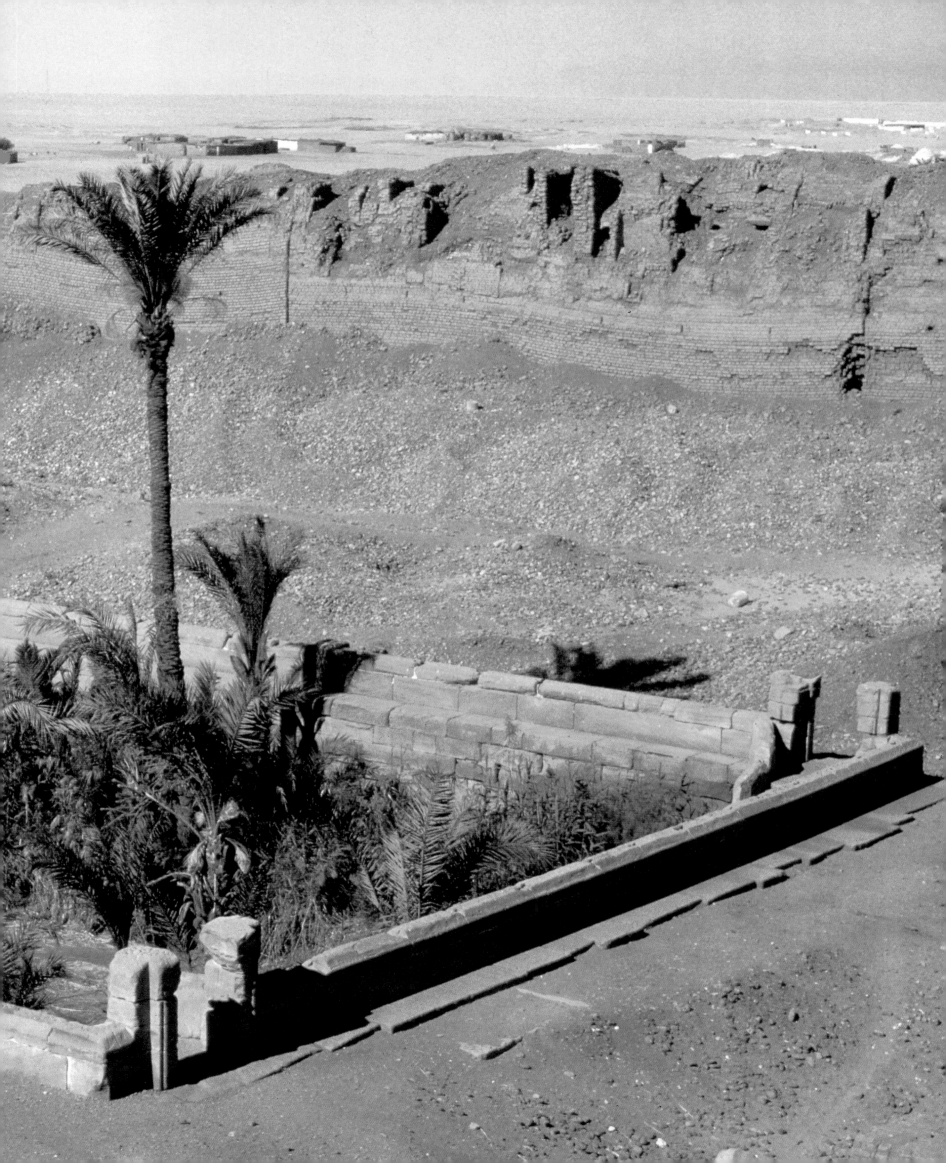

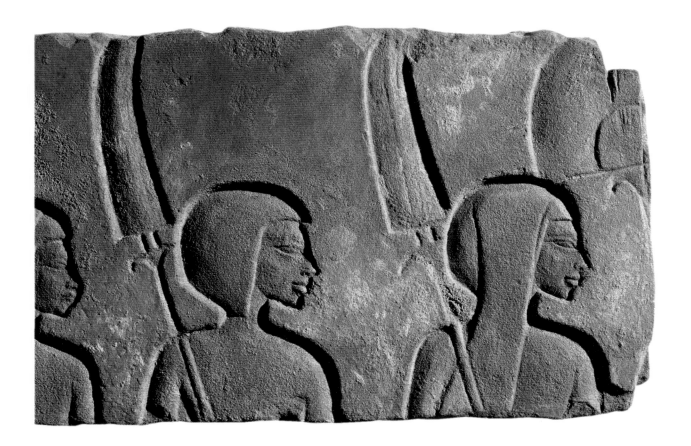

In his capital city and in Karnak, Akhenaten had open-air religious buildings, which facilitated construction. The massive blocks used elsewhere for walls were superfluous because there was no roof to support, and they were replaced by rectangular sandstone or limestone slabs that were easily transportable by a single man. Egyptologists call them talatat blocks after an Arabic numerical word to describe their measurements. After the monuments of the heretical pharaoh were dismantled, these blocks were reused in his successors' monuments, where archaeologists uncovered them. They were pieces of gigantic jigsaw puzzles.

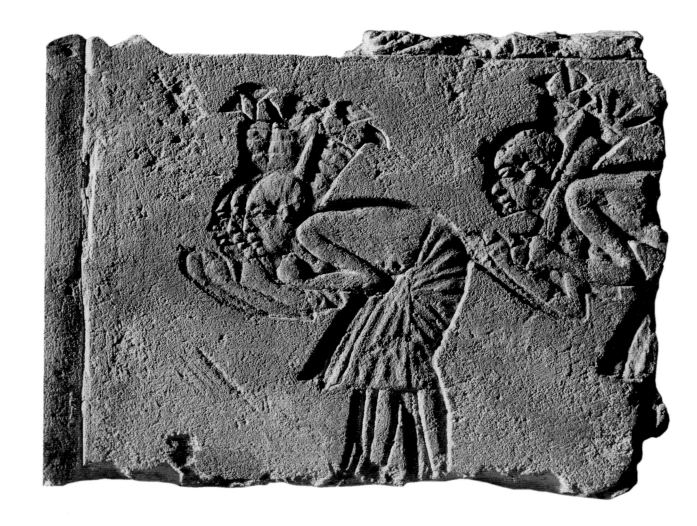

The decorations on talatat blocks allude to religious ceremonies celebrated by Akhenaten on behalf of Aten. These vast tableaux, though culminating in the depiction of the officiating pharaoh, also include scenes showing the preparations for the rituals, as seen above in this talatat from the annexes of the temples of Aten.

B.C.), but also throughout the Greco-Roman Era, as long as the last sanctuaries of pharaonic religion remained active. There was only one breach in that monolithic permanence: the famous episode of Tell el-Amarna (about 1353 to 1336 B.C.).

Let us recall the events. Amenhotep IV had just succeeded his father, Amenhotep III, the Pasha pharaoh whose reign was marked by utter opulence and pleasure. The son first demonstrated his nonconformism in the style adopted for his Theban bas-reliefs: he imposed on the sun god Harakhty the same distended belly and androgynous soft breasts that he himself possessed. That was only the beginning, and he moved quickly from evolution to revolution. In year four of his reign, he renounced the name Amenhotep, even though three of his predecessors had borne it proudly, and took the name Akhenaten, "profitable to the Aten." "Aten" was the Egyptian word for the sun disc, which Akhenaten elevated to be the god of choice.

The break with tradition was completed when Akhenaten retreated to a meadow in Middle Egypt, about thirty kilometers square, whose borders were marked by a series of steles. There, on the east bank, he built his new capital built and named it Akhetaten, "horizon of the Aten." In modern times, the remains of that city are called Tell el-Amarna. Having holed up with a clique of parvenus named to the highest offices, he established a new religion, which he meant to extract from the gangue of traditional beliefs.

There was to be only one god, the Aten, the sun disc whose rays ended in hands. That god was given a name composed of two cartouches, like the two major names of the pharaohs: "The living, Ra-Harakhty, who rejoices in the horizon" and "in his name, light, which is in the disc." Later, that identity was modified to "the living, Ra, ruler of both horizons, who rejoices in the horizon," and "in his name, luminosity, which comes from the disc." There was only one god and only one interlocutor, Akhenaten himself. By extension, however, the queen and her daughters participated metonymically in that exclusive relationship. The rest of humanity was fit only to lie facedown in the

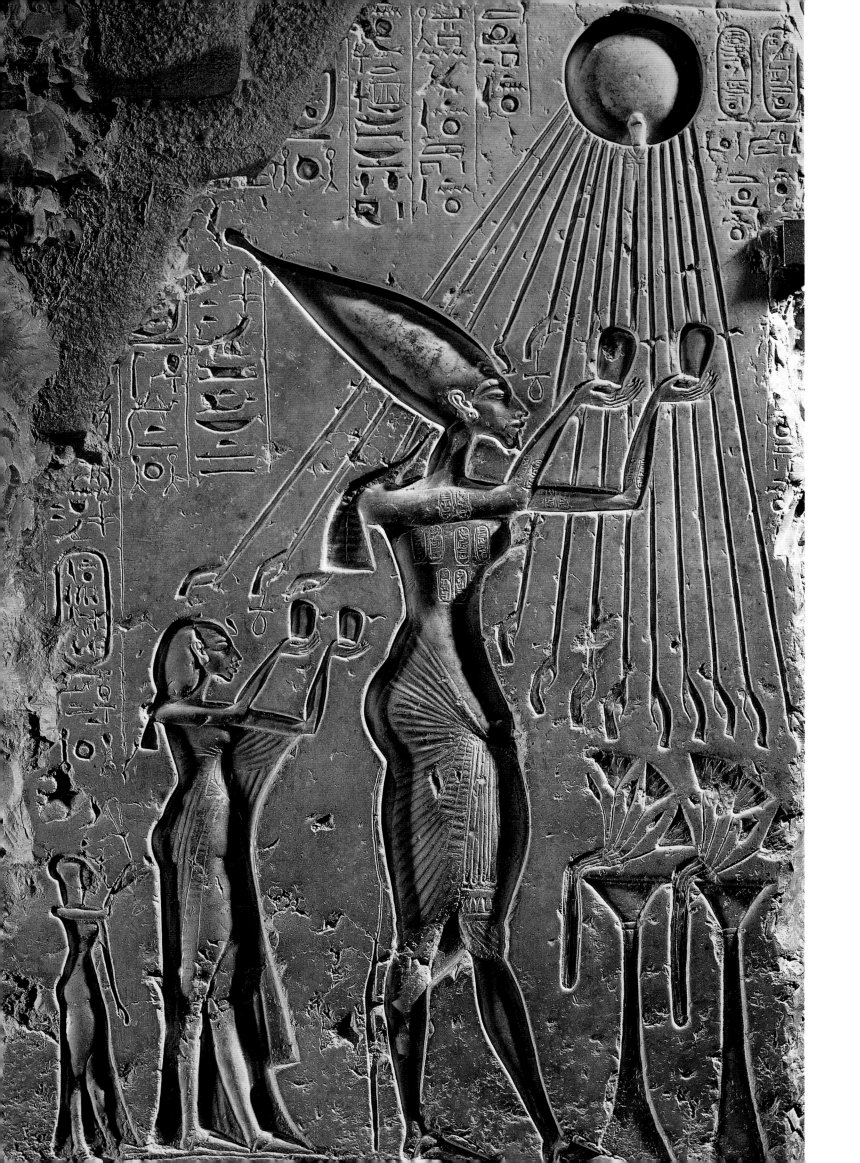

dust and venerate the god who, having already shown far too much generosity in providing them with light, gave signs to them only through the teachings dispensed by the pharaoh, his prophet and earthly replica.

At the same time, other gods were proscribed. Although the names of some of them were still tolerated as long as they were simply metaphors or linguistic fossils, the plural form "gods" was forbidden. In particular, anathema was heaped on Amun, the great national god. From one end of Egypt to the other, frenzied fanatics violently struck out his name, and sometimes, along with that name, poor, innocent words that had the misfortune of sharing certain hieroglyphs with it!

After Akhenaten's death, the heresy was liquidated. And of course, the king's unprecedented radicalism produced a persecution befitting his memory. In contrast, moderns often tend to feel sympathy for Akhenaten. First, his anti-conformism was such a departure from the apparently infrangible monolithism of Egyptian ideology. Second, his art produced a few masterpieces that might make us forget the technical mediocrity and insipid, pernicious style of the common lot of works. Third, he promoted touching scenes of family intimacy—himself, Nefertiti, and their daughters—where hieratic stiffness had been the rule.

The Amarna heresy offended ancient Egyptians because it profoundly contradicted the spirit of pharaonic religion, even though it used the old foundation of sun theology. First, its exclusive monotheism went against the grain of a civilization that venerated so many gods. Second, its very conception of the world was different: Akhenaten reduced everything to a single, ineluctable principle, light. Before and after him, it was believed there were many gods and that they always transcended the thing through which they manifested themselves. For Akhenaten, the presence of the Aten alone was the necessary and sufficient cause that allowed creation to continue without adversity.

In the traditional view, the collaboration of gods and men was required to maintain creation in the face of indifferentiation, which always threatened to reclaim what belonged to it. That collaboration took the form of a dialogue between equal partners, indicated in the thousands of scenes showing the pharaoh performing his rite in front of anthropomorphic deities who address him. The Aten, in contrast, stood above men, above even Akhenaten, and remained forever silent, conceding to human figuration only the condescending hands at the end of its rays.

A typical scene of the new religion: Akhenaten, followed by his wife, Nefertiti, and one of their daughters. Both females are reduced to emphasize Akhenaten's superior status. The king and queen make a ritual offering by presenting libation jars, even as bouquets of flowers are placed on small altars. From his zenith, the Aten, the sun disc and only god, hurls his human-handed rays upon his zealous followers.

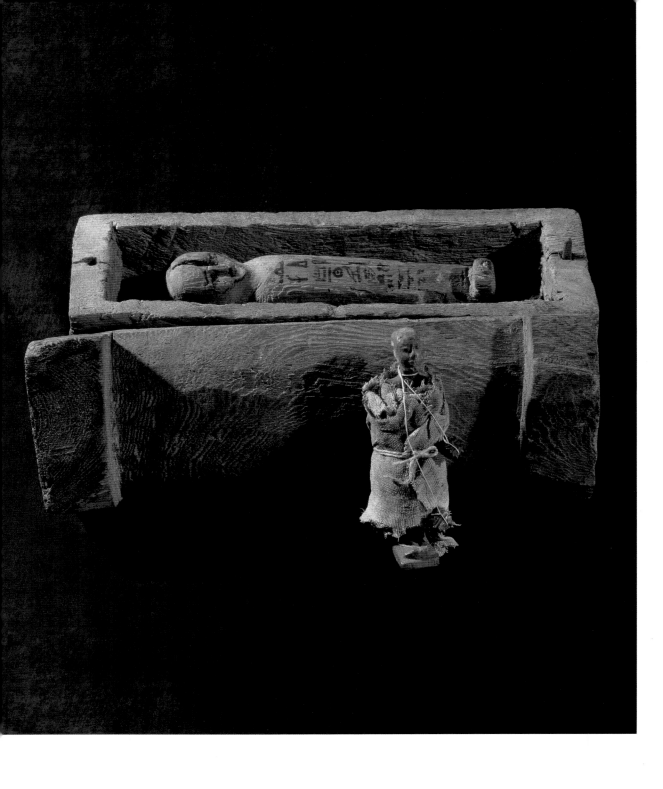

A prototype of a shabti
with an offering formula
on behalf of the deceased.

Opposite: One of two
life-size statues of
Tutankhamun, placed in
the antechamber on either
side of the approach to the
funerary chamber. Both
statues were made of wood
coated with black resin, or
gold leaf in the case of the
kilt, the ornaments, and
the headpiece. This statue
wears the so-called afnet
headdress; the other, the
striped nemes. The eyes
are made of limestone with
obsidian pupils. Made
before the king's death, these
sculptures were thus
immediately available for
the deceased king and
served as receptacles for his
manifestations. Among its
other symbolism, black was
used to express regen-
eration, since the black
earth of Egypt's alluvial
plain makes vegetation
germinate anew.

The Challenge of Death

Death is part of human life itself; in fact, Martin Heidegger defines man as "the being for death." In the face of that inexorable fact, different civilizations have adopted different attitudes. Under the sway of resigned skepticism, some embraced the value of life and did not show great interest in funerary beliefs. Others, in contrast, movingly refused to believe that death was the final end and hoped to move from earthly life to something other than absolute nothingness.

Ancient Egyptians chose the latter attitude and elaborated it in a systematic and spectacular way. Their endeavor has never been equaled. Are not the pyramids, the most gigantic monuments of antiquity, sepulchers? Archaeology has uncovered very few ordinary dwellings, but countless tombs. Houses were built of unbaked brick, cheap but perishable materials. Tombs, however, were constructed of stone, costly but resistant to the test of time. This preference clearly suggests the exceptional importance of funerary beliefs, though Egyptians had no contempt for earthly existence either.

The Crossroads

One fundamental idea was that the end of earthly existence presented human beings with an alternative. Either they would experience a "second death," to use the Egyptian expression, a definitive death, annihilation, the return to the nonbeing that constantly seeped into creation or their death would be the beginning of another form of life. In Egyptian ontology, death, that is, the "first death," was not the absence of life but rather a phase in the biological cycle governing the world. The potential for new developments was latent within it. The dead man who realized this potential was called an *akh*, a word conventionally translated as "the glorified deceased" or "spirit." The word designates the successful access to a new biological state, something like "the transfigured."

That state was marked by a redistribution of the components of personality. The *ka*, born simultaneously with the individual, was his double in a world existing parallel to the world of the living. This other realm was the domain of the unconscious, a place peopled by the dense crowd of deceased

ancestors. It was the world of sleep and of the hereafter. The *ka* was represented by two arms, apparently raised. According to the conventions of Egyptian drawing, however, they were to be understood as extended horizontally, as if to pass on either side of a person in a gesture of protection. The *ka* was a reserve of vital force and energy, linked to the force of ancestry, and during the individual's life it stored up the essence of all food that was consumed. Upon dying, the individual entered the realm of his *ka* on equal footing with it; thus, the expression "to move to one's *ka*," signified "to die."

At the same time, the deceased now possessed the *ba*, which was both the capacity to manifest himself in a being or object, and the forms through which he manifested himself. The *ba* was represented as a human-headed bird; according to an ancient belief (shared by other peoples of the world as well), birds were manifestations of the dead.

For what fate could the dead man hope? Several forms of afterlife, by no means mutually exclusive, were offered. Although the historical, sociological, and even cultural origins of various funerary beliefs were clearly distinct, they were not only juxtaposed early on but also combined in inextricably overlapping ways, elements of one transposed or simply transplanted onto the other systems.

Forms of Afterlife

In that exuberant muddle of beliefs, one can distinguish three major conceptions of the afterlife. The first and most elementary manifested itself in the world of the *ka*, within the tomb itself, and relied heavily on the mummy and funerary statues. The tomb was a poor replica of the earthly world, barely revealing its joys, its annoyances, and its dangers. The dead could attend banquets but, if they did not know the preventive formulas, they could also be forced to feed on excrement, to drink urine, and to walk upside down.

To make the world as agreeable as possible for the deceased, artifacts, such as the pictures that adorned the walls of their chapel, re-created an idealized environment. Their power of evocation was

A necklace called wesekh. *The name of this necklace derives from an Egyptian word meaning "to be broad." The ends are shaped like a falcon's head bearing the sun disc.*

Following pages: Temple of Queen Hatshepsut (1495–1475 B.C.) and Pharaoh Thutmose III in Deir el-Bahri. Eighteenth Dynasty (1554–1305 B.C.).

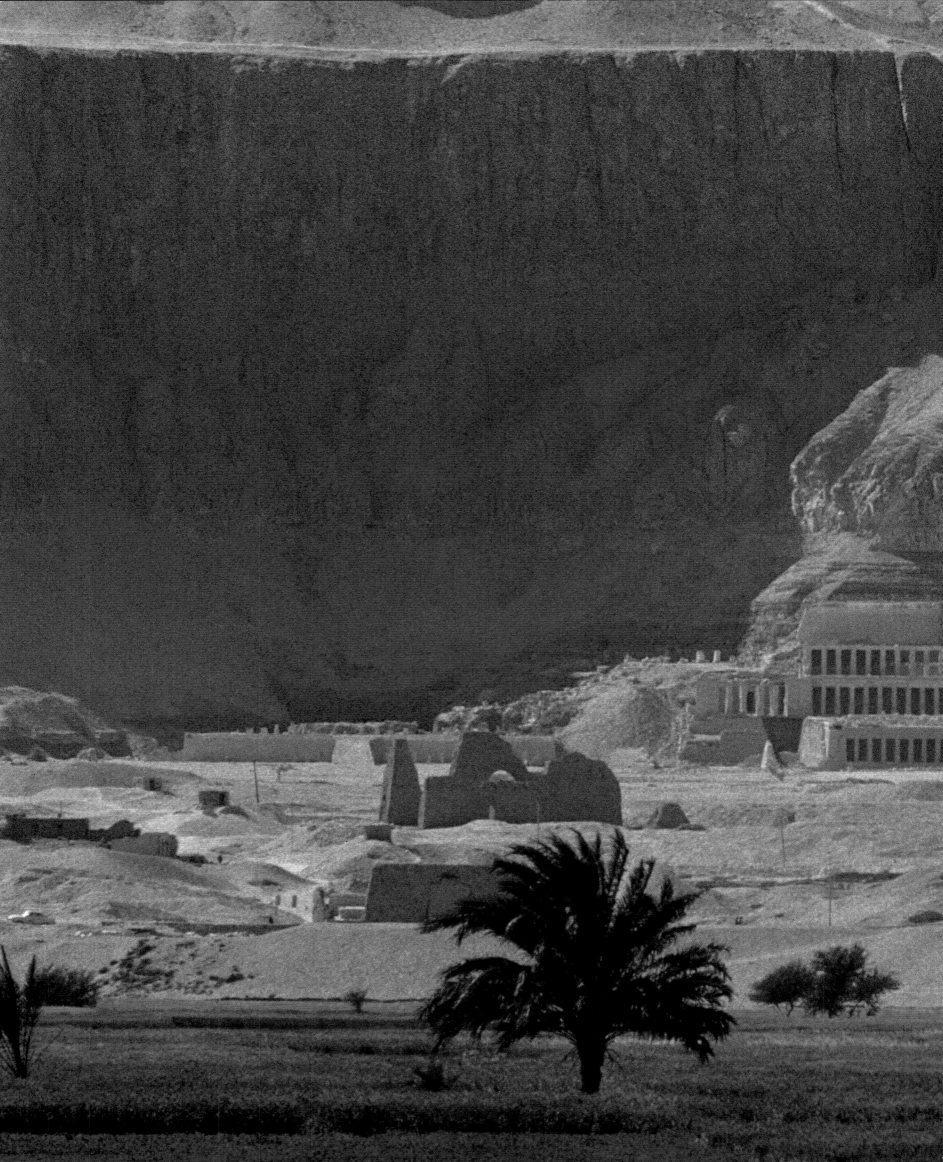

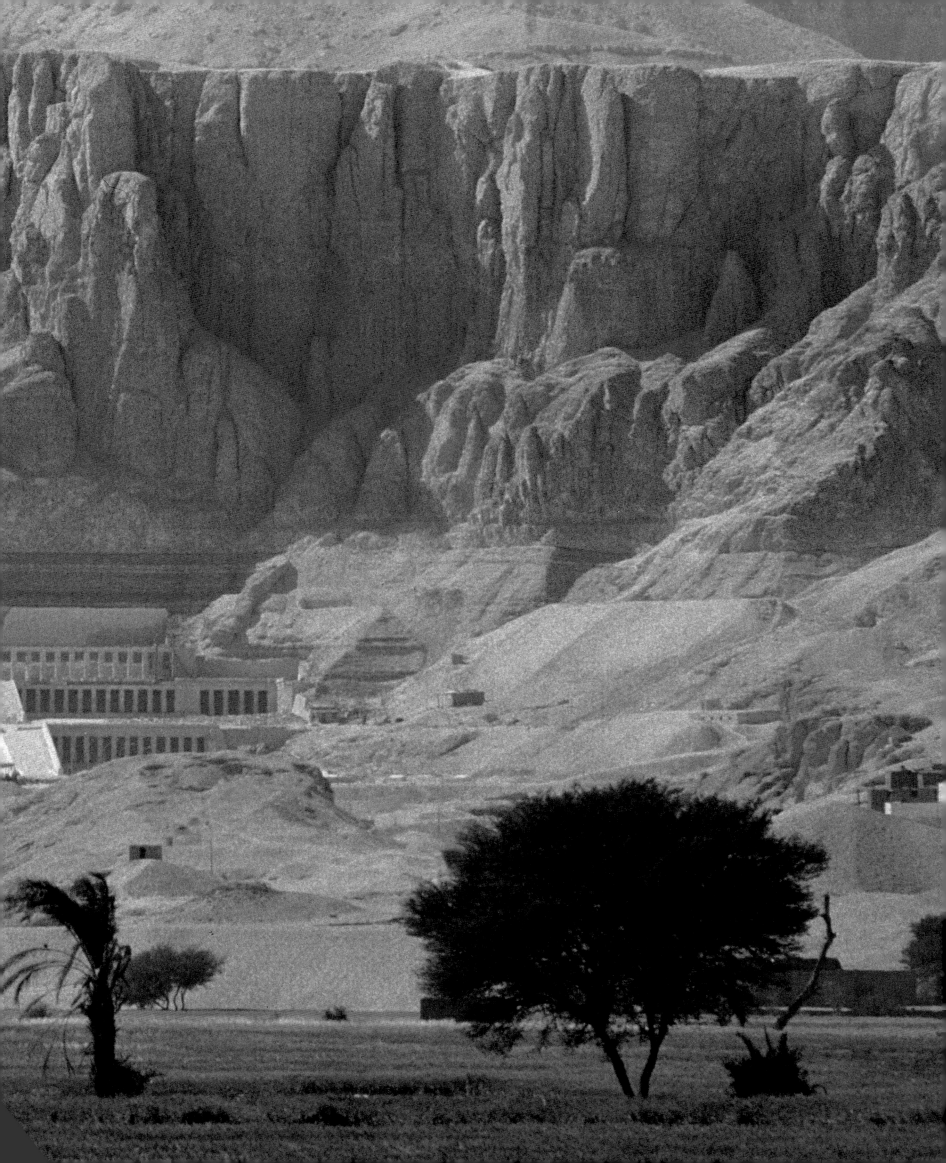

reinforced by falsely realistic notations—a monkey stealing figs or the sharp retort of a peasant displaying the conventional blunders of everyday speech. Thus the dead took part in a rich assortment of stereotypical situations in which they were given the leading role. They were depicted receiving piles of food or inspecting their farms or workshops.

Sometimes, precise events were recorded for the sheer delight of remembering them: the vizier Rekmire was depicted in his tomb supervising work on the Theban necropolis. We know through other sources that he was, in fact, in charge of that project. The dead man could also transform himself into various animals—hawk, swallow, scarab beetle, phoenix—and as such come out of the darkness of the burial vault and entertain himself by fluttering about in the chapel or even by making a few forays into the world of the living.

Birds were ontologically linked to the mummy, a connection that became stronger every night. If, therefore, a beautiful bird landed beside the mummy, it was free to climb out of the grave and into daylight, to drink at the curbstone of a basin. In addition, the deceased could actively intervene in the daily life of the living and not always in a beneficial manner; it was believed they were without rival for poisoning their loved ones' earthly existence.

Thus, certain formulas were designed to prevent a dead father from shortening the life of his son, so that the son might come to the hereafter and take the father's place! The dead were attributed with such destructive power that black magic was sometimes used against them, just as it was used against the living. Effigies bearing the name of the dead had spells cast on them and were then destroyed by fire. The dead were hagglers, quick to drag persons who had wronged them—by profaning their graves, for example—before the court of the hereafter.

Showing a great deal of common sense, some living persons tried to take advantage of the dead's good knowledge of the judicial world of the hereafter by asking them to intervene in their favor in suits brought against one annoying person or another. How was this sort of request made? In letters written on vases containing offerings and placed in the tomb of the dead person whose help was

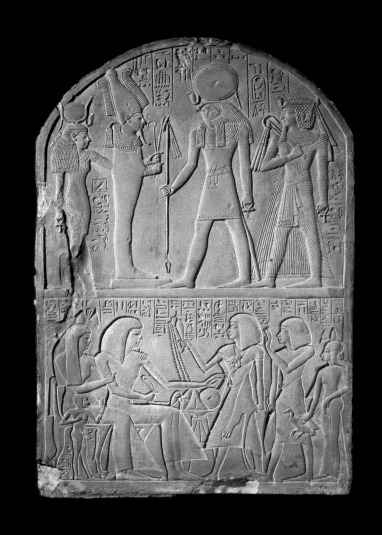

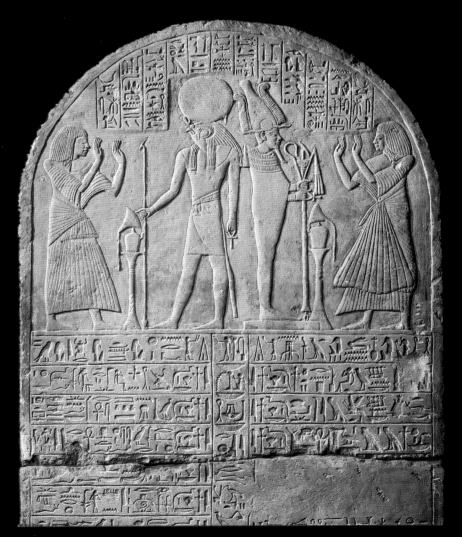

Detail of a procession of dignitaries who participate in a funeral ceremony.

Opposite: A Middle Kingdom funerary stela. The ankh (sign of life) has been carved in sunk relief, and three images of the mummified deceased person have been rendered in raised relief.

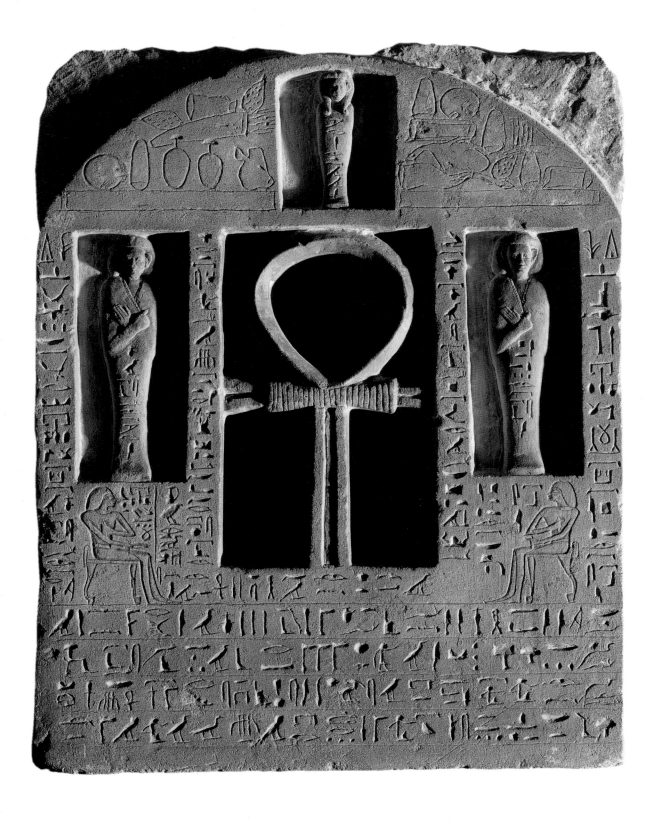

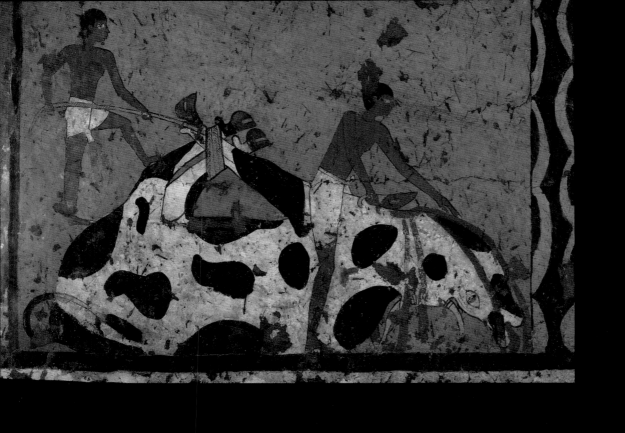

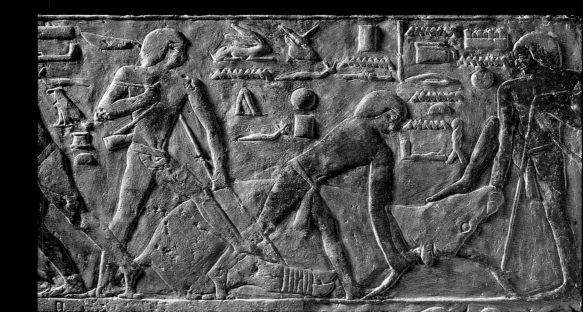

being solicited. Sometimes, the deceased was summoned not for help, but rather to threaten someone. Witness the famous letter in which a widower orders his deceased wife to either cease persecuting him or face legal action.

To reconcile with the ill-tempered dead, the living erected stelae or busts in the family home, devoted to their great ancestors, and regularly made offerings to them. Those we call "our dear departed" were thus not so dear to ancient Egyptians, who were truly haunted by the dealings of the dead on earth.

Happily, there were other forms of afterlife for the dead that were less troublesome for the living. There was the afterlife in the underground realm of the hereafter, traditionally called the "chthonic afterlife," whose patron saint was the god Osiris. The planting cycle, in which seeds are returned to the earth to germinate anew, provided a rich metaphor to illustrate the view that death was only the prelude to a new phase in the biological cycle.

Among the many expressions of Osirian rebirth, a particularly striking one was the image of stalks of wheat growing thick on the god's mummified body. This metaphor was even given concrete form in temple rituals, such as the ritual of the month of Choyak where a mummy-shaped tub was used to germinate seeds in a soil mixture. Such objects, called "Osiris beds" or "corn mummies," were also part of the funerary equipment, so powerful was their symbolism. The regenerative power of the earth and the trivial fact that the dead were buried in the ground never failed to promote the belief in an afterlife in the "Duat," a kingdom of the dead located underground and accessible from the west.

That kingdom had a king—Osiris, of course—and a tribunal, which ruled on the candidate's suitability for entrance. This was the famous judgment of the dead. The territory of the Duat was surrounded by iron walls, and its "field of reeds," a constellation of plots of land, was delimited by a network of canals. There were no snakes and no fish—a taboo that may have come down from the culture of hunters—but it was a land so fertile that it produced magnificent crops to anyone who worked it. Imagine: ears of barley two cubits high (about 3 feet, or 1.2 meters) on a stalk three cubits high (about 3 feet, or 1.53 meters); and spelt with ears three cubits high and stalks about 13 feet (four meters) high!

Was this simply the land of milk and honey for a people of peasants? Not altogether, since the organization of the Osirian government had an underside. The dead person living in the underworld could be drafted for one of the mandatory laborious tasks that the bureaucratic and centralized state imposed to complete its large public works projects. A subterfuge was created: the *shabti*, later

One of the most important funeral offerings was a haunch of beef. Thus, many scenes depict slaughtering and butchering.

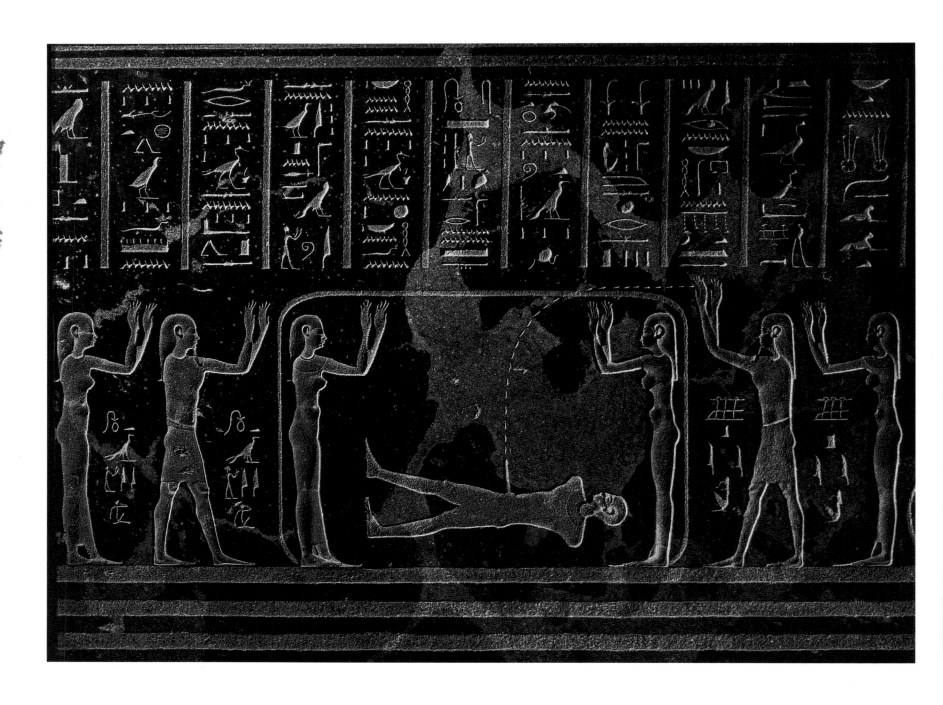

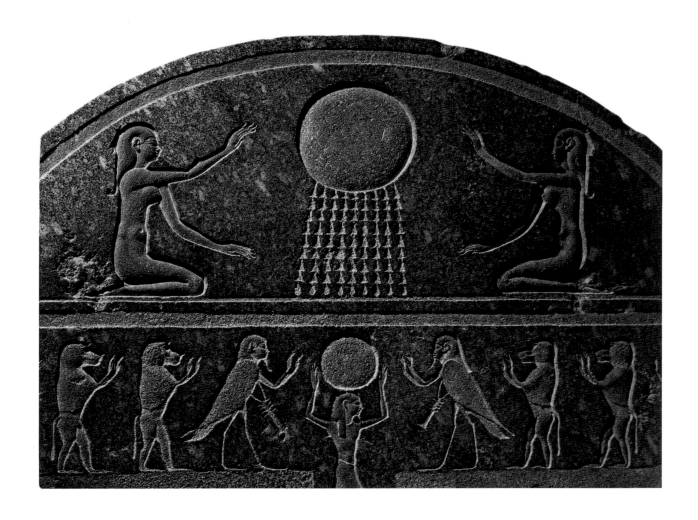

*Opposite: The daily
incarnations of the sun
were considered the
prototype of regeneration.
In the critical phase of its
nocturnal journey, the sun
traveled through the
underworld and
participated in mysterious
activities that caused life to
surge through the dead
Osiris, just as sperm
spurts from his cadaver in
this illustration.*

*The sun in its daily
triumph at dawn is greeted
by deities, the* ba, *and
baboons.*

A shabti *box from the
Ramesside era decorated
with the famous scene of
the judgment of the dead
and the weighing of the
heart. Although Osiris
normally presided, here the
sun god Ra-Horakhty,
seated at the left, officiates.
This variation is not an
error, but a suggestion that
the two deities are aspects
of a single god.*

*Below: A mythological
map of the sky. The
elongated and bent-over
sky goddess, Nut, gives
birth to the winged disc,
which will later undertake
its celestial journey in a
bark.*

called a *ushabti*, or "answerer." These little figurines, made of faience, wood, stone, or even gold, which have delighted collectors and have made the fortune of antiquarians, were supposed to come to life by magic and labor in place of the dead person, whose name they bore. "Formula to make a *shabti* do the work for its owner in the necropolis. . . . If that person be summoned to remove obstructions, to raze mounds, to move earth from the riverbanks, to plow new fields for the king of his time, you will say 'here I am in his place!' to any messenger who comes regarding the person in question."

Though these figurines were in the form of mummies, they were provided with tools indispensable for performing their duties: hoes and baskets. The number of *shabtis* placed in the sepulcher varied over time, increasing as beliefs evolved. Originally, there was only one, then several, until there were finally 365—one for every day of the year—or even more, since 36 "supervisory" *shabtis* wearing clothes of the living were sometimes added, one for every ten figurines. Their omnipresence among funerary articles shows how much the Egyptians feared corvées in the underworld.

Celestial and Solar Afterlife

Fortunately, the dead had another place for an afterlife: the sky. Anyone who has contemplated an Egyptian sky on a summer evening can easily understand how it could have inspired the ancient imagination. According to a probably very ancient belief, circumpolar stars, which were always visible, received the dead; hence their name, "imperishable." It was their immutability that accounted for their use as a figure for the afterlife. Other stars, which disappeared from the sky and later reappeared, implied a phase of regeneration after a phase of decline. Such was the case for the stars called *decans*, Sirius and Orion in particular, which reappear in the sky after an absence of seventy days—a duration related to the mummy's stay in the embalming tent.

The moon was only rarely considered a manifestation of life after death. But in a country such as Egypt, what heavenly body could represent the hope of a new life after death better than the sun, which, after reaching its blinding zenith, declines and then disappears below the horizon, only to rise again the next day? In the glory days of the Old Kingdom, only the pharaoh had the right to apply for a new life in the company of the sun god, by virtue of his position, which gave him the status, the means, and the necessary knowledge for such a fabulous destiny.

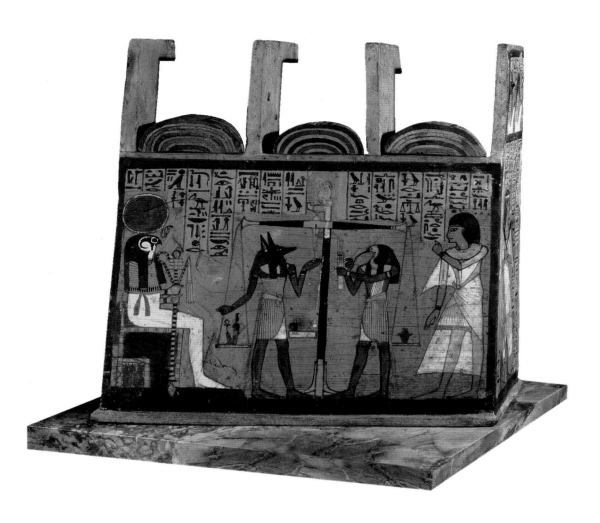

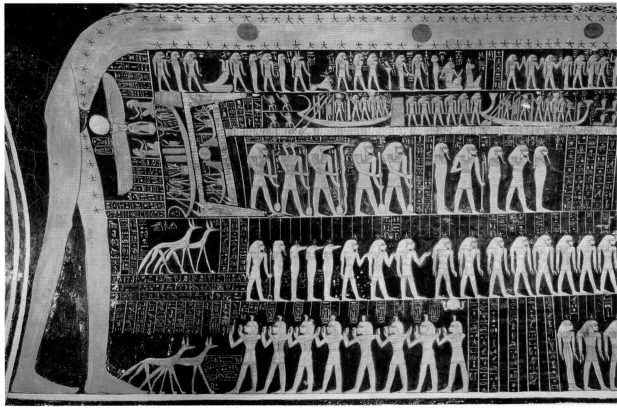

Shabtis *or* ushabtis.
*Figurines depicting the
deceased, which are
supposed to take his place
in performing the corvées
required of all who stay in
the underground world of
the hereafter.*

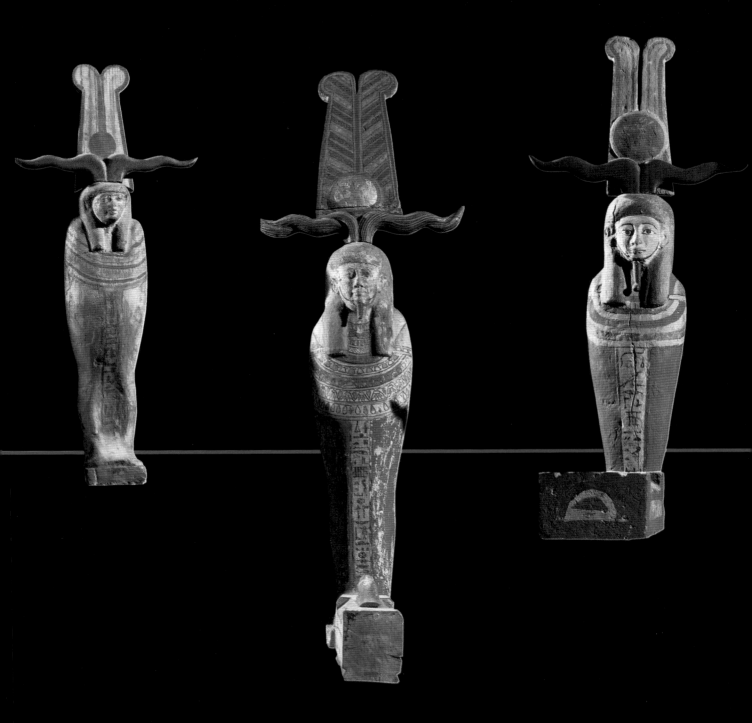

Figurines of the deceased wearing the atef *crown.*

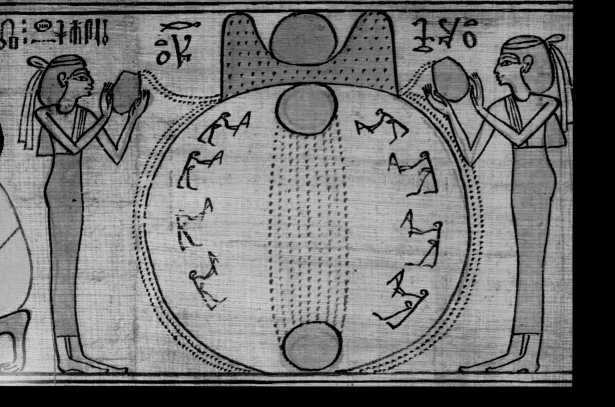
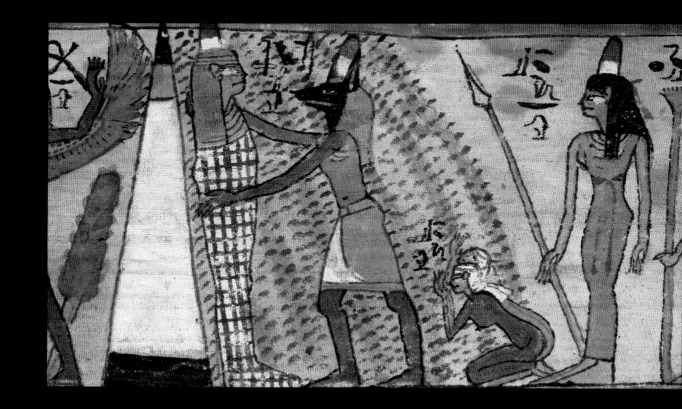

Later, the solar afterlife spread to his subjects, in accordance with a process Egyptologists have named, quite inaccurately, "democratization of funerary beliefs." In fact, there was nothing very democratic about it. With the collapse of the central government, which marked the First Intermediate Period (about 2150 B.C.), local aristocrats came to occupy the role of pharaoh in their provinces and claimed his prerogatives. Through them and their clients, "solar" texts and rites spread. The process may have been facilitated as well by the opening of the sacred archives.

In any case, "solar" fate promised the dead man he could reach heaven via a ladder, or by transforming himself into a hawk or even a grasshopper. Doors opened, and he accompanied the sun god, or was quite simply identified with him. The journey was made in a bark that traveled the vault of heaven and took place at night when, after reaching the western horizon, the sun penetrated the underworld. Thus, solar fate unfolded both in the sky and underground. The nocturnal part of the trip occupied an increasingly important place in beliefs.

That is easy to explain: it was during that mysterious part, when the sun regenerated itself in darkness until it recovered its diurnal brilliance, that all the force of the solar cycle was concentrated. That is, it exemplified the belief in a rebirth in a new biological state after death. But in passing through the underworld, the solar bark traveled through the kingdom of Osiris. As a result, solar fate and chthonic fate intersected. Early on, theologians attempted to reconcile one with the other through speculations of growing complexity and refinement. In this way, they expressed the symbiotic relationship between Osiris and the sun god. Witness the famous scene from the tomb of Nefertari, where a ram, mummified and bearing the solar disc, hence displaying the attributes of both gods, is described in the following terms: "When Osiris finds himself at rest in the form of Ra, Ra finds himself at rest in the form of Osiris"!

An End to Dismemberment

Death placed the individual at a crossroads, with one path leading to this new biological state and the other to annihilation. Needless to say, Egyptians preferred the first alternative! Yet it could not be taken for granted. The deceased had to satisfy many conditions, confront grave adversity, and overcome great obstacles to force his way through death and so attain the afterlife. Death was a challenge.

A "corn Osiris."
At the bottom of a tub a depression in the form of Osiris's silhouette was filled with seeds, which later germinated.

Opposite, above: Mythological illustration of the daily path of the sun.

Opposite, below: Aided by the attentive Anubis and Isis, the mummy of a dead man stands in front of the pyramidion at the entrance to his tomb.

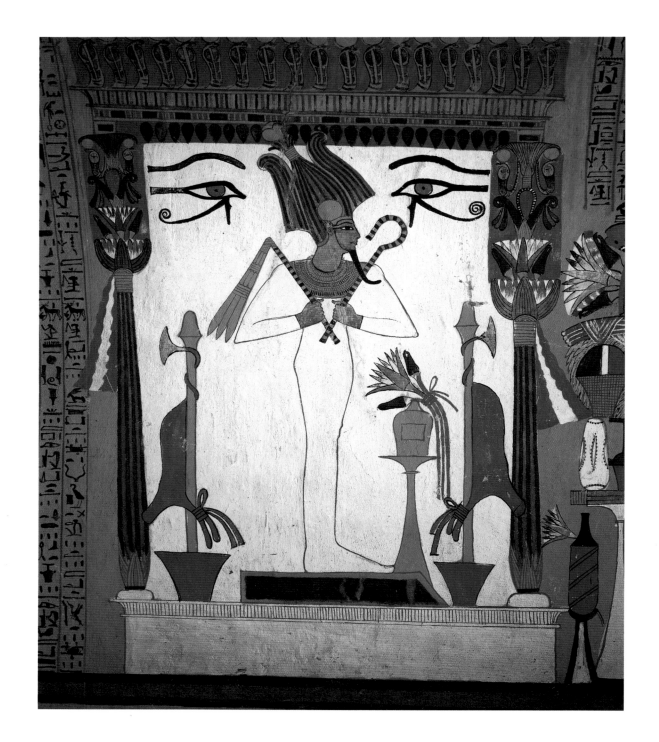

Osiris in his characteristic aspect, holding the heqa scepter in his left hand and a flail in his right.

Opposite: Anubis officiates over a mummy placed on the embalming bed.

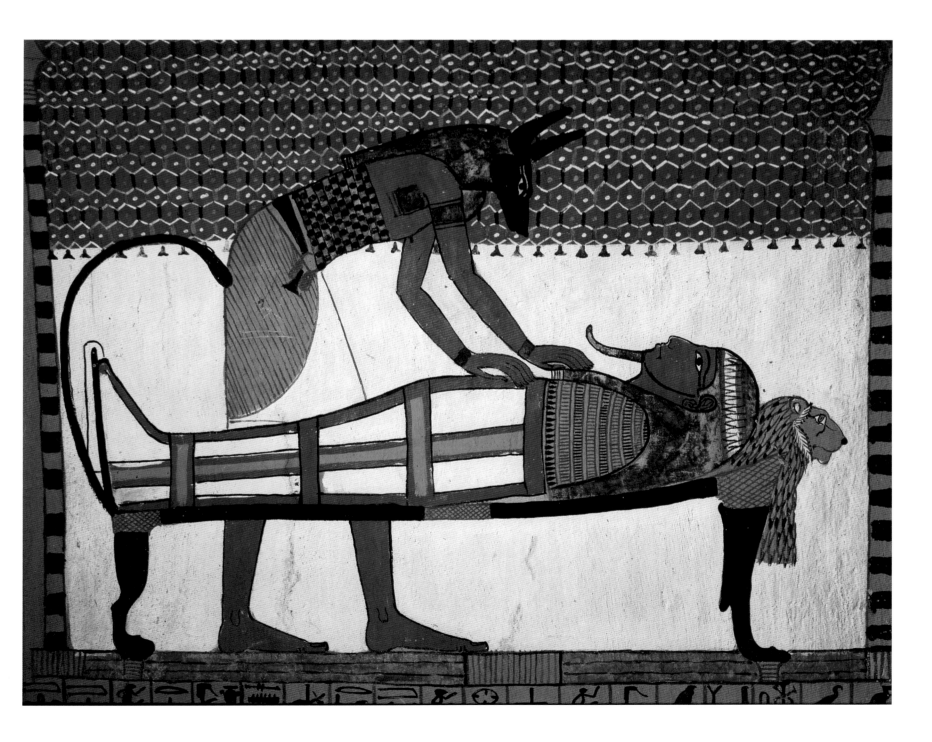

To take up that challenge, there was one condition *sine qua non*: the body had to remain intact. There was nothing more foreign to Egyptian beliefs than cremation, which, in the Hindu world, eliminates the body, considered impure by virtue of its very materiality, or the Christian conception of the corpse, which disintegrates to dust so that the soul can be liberated. There was no curse on the physical body among the pharaohs, nor was there an opposition between the body and components of the human personality; they were merely different aspects of the individual as a whole. The body was not an envelope or gangue from which one had to be set free, but rather a manifestation in harmony with all other possible manifestations, and which allowed one to escape annihilation. The integrity of the body, threatened by death, thus had to be preserved at all costs.

That was no small matter. For Egyptians, the body was understood less as an organic unity than as a collection of pieces attached to one another, and quick to break apart. It was imperative that the head, which commanded the rest of the body, remain firmly attached to the neck. The danger—the fantasy?—of decapitation haunts funerary texts: "May his head be returned to him after being cut off/ His head will not be taken away after being cut off." Decapitation was just as frightening to the living. A magician, famous for his ability to reattach severed heads, refused to apply his art to a prisoner, as the ruthless pharaoh Khufu suggested: "Not for a man, your Majesty, life, health, strength, my lord. It was not ordained that such treatment be inflicted on the cattle of god [men]."

Death also endangered all other body parts, which, in the "analytic" view of Egyptian somatology, were vulnerable independent of the whole. Each part therefore required protection. Consider this procedure, designated by the scholarly term "melothesia" (literally, "placement of members"), which placed body parts one by one under the protection of a deity:

> Your head is now the head of Horus of the underworld, imperishable.
> Your face is that of Mekhentyirty, imperishable.
> Your two ears are those of the son and daughter of Aum, imperishable.
> Your two eyes are those of the son and daughter of Aum, imperishable.
> Your nose is now that of a jackal, imperishable;
> Your teeth are those of Sopdu, imperishable;
> Your arms are those of Hapy and of Duamutef; if you need to depart for heaven, may you depart.
> Your feet are those of Imsety and Qebehsenuef; if you need to descend to the lower heaven, may you descend.

> Your flesh is that of the son and daughter of Aum, imperishable.
> You shall not perish; your *ka* shall not perish. You are a *ka*.

If the formula took effect, the dead man could then proclaim: "I am altogether in the state of a god. There is no member of mine without a god."

A famous myth served as the archetype for the preservation of the body's integrity. Seth, not content to murder his brother Osiris, took the trouble to cut up his corpse and disperse its parts across Egypt. Isis, sister and wife of the dead man, set out on a stubborn quest and, after many vicissitudes, reconstituted the dead and mutilated body and conceived Horus by it. Beyond its countless variations, this myth expressed the fundamental principle of funerary beliefs: anyone whose corpse overcomes the threat of dismemberment posed by death can aspire to the afterlife.

Mummification

Of course, efforts made to preserve the corpse's integrity also manifested themselves in ritualized techniques, and in the first place, in mummification. This technique accounts for much of the interest, sometimes unhealthy perhaps, in the civilization of ancient Egypt. In the Middle Ages, powder made from mummies was an ingredient in great demand in pharmacopoeia. Its value lay in its very components, obviously heightened by magical funerary connotations: the resin injected into the skull, and, in later samples, the bitumen.

The practice of mummification was no doubt inspired by the preservative climate of the Egyptian desert, where the process sometimes occurred spontaneously. This is attested to by the discovery of human remains in excellent condition after five millennia, even though the corpse received no particular care. Beyond variations arising over a period of more than three millennia, the basic principles of mummification were the following:

1. Evisceration through an opening in the left flank. The organs were removed, bathed in various solutions—some with a base of cooked wine and aromatics—then placed in four containers called "canopic jars" and set near the mummy. Each of the four jars

Since the appetite of the deceased was insatiable, processions of servants file in continually bearing food.

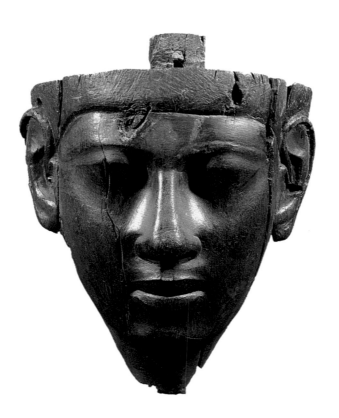

Above: A wooden funerary mask dating to the Third Intermediate Period (1080–660 B.C.).

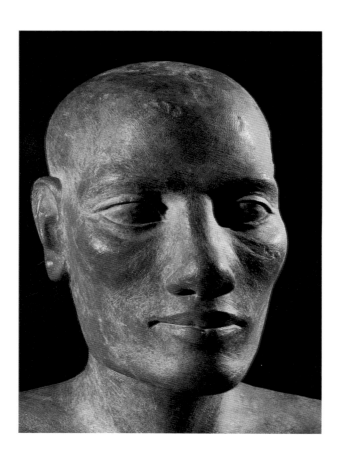

At left and right: The so-called reserve heads. Occasionally placed in Old Kingdom tombs, sculptured heads of the deceased had a role that is not perfectly understood. Marks on some of them suggest that they were used in rituals.

Opposite: Although the entire body had to be preserved, the face had particular importance. Hence, in the Roman Era, portraits painted on wood, or, as here, plaster masks, were placed on the mummy. These are from Antinoë and date from the second or third century A.D.

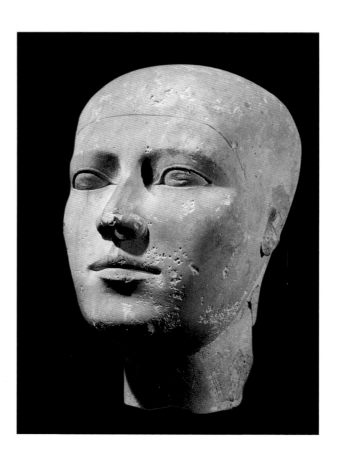

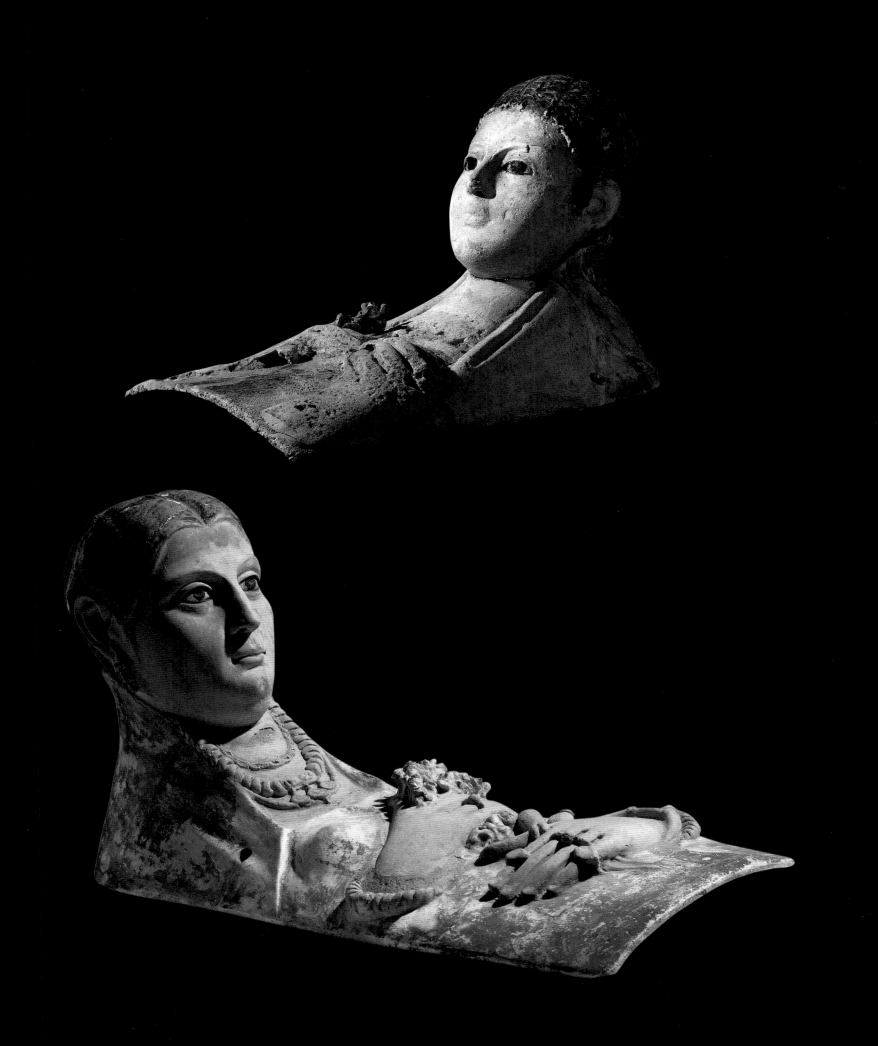

represented one of the so-called Four Sons of Horus: the baboon-headed Hapy watched over the lungs; the human-headed Imsety, the liver; the hawk-headed Qebehsenuef, the intestines; and the jackal-headed Duamutef, the stomach. In later periods, the viscera were carefully wrapped and placed back in the mummy.

In any case, the inside of the body was packed tight with linen pads, resin, myrrh, and aromatics with a desiccating property. They were the source of the famous nicotine found in the mummy of Rameses II. It came not from the pharaoh's cigars, but from the plant *Nicotinia l.* The brain too was usually removed and replaced by resin. Conversely, the heart, seat of consciousness, intellect, will, and affect, was left inside the mummy and sometimes received special treatment. To ensure the proper functioning of the personality, it was important that "the heart be in its place," according to an Egyptian expression.

2. Desiccation of the flesh by application on the washed skin of natron, a mixture of sodium carbonate and sodium bicarbonate with traces of chloride and sodium sulfate.

3. Bandaging of the body, after it had been washed to rid it of the natron residue and rubbed with various products—oil, myrrh, and resin. That phase was considered so important that it had its own specialist, the bandager. The corpse was enveloped in a shroud, a winding sheet, and bandages; amulets were inserted between the strips of cloth. This combined a practical advantage and a symbolic meaning: the flesh was isolated, and the complex network of cloth surrounding it was supposed to prevent the feared dismemberment of the body.

The waste products of the operation, pads and linen, were carefully preserved, because the humors with which they were soiled were believed to possess regenerative powers, like the floodwaters of the Nile. They were buried separately, often outside the tomb. In fact, it was the discovery of a pit in which the waste products of mummification had been collected that allowed Howard Carter to circumscribe the sector where the tomb of Tutankhamun was eventually found. Practices related to mummification and the reconstitution of the body evolved in the direction of increased complexity, at least in theory.

Later rituals of mummification—though for sacred bulls—prescribed an endless series of rites

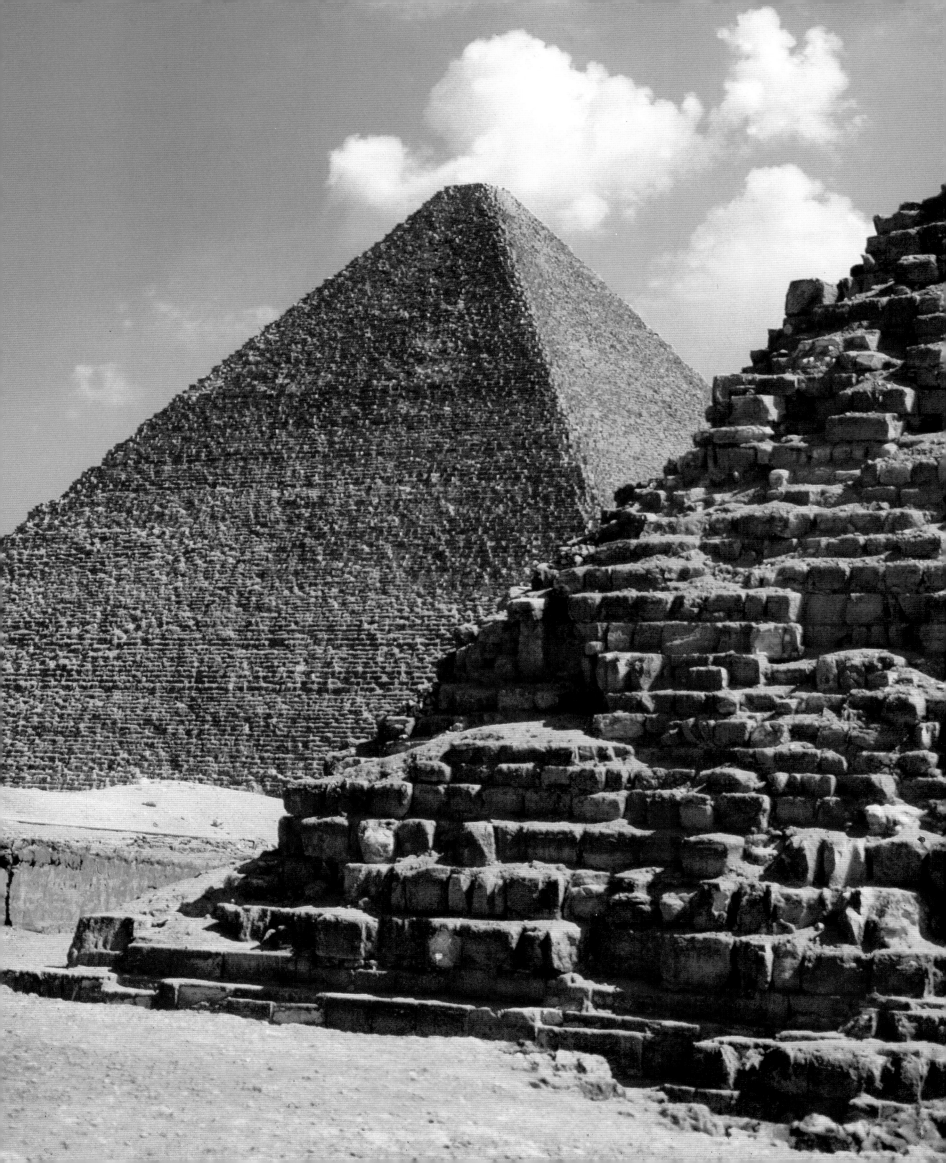

Mummy portraits. In pharaonic Egypt, the face of the mummy was covered with a wooden, plaster, or even gold mask, which idealized the deceased, since he was supposed to accede to the world of the gods. Beginning in the Roman Era, under the influence of Italic cultures, there was an increasing tendency to attach to the mummy a portrait, or several portraits, that were truly individualized, or whose aim was to give that impression. They were painted on linen or stuccoed wood using the tempera or encaustic technique. Several of these portraits are masterpieces of world painting; some of the jewels of ancient Egypt were creations that, at least in part, were independent of pharaonic civilization.

Mummification presented the deceased at his or her most beautiful, or even idealized. Instead of verisimilitude embalmers often transfigured the dead through masks made of gold because the metal was considered the flesh of the gods.

and formulas; it is even doubtful whether they were ever truly implemented. In general, as was often the case, one can discern a gap between canonical imperatives and actual practices. For example, there is reason to believe that the mummy did not actually stay in the embalming tent for seventy days, as tradition required. These tents were so overcrowded with clients that, to avoid confusion, identity tags were attached to them. The unsavory odor that escaped the tents was reminiscent of fish salteries. In fact, the same Greek word, *taricheute*, designated both embalming specialists and salting specialists.

Transfiguration and Animation of the Deceased

After mummification, the prominent traits of the face were still clearly marked, perhaps too clearly. It was not the face of earthly life that had to be suggested, but a face transfigured by the new state, in proximity with the gods, which the dead were supposed to have reached.

Thus a mask, sometimes molded on the mummy, was placed on the bandaged corpse; this mask could be made of plaster, wood, or even gold, like the mask of Tutankhamun, images of which have been reproduced so often. In contrast, in the Roman Era, when the yoke of pharaonic traditions was lighter, an actual portrait painted in tempera was placed on the mummy; these so-called Faiyum portraits are among the masterpieces of ancient Egypt, and perhaps even of pictorial art generally. A dialogue spanning the centuries is established between them and the portraits of Frans Hals. The placement of the mask returned the dead man's individuality to him and at the same time eliminated the threat of decapitation.

To complete the process of bringing the mummy back to life, the very important Opening of the Mouth ritual occurred during the funeral ceremony. This ritual, which was sometimes also performed on the statue of a god, consisted primarily of touching the mummy's mouth, but also its eyes, nostrils, and ears, with highly symbolic instruments: a snake's-head staff, an adze, a flint, or a knife made from meteoric iron. The task was to open all the sense faculties, particularly the respiratory apparatus, to make them available in the world of the hereafter: "Breath belongs to X, the deceased, breath belongs to his nose, breath belongs to his two nostrils!"

With so much care given to the head, the feet also had to receive their due. In the later periods, the mummy was placed in a case depicting feet clad in sandals, in relief or painted pink like the flesh of the sun god. It was important that, in the world to which the deceased was going, he be able

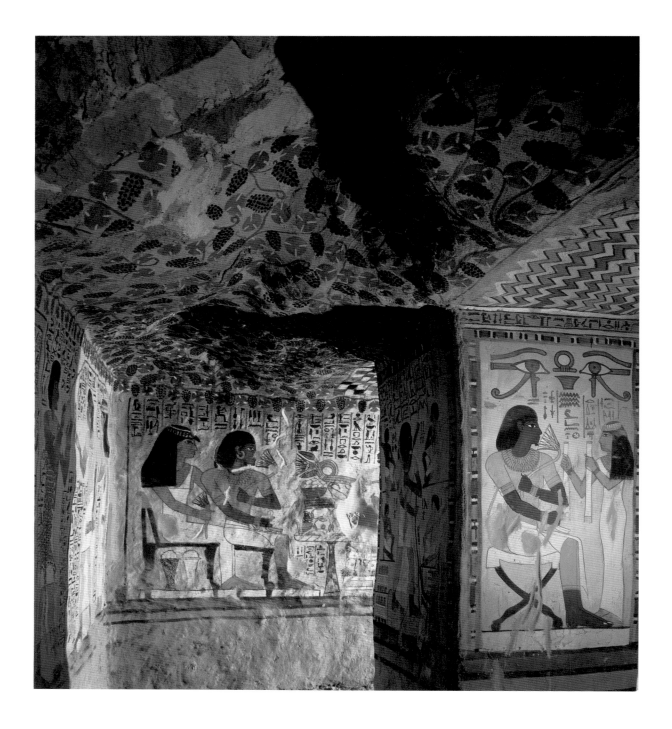

The mortuary chapel was decorated with scenes from the life of the deceased. Far from realistic, they were ritualistic and symbolic. Sennefer, a governor of Thebes under Amenhotep II, receives from his wife an offering of cloth. The presentation magically reinforces the efficacy of his mummy bandages.

Opposite: Another dignitary hunts birds with a boomerang, the transposition on earth of hunts for evil spirits, which he must conduct in the hereafter.

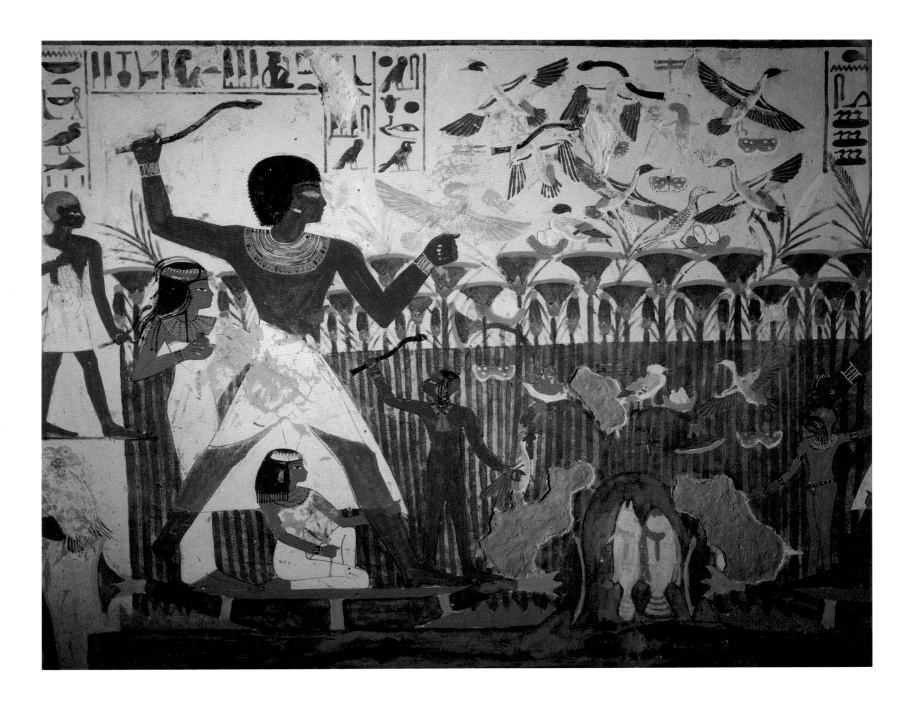

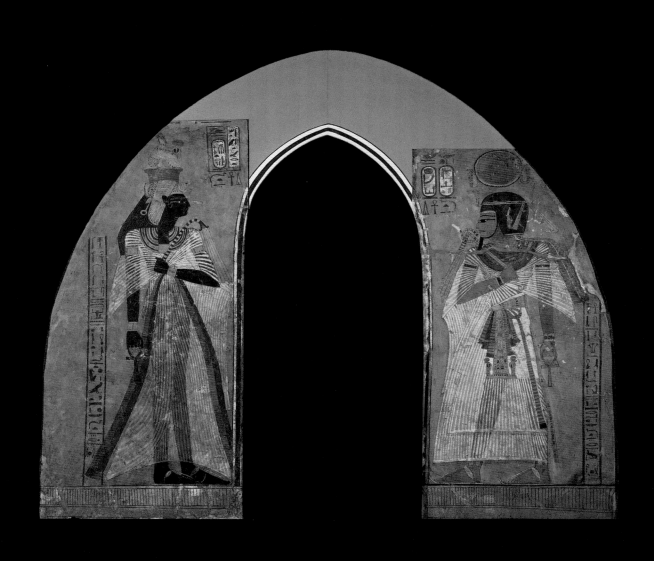
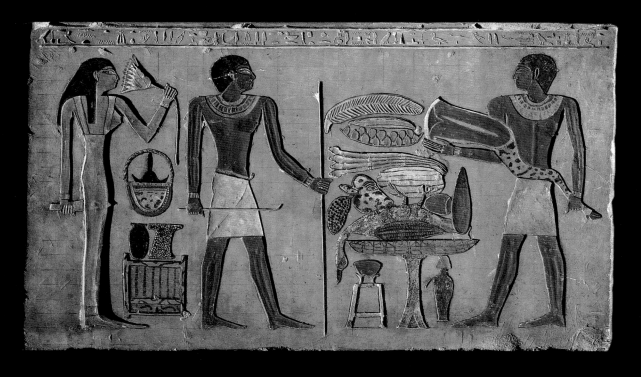

to stand up and move around as the journeys that presented themselves required: "Let your feet be at your disposal!" proclaimed the funerary formulas.

The Tomb

A secure place was needed to preserve what had been the object of so much attentive care: the tomb. There were a great variety of tombs, from a simple pit for the lower classes to pyramids for pharaohs. Pyramids were built at least between the Third Dynasty, with its famous step pyramid of Djoser, and the Second Intermediate Period, with its brick pyramids, now destroyed, for Theban princes of the Seventeenth Dynasty. Individuals living during the New Kingdom perpetuated the notion of pyramids by erecting brick pyramidions near their cult chapel, and Ethiopian kings adopted that form of sepulcher in the first millennium B.C. We have recently realized that not all pyramids were necessarily true sepulchers. Some served as cenotaphs or simply as monuments designed to be the object of cult worship.

Thus, although we already knew of three pyramids for the good pharaoh Sneferu of the Fourth Dynasty, father of the notorious Khufu, excavations have now revealed that the pyramid of Seila, perched on a peak overlooking the Meidum plain, should also be attributed to him. In addition to pyramids, tombs could be dug into cliffs (the cave tombs of Middle Egypt), sunk deep in the side of a mountain (the hypogea in the Valley of the Kings), constructed as mounds of brick or stone (the mastabas), or inspired by the architecture of temples (the tomb of Petosiris). Necropoleis were established on the *gebel* or on sandy knolls on the Delta to avoid the ravages of flooding and were usually located in the west, which was considered the realm of the dead. But that situation did not prevail everywhere, despite what certain "symbolist" excesses have suggested.

The structure of the tomb was twofold. First, there was the sepulchral sector where the mummy was placed, which was supposedly closed forever once the funeral ceremony was over. Second, there was the cult chapel, open to the living so that they could practice the mortuary cult. In general, both parts were located at the same place, next to or across from each other, but they could also be separated. In the New Kingdom, mortuary cults were practiced in mortuary temples located at the edge of farmlands, but the pharaohs were buried in the Valley of the Kings a few kilometers away.

Every Egyptian wanted to be buried in his home region, except when he considered it more

Above: Queen Ahmose-Nefertari, at left with black skin, and her son, the pharaoh Amenhotep I. They were invoked as patron saints of the necropolis and also guarded an entrance to the mortuary chapel.

Below: It was the duty of the son (right), to look after the funerary arrangements of his parents (left), by presenting them with the necessary food, in particular an enormous haunch of beef.

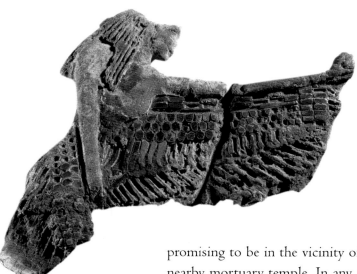

promising to be in the vicinity of the royal tomb and the piles of offerings dedicated to it in the nearby mortuary temple. In any case, it was absolutely imperative to take care of such matters as soon as possible, as this wisdom text urges:

> Prepare your place in the valley, the underground world that conceals your body.
> Give it the first place [literally, "place it in front of you"] among the things that count.
> And may you rest among the great ancestors' tombs.
> No reproach shall fall on he who does that.
> Blessed is he who is thus provided for.
> When the messenger comes to take you away, may he find [you] ready.
> For be assured, he will not wait for you, saying:
> "See, you who are coming now, prepare yourself, it's your time!"
> Do not say: "I'm [too] young to be taken away!"
> For you do not know the time of your death.
> Death comes to take the child in its mother's womb
> As well as the one who has grown to be an old man.

This type of recommendation had a real impact. Egyptians invested as much as their means allowed in their tombs. Thus, in some sense, funerary equipment was the external sign of social status. The extraordinary role of the tomb was obviously linked to funerary beliefs. The tomb, far from being simply the place where the corpse was disposed of, was an integral part of the mechanisms established to accede to the afterlife, through the materials it housed and through its funerary displays. In a word, as the texts say, it guaranteed that the dead were well "provided for."

Funerary Displays

And the dead *were* well served, at least those who had been lucky enough to have a prominent social position during their earthly life. When Howard Carter opened the tomb of Tutankhamun, he had

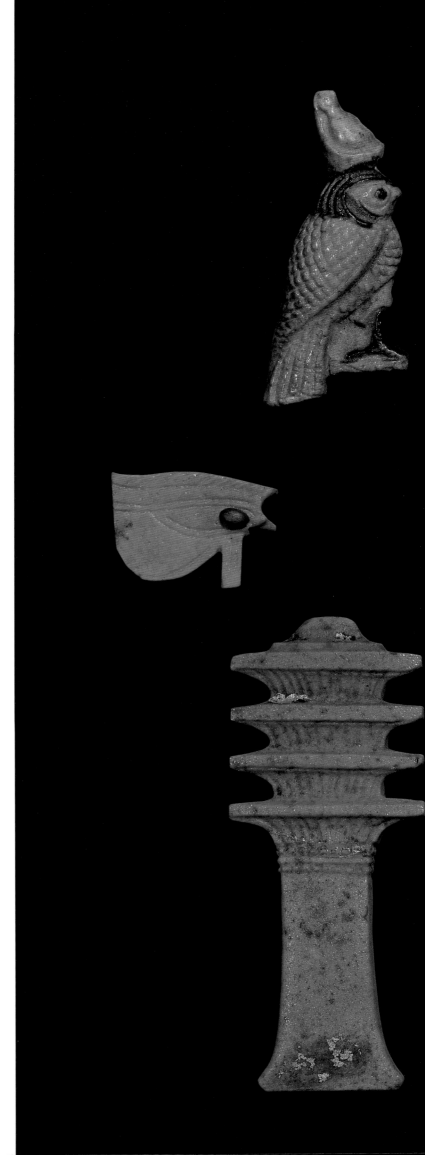

Amulets. Above, the hawk, wearing the double crown of Upper and Lower Egypt. At left, the wedjat—the eye of Horus restored and made healthy by Thoth after it had been torn to pieces by Seth. At right, a papyrus stalk, wadj *in Egyptian, symbol of growth and new greenery. Below, the* djed *pillar, symbol of Osiris's new-found stability after Seth buried him.*

The pyramid (height: about
170 feet, or 52 meters)
erected in Abusir by the
pharaoh Nyuserre of the
Fifth Dynasty (about
2404–2384 B.C.). View
of a colonnaded hall in a
dignitary's tomb.

Opposite: The famous step
pyramid of Pharaoh
Djoser from the Third
Dynasty (about
2677–2599 B.C.).

a hard time clearing a path through the incredible clutter of funerary material. It took him several years to record the objects and send them off to the Cairo Museum. Of course, this was the sepulcher of a pharaoh, but the tombs of individuals of respectable rank were also abundantly stocked, to judge by those that have been discovered untouched. For example, Kha (reign of Amenhotep III, fourteenth century B.C.) and Sennedjem (reign of Rameses II, thirteenth century B.C.), whose positions among the community of royal tomb workers of Deir el-Medina placed them hardly higher than what we would call the petty bourgeoisie, were wealthy enough to have their burial vaults contain an abundance of articles: two coffins, which were themselves in a sarcophagus, canopic jars, *shabtis*, statuettes of deities, and also piles of furniture, beds and chairs, cases and boxes, a multitude of jewels, stacks of vases made of ceramic but also of more noble materials, garlands of flowers, papyri, or, lacking anything better, ostraca with funerary—but also literary—texts.

This means that the dead man was not abandoned in the depths of the burial vault; on the contrary, he was provided with supplies as plentiful as his resources allowed. The decoration of the tomb itself, its texts and images, was also part of funerary displays. It served the same ends as material goods, which were themselves often decorated with texts and images. There were two ends served: first, funerary displays made available whatever the deceased needed to satisfy his needs in the hereafter, both nutritional needs and the knowledge necessary to overcome the countless adversities he could not fail to encounter; and second, they guaranteed, affirmed, and immortalized the expression of his personality.

The Hunger and Thirst of the Dead

One basic preoccupation was to provide for the subsistence of a dead person who, in the hereafter, whatever form that might take, continued to feel hunger and thirst, just as he had when he lived on earth. Without fail, the living placed food and drink, or simulations of food and drink, on the tomb. And yet, true to a general tendency in funerary practices, it was believed that one could never be too careful. So why not immortalize the fact that the dead person had food by mentioning it in formulas written in the tomb? Why not increase the effectiveness of those formulas by reciting them periodically and as frequently as possible? And finally, why leave anything to chance? Why not

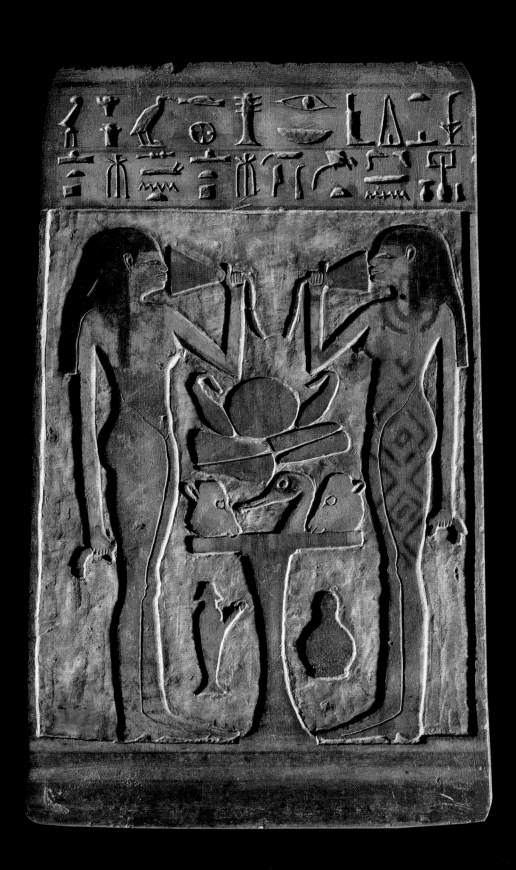

combine that recitation with the presentation of real offerings? This chain of thought was the source of one of the most important institutions of pharaonic Egypt, the mortuary cult.

What was not done to sustain the dead! Pharaohs built mortuary temples and established foundations providing goods and workers. Individuals made donations and testaments, complex legal documents that allowed them to depart for the hereafter with the certainty that their sons, thanks to a legacy, or funerary priests, would be compelled out of contractual obligations to present them with offerings and a libation, bread and beer at the very least, while reciting the appropriate formulas. In addition, the dead were attributed such great appetites that they were fed, so to speak, during their lifetime. In fact, many Egyptians, including pharaohs, erected statues, offering tables, and stelae in temples and holy places while they were still alive to capture the essence of consecrated food so that they could accumulate it in their *ka* in anticipation of their needs after death.

Spurred by such offerings, networks of economic interest were created, complicated by the fact that the food offered was not destroyed by the rite. Once consecrated, it could be reused for another ceremony, and so on down the line, before finally being consumed. Such networks, called "reversion of offerings," gave the Egyptian economic organization its originality. Available indicators suggest that, as one might expect, these mortuary cults did not last long. Egyptians were not dupes, but they did not give up on the idea either. Even the dead live on hope!

The Initiated Dead

To take proper advantage of the hereafter, it was not enough to be fed: the dead had to overcome difficulties, and there were no lack of these. The deceased had to get through many doors watched by disagreeable guards; appease intimidating ferrymen to get a place on the ferry that crossed bodies of water; avoid infernos and torture chambers. And how many dangerous animals—snakes, crocodiles—how many monsters, how many spirits full of evil intentions had to be repelled!

Fortunately, these obstacles, as formidable as they might be, could be overcome through magic. If the dead could name them, list their components, if the deceased possessed the proper apotropaic formula to get rid of them, they would vanish, not "as if by enchantment," but because they were, in fact, enchanted, in the strong sense of the term. In other words, the afterlife was a matter of

knowledge. An initiated dead person was a powerful dead man. Not that some transcendental revelation was achieved after a mystic period of asceticism; rather, the deceased had simply acquired a knowledge of the creatures and things of the hereafter. The following sort of declaration was constantly being made: "I am the 'transfigured dead,' skillful, one who knows his or her formula. I know the formula for reaching god, great lord of heaven"; "I know you, I know your names."

The famous so-called judgment of the deceased (the *psychotasia*) in the Book of the Dead must be understood in that sense. The dead who appeared before the court of Osiris for the "weighing of the heart" launched into a long series of denials, each addressed to a particular judge. Egyptologists traditionally call this a "negative confession," an unfortunate term, since the word "confession" has misleading connotations. The point was not purification of sins by admitting them, but acceptance into the circle of gods by promising that the prohibitions and taboos specific to that circle have not been violated.

More generally, success in the ordeal of the judgment of the dead, far from resting on the scrupulous observance of moral laws during a person's lifetime, lay quite simply in a knowledge of the names and formulas that allowed the balancing of the scales at the court of Osiris. The deceased stocked their memories—or rather, their hearts, as Egyptians believed—with this necessary knowledge. There were even formulas to allow the dead to recall what they had known during their lifetime. But two precautions were better than one, and it was therefore considered prudent to make texts conveying that knowledge available in the tomb. These texts were usually combined with others, which reproduced the rituals that had been performed during the deceased's funeral as a way of immortalizing their effect.

Guides to the Hereafter

Texts could be copied onto the structure of the tomb itself or onto the sarcophagus. They were arranged in such a way as to adapt the thing they were written on to the symbolic function with which it was invested. (This is a simplification, since the details were extremely complex.) For example, in a funerary complex, the text plotted a journey that began at the sarcophagus and led outside, following the path the deceased would have to take to his new life.

In addition, funerary texts could be copied onto scrolls or sheets of papyrus placed near the deceased. They composed a rich body of literature. The most ancient are the Pyramid Texts, whose first known

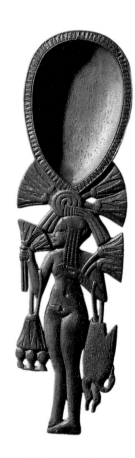

Probably part of the equipment placed in a tomb, this unguent spoon is decorated on the handle by the profile of a servant girl carrying offerings.

Following pages: Valley of the Kings, Biban el-Moluk, Thebes. View of the entrance to the tomb of Rameses VI. The earth that spilled down the hillside during the construction of the tomb covered the entrance to the burial of Tutankhamun, and thus kept it safe from the depradations of looters.

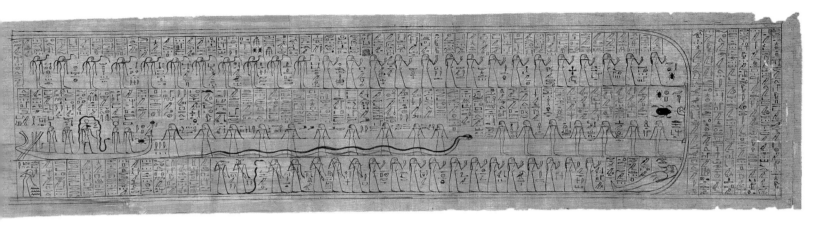

version is in the pyramid of Unas, last pharaoh of the Fifth Dynasty (c. 2350–2321 B.C.). The genesis of these texts certainly predates that time by a great deal. Originally reserved for the pharaoh's use, the Pyramid Texts were later widely diffused and often reused in other compilations or compositions.

By the beginning of the Middle Kingdom, a new body of funerary texts had come into existence, which now took precedence in funerary displays. They are known as the Coffin Texts because they were usually, but not always, inscribed on the coffin or sarcophagus. During the New Kingdom, certain formulas from the Coffin Texts were added to many others from various sources to compile the famous Book of the Dead, another misleading Egyptological designation. In fact, it was never more than a compilation: the number and order of chapters varied from one copy to the next until the Late Period, when a canonical version was established, and even then it did not have a truly organic unity.

During the Ptolemaic and Roman Eras, other funerary compositions appeared, for example, the Book of Breathing and the Book of Passing through the Netherworld. One of the major tendencies of funerary literature was to give an increasingly precise description of the hereafter. Although its topography remained very vague in the Pyramid Texts, the Coffin Texts included an autonomous work, the Book of Two Ways, which was a description and map of the hereafter, with supporting illustrations. In the New Kingdom, a series of guides to the hereafter appeared, initially for the pharaoh's use. They described in minute detail the mythological topography of the regions traversed by the sun at night or by the stars during the day. These guides, the most elaborate of which was the Book of That Which Is in the Netherworld, decorated the endless corridors of tombs in the Valley of the Kings with their strange, sometimes fantastic images.

Tomb of the Personality

The tomb made available whatever the deceased needed to face the hereafter, but it also aimed to express his individuality. It was by no means limited to reconstituting his physical integrity through mummification; rather, it was as well the most visible manifestation of his emotional, moral, and

social being. Thus every element possible was collected in the tomb, even relics of the personality.
In the tomb of Tutankhamun are three containers with the inscription: "Purse of His Majesty, life,
health, strength, when he was a child!" The following formula allowed the heart, seat of memory, to
remember life experiences: "My heart, rise to your place so that you remember what is in you."

The deceased were also provided with particularly cherished things, for example, manuscripts of
favorite literary works. This proved to be a boon for Egyptologists, who are indebted to dead
Egyptians for their knowledge of the literature living Egyptians enjoyed. Identity was affirmed and
reaffirmed everywhere, so that there would be no mistaking the person in question. This was clearly
necessary if the articles and funerary rites, as well as the statues and effigies, were to be fully effective.

The proper name of the deceased was systematically marked on every funerary object, every text,
every part of text or object. Names in pharaonic Egypt were chosen from a relatively limited repertoire,
though selection varied with the era. Therefore, titles and sometimes epithets of the deceased were also
indicated, as was the filiation, for greater precision and to avoid confusion. Above all, the tomb, as we have
seen, included a public part where the social personality of the deceased was re-created, affirmed, and
immortalized. That public part could extend into monuments, objects, or other traces located far from
the burial site: dedicated statues in temples; cenotaphs erected in holy places, such as Abydos; or graffiti
placed at a site inhabited by a divine presence on the occasion of a professional visit.

Funerary monuments were therefore dedicated to posterity. The deceased required presentation
in the most favorable light possible, and for three reasons. First, the dead person had to inspire
enough respect to dissuade anyone from touching the monument, appropriating it, taking elements
from it, or profaning it in some way. It was believed that a potential violator would think twice
before attacking the tomb of a person whose conduct was beyond reproach. Such a person would
probably have the ear of the gods and therefore a strong ally, not to mention technical knowledge
in magic, which the deceased could use in the world of the living.

Second, a good self-description led tomb visitors or the public at funerary monuments, to recite
offering formulas, and thus participate in the mortuary cult previously mentioned. The self-

Once accepted into the kingdom of Osiris, the deceased man will live in a land of milk and honey. Surrounded by trees heavy with fruit, he and his wife will reap long, supple flax and heavy ears of wheat from gigantic stalks.

description was often linked to the "call to the living," which urged the living to participate. This participation could take the form of an offering, a libation, or the simple recitation of an appropriate formula, which cost no more than "breath from the mouth," in the traditional expression. What did the living get in return? The dead promised—or implied—that they would use their influence with the gods on behalf of anyone who would recite the formula. And the living considered that influence more effective when it came from someone whose conduct was meritorious, according to the portrait he gave of himself.

Third, a good image quite simply made it possible for the deceased to be remembered. Was that not also a form of afterlife? The same Egyptian word, *ren*, meant both "name" and "renown." Far from serving as a mere label to designate the deceased, the name contained his or her actions and reputation. Certain elite did not hide the fact that, in the end, renown and the memory of posterity were the only form of afterlife they could really believe in. The funerary monument, even though it finally proved fragile and labile, at least had the value of perpetuating the individual's idealized form in human memory.

Thus the personality was reconstituted, reshaped, and manifested in the tomb and its extensions. The need to ensure an afterlife for oneself elicited an ostentatious expression of individuality in a society crushed by the weight of the pharaoh's totalitarian ideology.

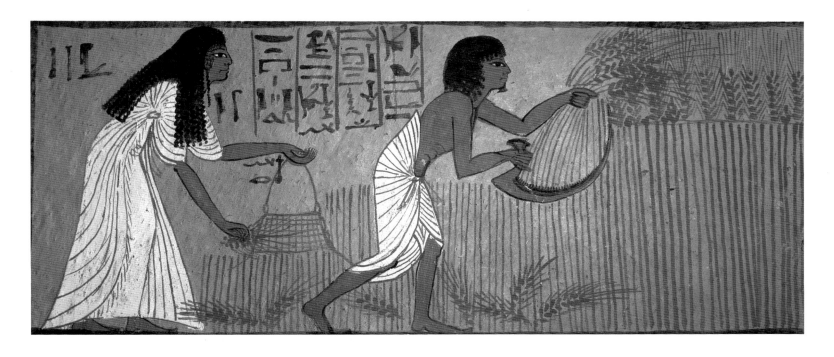

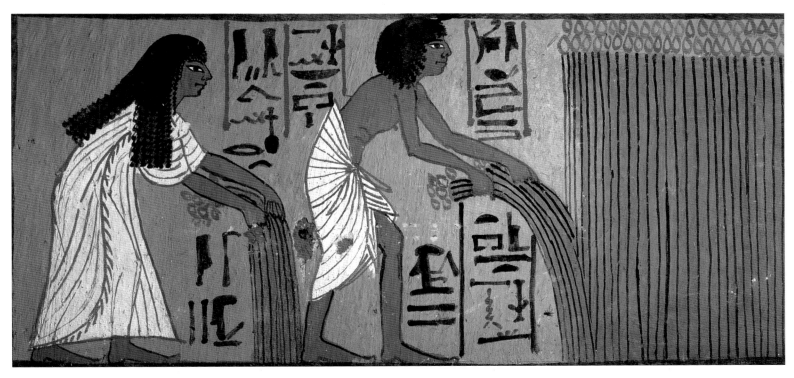

Man in the attitude of a mourner, rendered with an expressiveness rare in ancient Egyptian statuary.

Opposite: A dutiful man bearing offerings kneels before his preferred deity, the lion goddess Wadjyt. The disproportion between man and goddess expresses the humility of the individual before divine omnipotence. Representations of individuals directly addressing a god first appeared during the Middle Kingdom (first half of the second millennium B.C.). Non-royal persons were not depicted in the round until the New Kingdom (second half of the second millennium B.C.). This work, which dates from the Late Period (seventh or sixth century B.C.), attests to how far ideas had evolved.

The Individual and the Gods

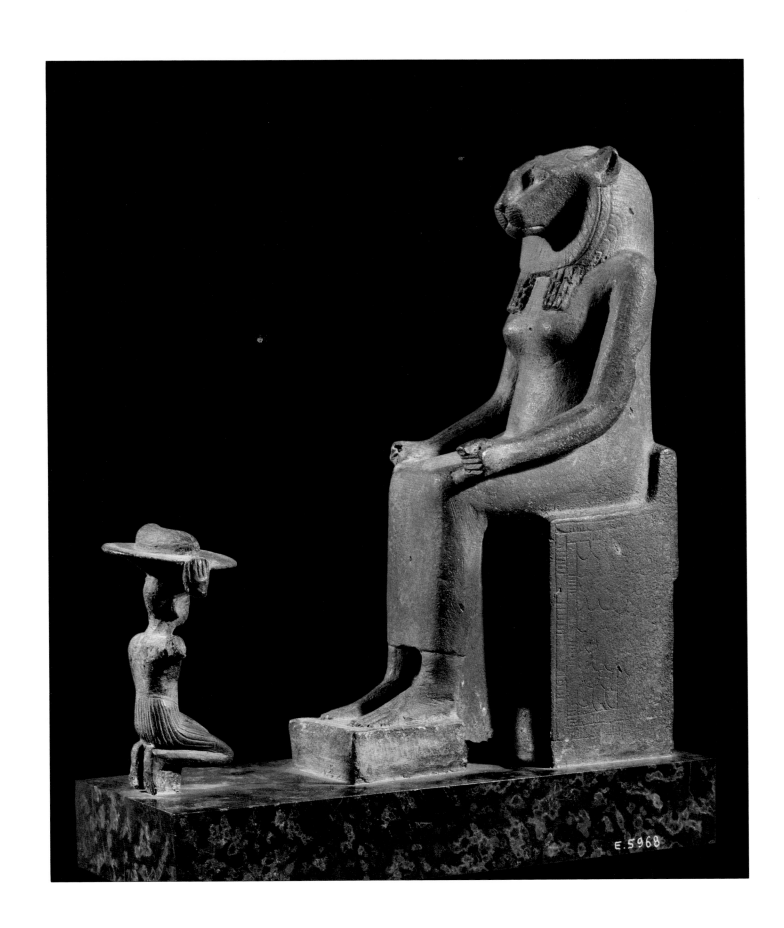

At first glance, the columns rising to conquer the sky, the arrogant pylons, the blocks arranged in straight rows render the individual absurd, as if crushed under their weight. The massive, even colossal dimensions of Egyptian temples impose the feeling that all of Egyptian society—and behind it, humanity, entrusted by the gods to govern society—is being expressed through these monuments. As we have seen, these temples were, in fact, cogs in a gigantic machine whose operation and maintenance were assured by the state, with the pharaoh at its head. The survival of creation depended on it. The relation between man and the gods manifested itself originally in the official cult, which was an integral part of institutions. And yet, that proud society was composed of individuals, with their anxieties, their desires, their worries, and their personal ambitions—not to mention their aspirations for the afterlife—which even sincere membership and participation in the state religion could not adequately take into account. These individuals therefore set up parallel, personal relationships with the forces that governed the world order.

From the outset, these relations did not occur outside state religion, or even less, in opposition to it; rather, they were based on it. Modern visitors to Karnak have only to climb out on the terrace of the temple of Khonsu to be assured of that. If they look toward the horizon, they will take in the enormous architectural complex dedicated to Amun, erected and constantly expanded to give the official cult a space worthy of the all-powerful deity it celebrated. If they then lower their heads for an instant, as if to take stock of the human once more, they will make out at their feet a maze of graffiti, often clumsily scrawled. Most consist simply of proper names, or sometimes a short prayer. The people who inscribed them were believers who had come to present their humble requests personally to the gods. What would later conventionally be called "personal religion" rested on the same fundamental principles as state religion; it was simply that the outlook was individual rather than collective.

The actions that placed the two partners in a relationship could be unilateral, either because the individual's relationship depended on the forces that governed the world—human beings were in the hands of the god—or conversely, because the individual had some power over these forces. In that case, the god was in the hands of human beings. These actions could also be bilateral, when a request was followed by a reply, when a dialogue was initiated, when the god and the individual were, so to speak, hand in hand.

During the Late Period, the myth of the child Horus, who was healed of scorpion stings by the magic of his mother, Isis, was extremely popular. At that time, there was a proliferation of stelae with the central motif of the young Horus defeating wild animals. These stelae were sometimes part of a statue that was covered with inscriptions and images and set on a pedestal with a basin, which collected water that had been poured on the statue. The water was thought to contain the healing virtue of the magic formulas and images over which it had flowed.

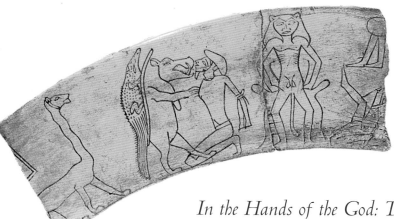

In the Hands of the God: The Human Fate

For Egyptians, humanity as a whole and every human being were created by a conscious and responsible demiurge. This was not the "lazy god" of certain religions, who abandoned his creatures to their fate. On the contrary, the demiurge continued to watch over them, because they had come from his flesh and were fashioned in his image. All the same, the way his solicitude manifested itself changed over time. During the early days of the Old and Middle Kingdoms, the creator god was content to govern individual destinies based on the order he had established, which possessed immanent mechanisms that favored the person who respected him and that punished the one who transgressed against him. As a result, an individual's success or failure depended on behavior.

Nonetheless, the demiurge was in control in the last instance: it was he who granted or refused an individual's capacity to know and conform to the laws of order. "He who obeys is someone god loves, but he whom god despises cannot obey." It was the god who reserved the right to intervene in the individual's life on occasion, when it seemed right, by irresistibly winning the person over in spite of him- or herself.

Thus, in The Tale of Sinuhe, a masterpiece of Egyptian literature, the hero is compelled to desert the pharaoh's army, even though he has no desire to do so:

> Yet when the servant took flight,
> I had not foreseen it, it was not in my mind,
> I did not decide on it. I do not know what made me leave and go to that place.
> It was like a dream . . .
> My feet ran, my heart led me,
> The god who had decided I should flee drew me.

Finally, the deity could sporadically produce events or prodigious signs to change human destiny. During the New Kingdom, a real "ideological shift" changed the relations between god and the

individual. The demiurge no longer controlled the world through the intermediary of an established order. Now, he watched over his creatures directly and modified their destinies according to an unknowable design, making and unmaking their lives without taking the ridiculous plans of human beings into account. As The Instruction of Amenemhat I elegantly puts it: "Man is made of clay and straw,/God is his builder./He demolishes and [re]builds him daily./He makes a thousand slaves according to his whim,/And he makes leaders of a thousand men." It was therefore better to be satisfied with one's condition and to submit to it, hoping for improvements in the future, a future that was fundamentally unforeseeable: "Because you do not know god's design/And therefore cannot lament the future,/Take your place in the arms of god." Such were the basic views that placed the individual's life in the hands of god.

God in the Hands of Man: Magic

Despite his ontological inferiority, man was not completely powerless. He possessed magic, as this hymn to the demiurge emphasizes: "For them he made a ruler with [his] fragrance,/A support to shore up the back of the feeble,/For them he made magic as a weapon/ To repel the blows of fate/Which one must guard against day and night."

Make no mistake, however: just as magic in itself was neither good nor bad, it was also not intrinsically individual or collective. Everything depended on the way it was used. State religion used it in its ritual practices, as did the individual in everyday life. Magic was a set of techniques that allowed people to manipulate the elements of the world by acting on the forces behind them. It was therefore based on knowledge, which itself rested on a notion we have already encountered, namely, that there was no discontinuity between being and the things used to signify it: symbols, images, and names, both in their written form and in the sounds they encoded.

Man could put this knowledge to use for his own benefit, either directly or by employing the

Usually carved from the curved lower canine teeth of the hippopotamus, "magical ivories" were decorated with images of animals and figures, most of them imaginary. In addition to the tortoise and scarab beetle, this ivory has a creature with a man's body and the ears, mane, and tail of a lion; a monstrous hybrid of hippopotamus and crocodile; a panther with a giraffe's neck; and other equally fantastic creatures. Possessing magical powers, these strange beings frightened away evil spirits, capable of threatening the dead, or the mother and her young child.

This Eighteenth Dynasty stone sculpture does not illustrate the devotion of the individual to his god because prayers and offerings are not at issue. Rather, the statue depicts the relation of an artist to his patron deity. In fact, the royal scribe Nebmertef, who is totally absorbed in his writing on the papyrus scrolls that are spread on his knees, enjoys the benevolent inspiration of Thoth, god of writing, who takes the form of a baboon here.

services of a magician. There was no lack of individuals who, on a professional or casual basis, used their skills in that powerful technique: the "wab priests" or "purifiers" of Sekhmet, chief priests of a goddess responsible for many of the ills that afflicted poor humans; the "magicians of Serket," experts in scorpion stings; the "lector priests," officiants specializing in books of spells, and who were given the more specific title "chief priests" (biblical Hebrew borrowed the Egyptian word, rendering it as *harummim*); and all those who haunted the "houses of life," places of religious science.

At the very least, the mastery of writing in itself gave access to magic via the countless compositions available. Magic was omnipresent in everyday life, and Egyptians used it especially for prevention, as prophylaxis. The result was an infinite proliferation of bric-a-brac: talismans, amulets, charms, and other fetishes placed around the house or in the tomb, or worn on one's person. To take one example among a thousand, spells and apotropaic drawings were scrawled on papyrus leaves; they were then folded and refolded, tied together with a string, and hung around the neck. Success guaranteed, if we are to believe the reviews!

Magic could be an offensive tactic when the individual used it to realize thwarted aspirations: to win the heart of an indifferent beauty, to make the hair of a rival fall out, to disable the bodyguards of a troublesome pharaoh one planned to assassinate. Finally, it could be a defensive weapon, used to get out of a difficulty when faced with one of the thousand and one affronts of life: accidents, wounds—especially those inflicted by the many dangerous animals with which Egyptians shared their world—illnesses, and ailments of every kind. The list of the processes used by magic would be endless. They combined the virtue of objects, the power of formulas, the potency of ingredients, and the efficacy of gestures and rites.

Beyond this incommensurable diversity, however, the ultimate cause was always the gods. Thus, illnesses had complex etiologies: pathogenic air, the scheming of "purifiers" motivated by bad feelings, traveling spirits, emissary demons. But what pulled the strings of all that unrest was a goddess, Sekhmet, who was ultimately an emanation of the demiurge. As a result, magic implied that human beings manipulated the divine world.

Very often, the basic procedure consisted of identifying a human situation with an archetypal divine situation. For example: "My two arms are here on this child; the two arms of Isis are on him, just as she placed her two arms on her son Horus." The magic of laying one's hands on a child to

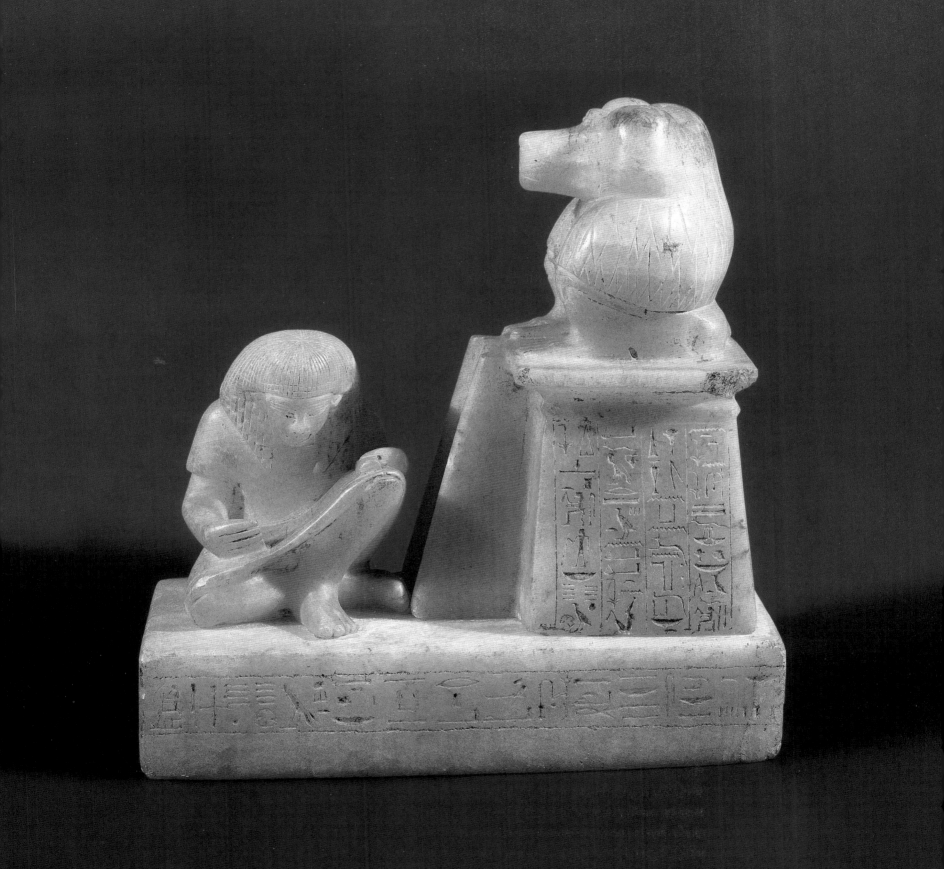

protect it was assimilated with the gesture Isis made long ago to heal her young son Horus. The gods were put in the service of human beings by the force of incantation.

If necessary, the gods were even blackmailed. To compel deities to chase away a bad spirit, the cause of a migraine, the magician prodded them by threatening their most basic attributes: "If you [the bad spirit] do not leave the forehead of X [the ill person] . . . I will cut off the head of a cow in the courtyard of the Hathor temple." The cow was the sacred animal of Hathor; therefore, it was in the goddess's self-interest to comply. Magic was a double-edged sword: the community used it in state religion to work with the gods in maintaining the world; the individual did not hesitate to turn it back against the gods for his own needs.

Dialogue with the Divine: In Search of Intercessors and Patron Saints

Let us refrain from reducing the relation between the individual and the god to mutual constraints imposed by one on the other. Simultaneously, a dialogue was initiated in which the god responded to the individual who petitioned him.

Whom did Egyptians call on for their personal problems? There was apparently an overabundance of choices in that myriad of deities, spirits, and various *numina*. All the same, natural considerations came into play: the individual needed to find a divine interlocutor, or one approaching the divine, who was geographically close if possible, but above all accessible, an interlocutor who did not discourage the poor human by being too arrogantly sacred. In very ancient times, the gods were intimidating, and the individual's relations with them were limited to the minimum: prayers, offerings, requests for children. The petty cares of life were entrusted to the dead.

The dead, provided that they were given effective funerary displays and equipment, could lay claim to the enviable status of *akh*, that is, "spirit." They could master magical techniques and thereby the capacity to intervene in the world of the living. Of course, people wrote first to the family's dead, leaving in the mortuary chapel a piece of cloth, or better, a bowl filled with food with a letter written on the side. The letter asked the deceased to transmit a request to the gods, or to settle shady family stories about which the deceased had something to say, since he had produced them out of feelings of revenge or irritation. "May you place an obstacle in the way of the enemies, men and

women, who have evil designs on your house, on your brother and your mother . . . [For] you are powerful on earth, you are effective in the necropolis," writes a mother to her deceased son. The last two sentences underscore the role played by the dead who had become *akh* spirits, go-betweens linking the earthly world and the hereafter. As late as the New Kingdom, stelae representing the dead of the family were sealed in family chapels and even in homes, where they were heaped with offerings and requests having to do with everyday life.

Personal religion, in its feverish quest for intercessors, moved from the family's dead to the dead in general, provided these dead were prestigious in some way. Toward the end of the Old Kingdom, posterity throughout Egypt began to select local or national personalities from the past as mediums between mere mortals and the powers supposedly governing the world. As a result, pilgrims flocked to their mortuary chapels, bringing various propitiatory gifts, setting up offering tables, erecting statues, or sealing stelae brick walls. They hoped not only to participate through these monuments in the cult worship carried out on behalf of these great men, but also to have their requests passed on to the gods, thanks to the mediation of such objects.

Mortuary priests were the source of these practices, and intended through them to supplement the contractual benefits of the mortuary cult they oversaw, by taking advantage of the high position of its beneficiary. As the venerable deceased was glorified in the oral tradition, however, the circle of the faithful grew, to such a point that the chapel became a center of devotion in competition with the temples and sanctuaries of gods.

In Saqqara, a vizier named Ptahhotep shared with his father, Akhethotep, one of the mastabas marking the visitor's obligatory itinerary. It was probably owing to the growing renown of his cult that he was named as the apocryphal author and guarantor of one of the most important wisdom texts that pharaonic Egypt has bequeathed to us. Kagemni had a similar fate: he was also a vizier, also the owner of a mastaba with the force of attraction, and he too was called upon to stand as guarantor of a wisdom text. There was one slight difference, however. He was presented as its recipient, not its author.

Much farther to the south, in Edfu, a nomarch named Isi, who served in the time of Pharaoh Teti (Sixth Dynasty), erected a mastaba, which was transformed into a pilgrimage site by virtue of the prestige he enjoyed in posterity.

Elephantine, the settlement perched on the rounded back of an island formed by a large granite

Following pages: The north gate (propylaeum) and ruins of the wall surrounding the temple of Hathor in Dendara.

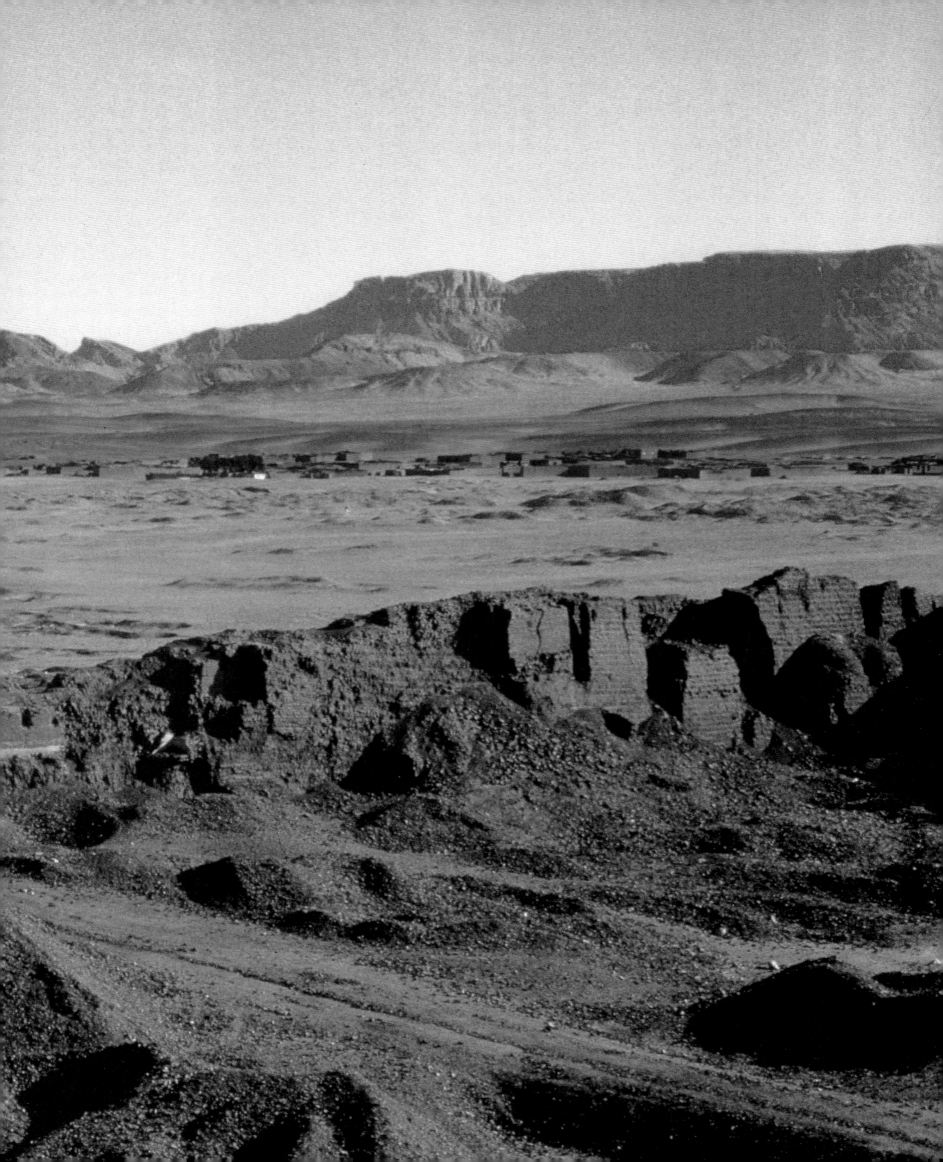

massif at the entry to the First Cataract, prided itself on the posthumous fate of its great man Heqaib, also called Pepynakht. Capitalizing on the renown of a brilliant expedition to Nubia under the reign of Pepy II, Heqaib became so well known that his mortuary chapel could no longer contain the devout, despite the renovations made. A sanctuary had to be built for him beside the temples of the great deities of the place, Khnum and Satis. Restored on several occasions, for four centuries it welcomed the petitions and monuments presented by leading elites to that local celebrity.

Posterity could be even more generous. Take the case of Imhotep and Amenhotep, son of Hapu, which the late tradition liked to pair up. Amenhotep came from a middle-class family in Athribis, a city in Lower Egypt. His fortunes changed when he was called to the court of Pharaoh Amenhotep III (c. 1391–1353 B.C.); having recognized his skill, the pharaoh entrusted to him nothing less than the responsibility for the huge public works projects in Thebes and elsewhere.

Through the grandeur and beauty of the monuments he built—simply put, they mark the acme of Egyptian civilization—Amenhotep, son of Hapu, earned a reputation as a divinely inspired sage especially because of his innovative work with large quantities of quartzite. He was showered with honors by his pharaoh, and by posterity, which promoted him to the rank of a god. A chapel was dedicated to him in the temple of Deir el-Bahri, and, until the Roman Era, the people of Thebes solicited his help in facing the worries of life.

He was paired with Imhotep (Greek form, *Imouthes*), whose destiny was even more fabulous. High priest of Ra and specialist in sculpture, Imhotep oversaw the construction of the gigantic complex of step pyramids for the pharaoh Djoser (c. 2677–2599 B.C.) in Saqqara. He was admired not only for the monument itself—which still produces astonishment—but also, like Amenhotep, son of Hapu, because of his innovations, in this case, the systematic use of stone, which until then had had a very minor place in architecture.

As a result of his popularity, which grew continuously until the Roman Era, a wisdom text was attributed to him, as was the construction of the temple of Edfu—an anachronism of two and a half millennia! A sector of Memphis was named after him and a large temple built for him there, supplied with lands and a large staff. Six feast days were celebrated in his honor during the year, and he received a libation poured by every scribe beginning his work—a veritable flood of the Nile, given the myriad "papyrus scribblers" in ancient Egypt. Finally, the god Ptah was named as his father,

On this New Kingdom stela, a man prays to Amun-Ra in one of the god's animal forms, "Amun the perfect ram," whose two facing representations adorn the arch. Often on monuments of personal piety, the attention of the god is magically captured by the six ears on the right half of the field. Through this stela, the god would supposedly listen to his believers' petitions.

which is not insignificant. Such divine paternity was unusual; in this case, it was also only partial, since Imhotep's mother, Kherduankh, was a mere mortal.

We come to an essential point regarding the status of these great men, who are often said to have been "deified." Is there good reason for that term? Of course, as Imhotep's ancestry indicates, they were recognized as having a share of divinity, but only a share. Their original humanity was never forgotten, however, and they were designated by ambiguous epithets such as "venerable patron, deified god" (sic), "vizier, living god," and so on. In fact, had they been entirely deified and their primary nature suppressed, their fundamental role would have been jeopardized, since they were supposed to act as a medium between the human and the divine.

These deified humans belonged to a category well known in the history of religions, a category that includes the patron saints of the Christian West and the sheiks of the Islamic world. The individual presented his requests to such beings because he believed it was more useful to address saints than God. The beliefs on which these cults rested appeared very clearly in Egypt. If these men had a glorious earthly life and, more important, if they distinguished it with exceptional feats or productive innovations, it was because they had the favor of the gods.

That favor made them excellent potential intercessors. They had the ear of the gods, but not their intimidating sacred character. Because they were men, even when dead they remained dependent on the living for their mortuary cult. One can surmise the bargain that was struck; the intercessor traded his credit with the gods for a few funerary offerings on the part of the person who wanted his request passed on.

Not a very mystical procedure. Yet some of these great men, such as Amenhotep, son of Hapu, were not ashamed to propose it in the inscriptions on their monuments:

> O people of Upper and Lower Egypt . . .
> Who come from the north and south to Thebes
> To implore the master of gods [Amun],
> Come to me, I shall transmit what you have said to Amun in Ipet-sut [Karnak].
> Make a funerary offering to me. Make a libation for me with what you have in your hand.
> I am an advocate such as the king names
> To hear the words of the unfortunate
> To bring forward the situation of Two Banks [Egypt].

This text is engraved on a statue depicting Amenhotep, son of Hapu, as a scribe holding a papyrus scroll, which is worn out from being touched by the hands of supplicants wishing to be permeated with the virtue of the texts by such physical contact.

Similarly, anyone who, lacking glory or adventure, could boast a few characteristics attributable to favor, claimed the rewarding and advantageous role of intercessor. Such was the case for bald men. Baldness, particularly on the top of the head (called "sincipital" baldness), was considered a mark of election given by the gods. Those who were afflicted with it traded on that defect, which was transformed into a mark of grace. For example, a provincial man from Middle Egypt, who lived near a sanctuary dedicated to the lion goddess Mehit, addressed visitors in the following words, inscribed on a statue depicting his baldness:

> I am a servant of the Mistress of Heaven
> A bald man from the land of Mehit, guardian of her temple precinct.
> I hear your requests . . .
> I convey them to Mehit, who reports back to me everything she has decided.
> I hear your requests so that you will travel in good condition,
> With your body preserved as it is, your homes filled with happiness, your children in good health.
> Therefore, place beer on my hand, bread on my arm, every day,
> Fill my lap with offerings and do not forget me in the circuit [of offerings]
> On every feast day in the land of Mehit, providing supplies daily.

Pharaohs did not perform this function of intercessor as easily as the dogma of divine filiation might suggest. Of course, sometimes funerary cults of pharaohs from the past continued long after their death. For example, in Middle Egypt, there were mortuary temples for rulers of the Old Kingdom such as Teti, Pepy I, and Pepy II. Usually, however, this was the result of political decisions, and the influence of the deceased king rarely extended beyond the narrow circle of his chief priests.

Only a few pharaohs were promoted by posterity to the rank of intercessor, for example, Sneferu of the Fourth Dynasty (c. 2561–2538 B.C.). His four pyramids dotting the Memphis plain, his expeditions to the Sinai mines, and above all, his image as a good-natured, pleasure-seeking monarch earned him long-lasting popularity.

Amenhotep I (c. 1514–1493 B.C.), the second king of the Eighteenth Dynasty, accompanied by

his mother, Ahmose Nefertari, became patron saints of the Theban necropolis because they had restored and revived classical culture. On the occasion of his feast day, which gave its name to one of the months of the year, the statue of Amenhotep was carried in a procession amid jubilation, and gave highly valued oracles.

During the New Kingdom, ideology devised a curious ruse for conferring the status of intercessor on the living pharaoh, through a kind of doubling of the personality. His emblems, primarily his cartouches but also some of his monuments, supposedly the hypostasis of one aspect of his divine personality, became the object of a cult practiced by the pharaoh himself, who became the intercessor for his loyal servants. The result was astonishing private stelae, where individual petitions were considered by the king, who had them pass before his own image, that is, a colossal statue of himself, in front of which he carried out one of the rites of the divine cult.

Gods of Personal Piety

That took a great deal of sophistication. Often, the believer, in his quest for an attentive ear to his requests, used much more simple means. To reach the gods, he quite simply addressed the gods directly. In principle, the individual could seek to establish a personal relationship with any deity he wished. Tradition obliged him to make certain adjustments, however.

It goes without saying that the divine personifications produced by abstruse theologies hardly tempted Egyptians anxious to assess the value of the donkey they planned to purchase or to find a cure for their headaches. A few gods specialized in such worries: for example, the god Shed, whose name signified "savior." Since exoticism was often the measure of mystery and efficacy, a Semitic word meaning "savior" was borrowed during the New Kingdom—it is present in the Hebrew name "Eleazar"—and became an epithet for divine forms of personal piety.

On the whole, however, personal piety was directed toward the major deities of "state religion," after a few adjustments and shifts, always in the same direction—toward the more visible and more concrete. In place of canonical representations of gods, elaborated and purified in rigorous conformity with schools of sacerdotal science, personal piety preferred accessible manifestations, judged particularly likely to be permeated with the power of the deity because of a particular trait.

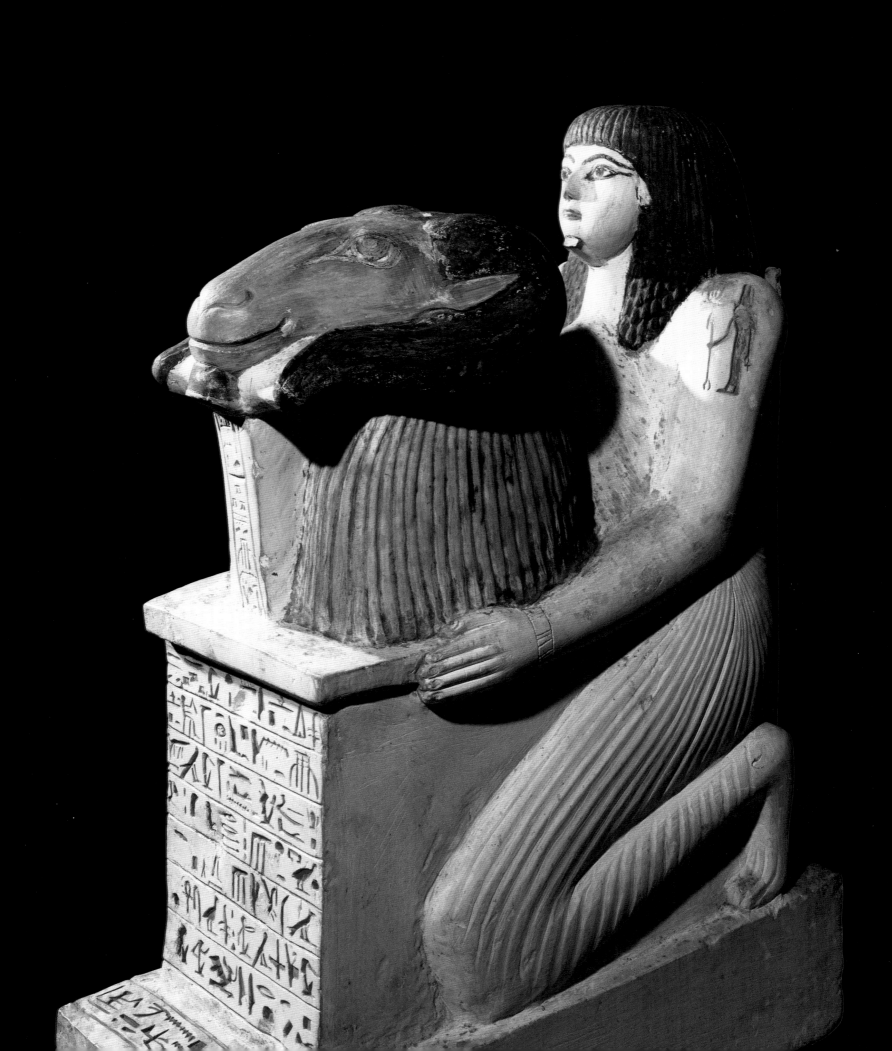

So it was that, in the temple of Sahure, a statue to the goddess Sekhmet, standing among other statues, was the object of devotion, though we do not know exactly why. In that case, one representation among the thousands decorating the walls was selected. A sumptuous display was the result: a frame driven into the stone, gold plating, and a setting of precious stones set the statue apart, designating it as an object of faith. Epithets defined the particular images under which the god soaked up pious effusions: "Amun of gold," "Amun of real lapis lazuli," "Ptah of the pillar," "Ptah of the great door."

The need the believer felt to provide himself with a concrete support for his relations with the gods explains the cult of sacred animals, which were considered "advocates" of the gods with which they were associated: Apis was the "advocate" of Ptah, and Mnevis was that of Ra. In performing that function, animals played the same role as deified men: there was no practical difference between the sage Imhotep, patron saint of intellectuals; and the monkey, the sacred animal of Thoth.

Although the drift toward animal worship was ineluctable in the Late Period, in early eras believers did not lose sight of the fact that behind the animal stood the god in all his power. It was this god who was worshiped, and often the monuments consecrated by believers proclaimed this, in the play between image and text. Such is the case for a stela whose arch is decorated with a male and female cat facing each other. These familiar animals should not mislead us. This was truly a religious object: the inscriptions identify the cats respectively as "the great merciful cat, in his great name of Aum when he lies down," and "the great cat of Pre."

In fact, myths tell us that the sun god, evoked under the names "Pre" and "Aum," took the form of a cat so that he could cut his enemy the snake into pieces. In addition, these animals were called upon to receive the request of an individual. The epithet "merciful" already leads us to expect as much, and the main text makes it explicit:

> Show your adoration for the Great Cat,
> Sniff the ground for Pre, the great god,
> The merciful, who changes his mind and forgives.

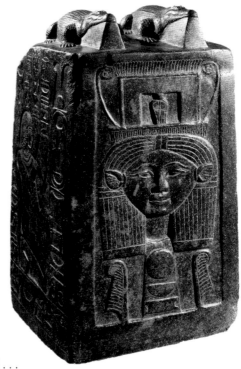

> May you allow me to see . . . thanks to what you have done.
> Let the light shine for me, so that I may see your beauty.
> Change your mind in my favor, my pretty one;
> Forgive me so that I may be at peace, O, you who know how to change your mind . . .
> May you give life, health, and strength.

Thus, the supplicant skillfully calls upon the inestimable power of the sun god through the most familiar of its manifestations: cats.

What places were propitious for such relations? The temple no doubt, but in a somewhat marginal way, since it was a closed space. This was especially true of the sanctuary, where the shrine stood with its cult statue of the god, which received the exclusive attentions of authorized priests. Not everyone who wished to enter could do so. At best, on solemn occasions the great mass of believers were relegated to the court of offerings, usually at the gates of the inner sanctum. There, at the foot of pylons, oratories were set up, temple offerings placed, and special rooms for healing opened for incubation and therapy. When part of the inner temple was dedicated to a form of devotion oriented toward personal piety, such as the temple of Amun-Who-Listens-to-Prayers within the temple precinct of Karnak, this part was located behind the sanctuary in the strict sense of the term, and its doors faced in the opposite direction.

Fortunately, the cult statue, the object in which the divine essence was most likely to dwell, came outdoors in a solemn procession on feast days, and there were many of these. It was at that time that petitions could be presented to the god and his oracles consulted. To keep the statue present in absentia, its itinerary was marked with chapels and small oratories. Many others were disseminated throughout the city, the countryside, the necropolis, and the desert fringe.

The entry to an ancient tomb was sometimes reused as a devotional site. Thus, in Assiut, in front of the subterranean portion of a tomb of a notable from the Middle Kingdom, more than six hundred stelae were erected as signs of personal piety. As we have seen, the deity found a receptacle to its liking in many places. In addition, the individual invited the god home to a small altar established in his house or, more comfortably, in a private chapel a few feet away. Such was the case

This rare monument links an individual with his favorite deities: Sobek of Sumenu, represented by two crocodiles; and Hathor, depicted by a sistrum that is decorated with a woman's head with cow's ears and is inserted into a monogram referring to the pharaoh Amenhotep III.

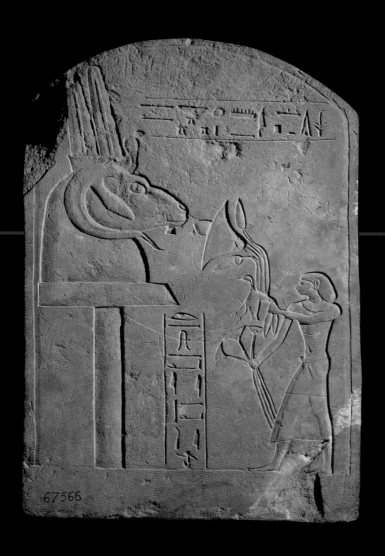

67566

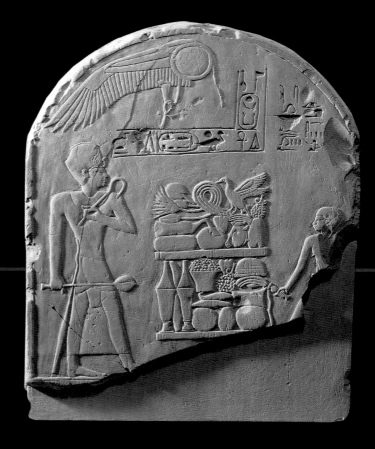

These four New Kingdom
stelae illustrate the use of
intermediate figures in the
communication between the
individual and the deity.

Above, the believer
addresses the god Amun
through one of his cult
objects, a standard bearing
a ram's head.

A stela dedicated to
Amenhotep I, second
pharaoh of the Eighteenth
Dynasty, whose prestige
was so great that he was
deified after his death. The
inhabitants of the west
bank of Thebes addressed
their petitions to him for
many centuries thereafter.

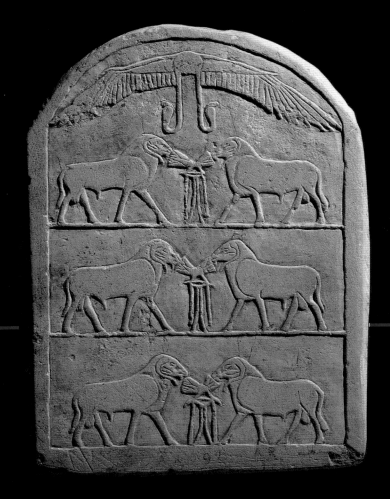

An anonymous stela, representing the rams of Amun breathing the fragrance of a lotus.

One of the of royal tomb workers addresses Amun and Mut through animals associated with them, the goose and the cat, respectively. The tomb-worker turned as well to the mediation of the royal son Wadjmes, son of Thutmose I, whose memory seems to have been alive among posterity despite his early death.

in the village of Deir el-Medina, where the chapel had an open courtyard, a covered hall with benches for ceremonies held by family or friends, a pronaos, a sanctuary, and even worship rooms.

The prayer was the most elementary form of a personal relationship with the gods, and a wisdom text recommended it daily, at sunrise, "To the disc when it rises you must make your prayer/Saying: 'Give me my full physical capacities and health!'/ So that it will give you your daily bread/And you will be safe from terror."

The prayer, reiterated whenever one wished to establish communication, was said out loud, standing up, kneeling, or lying facedown on the ground. It could be an act of pure adoration, or a prelude to other acts. The offering, whether a presentation of food, a libation, a burnt offering, or the burning of incense, complemented the prayer. When it took place in the temple during feast days, it was officially recorded, as the wisdom text of scribe Ani points out:

> Celebrate the feast day of your god,
> And do it again at its proper time.
> God is angry when someone ignores him.
> Take witnesses when you make the offering,
> The first time you do it.
> Someone comes to ask you to bear witness.
> Do so, and be recorded on the scroll.
> The time has come; we ask you for your receipt to exalt [god's] power.

There were many other times for making an offering. The ledger of the royal necropolis indicates that workers employed to decorate the pharaoh's tomb often abandoned their work because, in addition to illnesses that kept them in bed, their imperious religiosity forced them to set aside their tools and concern themselves with the altar instead. Such pious believers!

Prayers and offerings were only marks of submission, a tribute that was often a preliminary to more extensive communication. As in so many other civilizations, pharaonic Egypt considered dreams a privileged moment of contact with the "supernatural." Here again, an evolution can be perceived. In early times, the individual rarely entered into a relation with anyone but the dead, and only the pharaoh had the privilege of seeing gods appear to him in dreams. The New Kingdom abolished that distinction. Incubation became more widespread: the believer spent the night in the domain of his deity of choice, hoping it would appear to him in a dream to enlighten him.

On one surface of this
pyramidion a niche was
fashioned to receive the
raised-relief image of the
deceased in an attitude of
prayer. The dead person
was a very high-placed
individual, Ptahmose, the
high priest at Memphis.

Here, for example, is how one religious man addressed Hathor:

> I am a serv[ant] before his master.
> It is in your temple that I came into the world,
> The cave of Deir el-Bahri, near the temple of Menset.
> I ate offering cakes during feast days beside the great spirits [the dead].
> I walked in Set-neferu [Valley of the Queens]; I spent the night in your parvis;
> I drank water and broke the vessels on the curbstone in the parvis of Menet [a cave
> deep in the Valley of the Queens].
> I had my body spend the night, graced by the shadow of your presence;
> It was in your temple that I spent the night.
> I made stelae for the lords of Deir el-Bahri.

This is a description of incubation, mentioned among the practices of personal piety. It tended to become more widespread in the Late Period, when guilds of professional dream interpreters formed around incubation sites, offering—for a fee, of course—a more detailed and personalized service than what "keys to dreams" could provide.

Incubation was easy, but it did not allow the petitioner to formulate requests very precisely. Fortunately, there were other means. In addition to treatises on divination, which provided lists of portents based either on the calendar (menologies) or on meteorology, there was the local seer. But nothing was as valuable as the oracle.

Technically, the "oracle" was a codified procedure for publicly consulting the god; in that sense, it did not really appear until the New Kingdom. Before that, so-called oracles were simply prodigious, unsolicited signs or intimate contact, reserved for the pharaoh exclusively. In contrast with the Nineteenth Dynasty, the practice was institutionalized, and many oracles were given by a number of deities during their feast days.

At that time, their statues came outside in a solemn procession, placed in a bark borne by authorized priests. As one might imagine, this task was an envied honor. All these oracles were in competition with each other, and could be consulted concurrently. If a devout person was not satisfied with one, he consulted another and—why not?—a third.

During the ceremony, the god expressed himself through movements of the bark: if it tilted or came forward, he was giving his consent; if it retreated or did not move at all, he was denying the

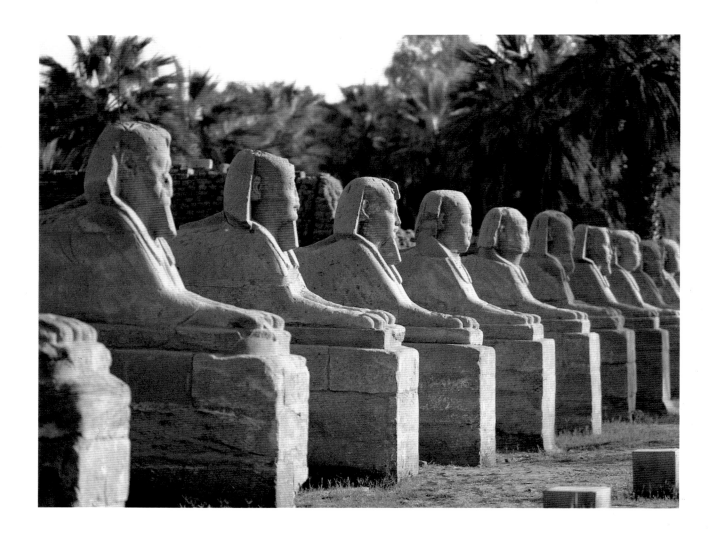

The processional paths that led to temples were lined with statues of sphinxes, which most often took the form of a human-headed lion (above), but sometimes were ram-headed lions (criosphinxes). The latter are found primarily at Amun temples, such as at Karnak, because one of the god's animals was a ram (opposite).

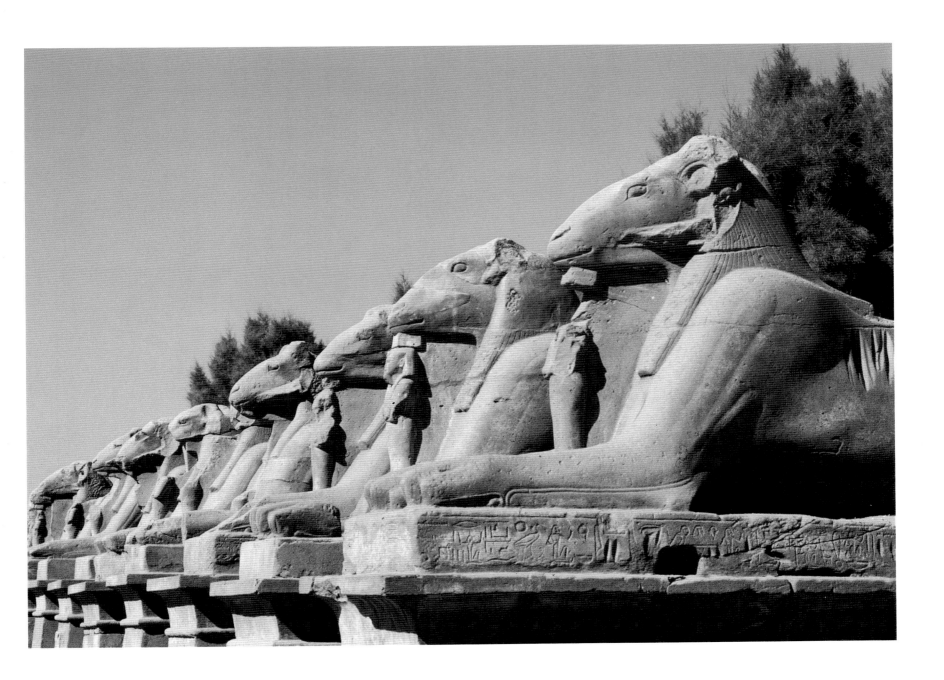

request. At any rate, that seems to have been the case, since the precise details are not known to us. In any case, the essential is clear: the oracle was fundamentally a dialogue. The believer invoked the real presence of god with the formula "Come to me!" and made his request. The latter answered him: the record of the oracle asserts that he truly spoke.

All the same, he did not manifest his will in the form of an actually uttered word. He confined himself to sanctioning with a positive or negative sign the question submitted to him on papyrus, ostraca, or tablets. Thus there was a restrictive procedure: sometimes a positive and a negative version were written on different tablets, and the oracle noted his approval in front of the one corresponding to his will. To designate a person, the petitioner had to list all the candidates possible before the oracle, until he decided to "signify" the one he had chosen.

The oracle's area of competence was very broad; he pronounced on nominations and on questions of law. At the end of the New Kingdom, with the advent of a new political theory—"theocracy"— according to which god reigned directly on earth, he even became the supreme agency to which the pharaoh was obliged to submit his government decisions. At the same time, however, from the time the institution of oracles was established until the end of pharaonic civilization, it remained the most developed form of dialogue between gods and the individual.

The individual held back none of the many metaphysical anxieties tormenting him: "Is this calf good [enough] for me to accept?" "Is he the one who stole the mat?" "Was the goat given to the water bearer Penpahapy?" "Will he designate me to take his place in his house?"

Dialogue

That sample of questions actually put to oracles illustrates in detail what was behind every form of communication between the Egyptian and the gods: the worries, however petty, of everyday life. Among all requests, two themes dominated, however: health and the desire for a child.

Requests for a child were repeated obsessively. A letter addressed to a dead man proposed to make offerings and recite funerary formulas, immortalized by being copied onto papyrus, in exchange for the following service: "May you present a request to the gods that living children be born, whole in

body and mind, in good health on earth, who will inherit my position on earth." The following was inscribed on a female figurine holding a child: "May your daughter Sehi give birth."

Of course, as in so many other civilizations, if a child was good, a son was even better. For example, there was this touching experience of a couple, desperate because they had only daughters. Fortunately, after being petitioned at length, Imhotep the deified sage gave in. He appeared in a dream to the husband, Pasherenptah, high priest of Ptah, to let him know that Imhotep was granting the desired son, on the condition that the sanctuary where his body lay be restored.

Behind these requests was not only the need that every person feels to have progeny but also the belief that it was the gods who determined procreation. As Egyptian texts with lists of names show, many proper names recall that their bearers came into the world because of a deity: "The deity X brought him (or her) into the world"; "The child the god X gave" "son (or daughter) of the deity X." The previously mentioned "Pasherenptah," for example, means "child of Ptah." Finally, these requests for a child were undoubtedly as frequent as they were because of a very high infant mortality rate.

Health also depended on the gods. Egyptians asked for health constantly, for themselves and their families. These general requests can be summed up in the wish, expressed a thousand times, to have a long life and to reach the ideal age of 110. In addition, recovery from accidents, illnesses, ailments, and infirmities was also at stake in the personal relationship with a god of choice. It was the practice to combine that request with an effigy of the god offered to him.

For example, Princess Merytneith, daughter of Pharaoh Psamtek I of the Twenty-Sixth Dynasty (664–610 B.C.), had a statue erected to the "deified" Amenhotep, son of Hapu, with the following inscription: "O Prince Amenhotep, son of Hapu, just of voice. Come, O good doctor. See, I am suffering in the eyes. May you heal me visibly. It is as payment for that [request] that I have made this [statue]."

Such a request was based on the principle of reciprocity: the god or intercessor answered the supplicant's request, and the supplicant in turn contributed to his glory with a monument or object representing him or evoking his personality. In the Late Period, gods were even offered mummified animals. But there is also a set of documents in which the request for healing was integrated into a much more elaborate view of the relation between the individual and the deity. These are stelae from the team of workers responsible for preparing the tomb of the reigning pharaoh, and whose village is visible even today on the site of Deir el-Medina.

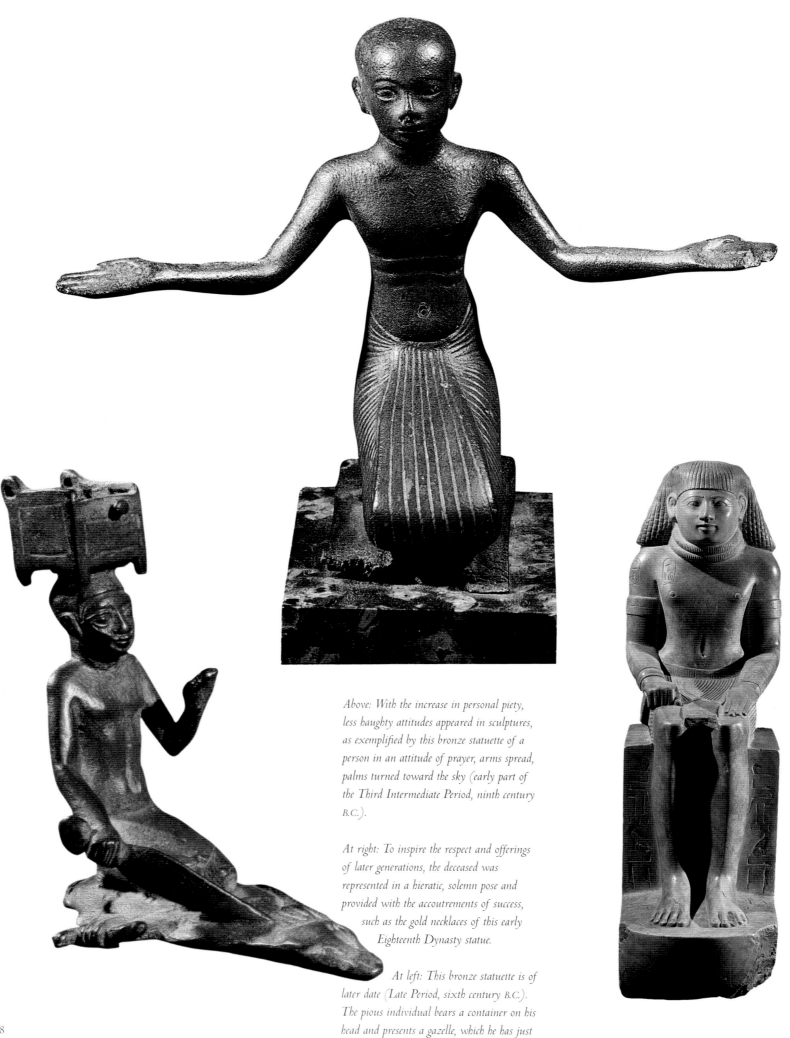

Above: With the increase in personal piety, less haughty attitudes appeared in sculptures, as exemplified by this bronze statuette of a person in an attitude of prayer, arms spread, palms turned toward the sky (early part of the Third Intermediate Period, ninth century B.C.).

At right: To inspire the respect and offerings of later generations, the deceased was represented in a hieratic, solemn pose and provided with the accoutrements of success, such as the gold necklaces of this early Eighteenth Dynasty statue.

At left: This bronze statuette is of later date (Late Period, sixth century B.C.). The pious individual bears a container on his head and presents a gazelle, which he has just sacrificed with the knife that he holds in his left hand.

The stelae tell us why they were erected: those who dedicated them were afflicted with an ailment, generally an illness or blindness, which they attributed to the punishment of a god angered by one of their misdeeds. Then the sinner repented, recognized the omnipotence of the offended deity, and begged for forgiveness:

> I am a man who bore false witness by Ptah, lord of justice.
> He made me see darkness during the day.
> I must tell of his power to those who know of it and to those who do not, to the mighty and the small.
> He made me like a dog in the street when I was in his power.
> He made men and gods look down on me,
> Like a man when he commits an abomination against his master.
> Ptah, lord of justice, has rightly inflicted punishment on me.
> Forgive me! Look down on me and forgive!

In this case, the stele mentions only the wish. There are others that tell of its being granted, after the deity's anger had dissipated and it had decided to heal the sinner. Take this one, dedicated to the Peak, the mountaintop overlooking the Theban necropolis, which was deified because of its imposing majesty:

> [I was] an ignorant man without a conscience;
> I did not distinguish good from evil.
> I committed the act of attacking the Peak.
> She inflicted punishment on me, and as a result I was in her hands
> At night and during the day.
> And I sat on a slab like a woman in childbirth,
> I called out for breath [healing], but it did not come to me.
> I poured libations on the Peak of the west, great in strength,
> And for every local god and goddess.
> I must say to the great and the small, who belong to the team [of royal tomb artisans]:
> "Beware of the Peak," for a lion dwells there.
> The Peak strikes with the blow of a ferocious lion,
> Pursuing whoever has attacked her.
> I called to my goddess. I found she came to me like sweet breath.
> She forgave me, after making me see her hand [her power].
> She changed her mind and forgave.
> She made me forget my illness . . .
> Because the Peak is merciful when one calls upon her.

In this text, the relation between the individual and the god is transfigured in a dialectic of sin and forgiveness. It is thus no longer a mere exchange of the proper procedures, the healing of a man in exchange for an increase in the god's renown. It is now a relation of one person with another, based on feelings:

> Just as it is known that the servant commits the sin,
> So it is known that the master forgives.
> This master does not spend a full day in anger.
> Although he becomes angry for an instant, his anger does not last.

Such a relation implies the individual's fear of god, but at the same time, a certain confidence, since the god is capable of mercy.

That is because he loves his creatures, especially when they show loyalty toward him. Forgiving sins is only one particular case of his predisposition toward helping them. In fact, the idea of the helpful god was forcefully asserted in the culture of the New Kingdom and illustrated in the most diverse ways. In one image, a provincial man from Assiut in Middle Egypt commemorated an episode during which his god of election, Wepwawet, had gotten him out of a very bad scrape: the jackal god used his spear to run through a crocodile, which was getting ready to bite into the devout man. In this case, the god saved someone from a chance danger.

Elsewhere, he was called upon to save the fool from his lack of inclination for study: "Thoth, come to me, decide for me;/ Make me knowledgeable in my trade [of scribe],/ For your trade is better than all [others]." In still other cases, the believer expects him to correct the waywardness of corrupt institutions:

> Amun-Ra, who brings help to the poor man in distress,
> Who makes the tribunal rule unanimously when it judges for the poor man.
> The poor man is awarded damages,
> And the man who took a bribe found at fault.
>
> . . . Amun, lend an ear to a man alone before the tribunal,
> And who is poor; he has no fortune [?],
> Yet the tribunal takes money from him to pay the mat scribe [a kind of clerk],

Following pages: Three
small pyramids in the
desert south of Giza.

> And clothing to profit the process server.
> May Amun transform himself into a vizier,
> To get the poor man out of it!
> May the poor man be awarded damages;
> May the poor man defeat the rich.

In the personal relationship he established with the deity, the individual stressed the humility of his position by presenting himself not only as a "servant," which was commonplace, but also as a "poor man," or even a "vagrant." This poverty was usually rhetorical, since it was claimed even by well-fed high dignitaries. Nonetheless, it served to express how the individual, aware of his weakness, was abandoning himself completely to the protective love of his personal god.

This idea developed in an interesting way. For example, the practice of the "gift of self" was a legal act by which a believer gave his deity all his possessions, in exchange for being accepted into the inner temple, where he found protection. This was a practice during the Ptolemaic Period, which might lead us to doubt its purely Egyptian character. However, it was, in fact, rooted in pharaonic culture. We know of similar actions in the New Kingdom. Witness the extraordinary spiritual journey of Samut, nicknamed Kyky, accountant in charge of the cattle of Amun:

> There once was a man from Heliopolis in the south [Thebes],
> A venerable scribe in Thebes, Samut, named after his mother, and nicknamed Kyky.
> And so his god instructed him and made him knowledgeable in his teachings.
> He placed him on life's path to protect his physical person.
> Then he [Samut] thought to himself that he would find himself a patron.
> He found Mut above all the gods,
> Shay and Renenutet [gods of destiny] were in her hands,
> The life span within her province, the breath of life under her jurisdiction,
> Everything that was created under her order.
> He said: "See, I give her all my possessions and all my acquisitions.
> I know she is useful, for I have seen it,
> And that she alone is effective.
> She took away my distress;
> She protected me in difficult times.
> She came, preceded by sweet breath, when I called her name."
> Given that a despoiler who opposed him is under her jurisdiction,

Of the magistrate when he did his damage, I say:
"However powerful he may be, he cannot cause injury,
For the matter is in the hands of Sekhmet the Great.
The scope of her actions cannot be measured,
No servant of hers can ever fall victim to chicanery."

This detailed, even literary autobiography posits a true partnership between the individual and the deity, sanctioned by a formal legal act: one party gives away his possessions; the other grants protection against the unrest and chaos of the world, and beyond. The two exchange love for each other.

Glossary and Index of Principal Deities

Amun In the early days of pharaonic civilization, Amun was only one of many gods—and not even the most important one—in an obscure province in the far south. But on two occasions, history favored Amun by entrusting the reunification of a splintered Egypt to his devotees. First, the important officials of the Theban province put an end to the First Intermediate Period by defeating their adversaries from the north and making Thebes their capital. In the early second millennium, that dynasty was supplanted by another, the Twelfth, also Theban, which promoted Amun to head god of the province. This province became the most powerful of all. Then, four centuries later, it was again a Theban dynasty that expelled the Hyksos occupiers and founded the New Kingdom.

The tributes from neighboring regions extracted by Egyptian imperialism benefited primarily Amun, the national god. His possessions and staff grew considerably, and his main temples, in Karnak and Luxor, were continuously expanded and embellished. The buildings and monuments that accumulated over hectares of land continue to tower over visitors even today. Amun, whose name means "the hidden one," was considered the driving power behind Ra the sun god, creator of the world. In that role, he bore the name Amunresonther (Amun, king of the gods).

His ascendancy was proclaimed in heaven. With the advent of theocracy toward the end of the Twentieth Dynasty, he also came to exercise it directly on earth, through his oracle. His cult spread in the Delta, particularly in Tanis, a city conceived to be the northern replica of Thebes. It also made inroads in the south, following a string of temples built across Nubia as far as Napata, capital of the land of Kush (Sudan). Nor did the indigenous dynasties that emancipated themselves from the Egyptian yoke during the dark ages of the Third Intermediate Period abandon Amun.

In his major form, which predominates in the temple of Karnak, Amun is depicted as a man wearing a crown with two tall plumes. In the temple of Luxor, Amun, called Amenemope, has the same ithyphallic appearance as the god Min. In later periods, Amun's statue was covered with a veil when it came out in a solemn procession, hence the term "aniconic (imageless) form" of Amun. His sacred animals were the ram and the goose. 31, 42, 52, 54, 58, 68, 69, 73, 74, 82, 99, 152, 163, 164, 166, 168, 169, 170, 171, 174, 180, 181.

Anubis Jackal or dog god, a reference to his function as tutelary deity of embalming, since such animals have a well-known predilection for feeding on cadavers, thus separating the corruptible (flesh, organs) from the incorruptible (bones) part of them. Anubis was recognized as a funeral specialist throughout Egypt. At the same time, he was the principal god of Hardai in Middle Egypt, called Cynopolis (city of dogs) by the Greeks. 34, 69, 119, 120, 180.

Anuket A goddess worshiped in Komir, south of Upper Egypt, and on the islands of Sehel and Elephantine, where she was part of a triad, alongside Khnum and Satis. She wore a headdress bristling with feathers, and the gazelle was her sacred animal.

Apis Name of the sacred bull of Memphis, who was the manifestation of Ptah. An animal was chosen for its particular traits as the mark of divine election. It spent a pleasant life, pampered by priests and believers, and, after a solemn funeral ceremony, was mummified in accordance with the most elaborate funerary rituals. The devout followers who mourned him showed no reluctance in fasting for long periods of time as a sign of grief. He was buried in the Serapeum of Saqqara, the catacombs discovered by Auguste Mariette. 26, 168.

Apophis Terrifying snake representing the constant threat that nonbeing posed for the created world. He stubbornly attacked the bark of the sun god. Seth or some other helper was no less stubborn in fighting him off. Yet Apophis's cause was not desperate since creation was destined to return to nothingness at the end of time. Apophis simply wanted to hasten the process. 34, 35, 86.

Aten The name Aten means "the disc." Akhenaten made the Aten the one and only god of his heretical religion. It was represented as a disk that offered the sign of life in its human-hand rays to humanity. 64, 97, 99.

Atum A demiurge, or solar god, often in the form of Ra-Atum, since creation began with the sun. Atum is also the setting sun, because his creative power was exercised especially during the sun's declining phase, to overcome the nocturnal period and ensure a new sunrise. His name is formed from a verb meaning "to be complete." Generally represented in human form, Atum took the eel as his sacred animal. Although he is the cornerstone of Heliopolitan cosmogony, his primary cult was located in the eastern Delta in the city of Pithom, which means "home of Atum." 45, 73, 75, 78, 79.

Bastet Cat goddess originally worshiped in the eastern Delta, in the city of Bubastis. The name of the city is a Hellenized form of the Egyptian toponym "home of Bastet." In the Late Period, Bastet's popularity led to a proliferation of sanctuaries, such as the one recently excavated in Saqqara, which has galleries filled with cat mummies. 32, 38, 66.

Buchis Sacred bull of Armant, manifestation of the god Montu.

Geb God of the earth, part of the second generation after the demiurge in the Heliopolitan cosmogony. He is represented as a man, with his sister and wife, the sky goddess Nut, arching over him. 78.

Hapy Spirit personifying the fertilizing inundation, represented as an obese man. A hymn composed to Hapy survives in a papyrus document. 24, 123, 126.

Harakhtes Hellenized form of the Egyptian Horakhty (Horus of the two horizons). 52, 69, 97, 106, 114.

Harendotes Hellenized form of the Egyptian Hornedjitef (Horus avenger of his father), referring to the young Horus who exacted revenge from Seth for the murder of their father, Osiris. 66.

Harmachis Hellenized form of the Egyptian Horemakhet (Horus in the horizon). 73.

Haroeris Hellenized form of the Egyptian Harur (Horus the Elder). Solar manifestation of Horus and equal partner of Sobek in the temple of Kom Ombo. 58, 77, 84.

Harpocrates Hellenized form of the Egyptian Horpakherd (Horus the child), one of the deities of choice in the populist fervor of the Late Period. He had the appearance of a young boy with the characteristic sidelock of youth and his finger in his mouth. 49.

Harsiesis Hellenized form of the Egyptian Horsaset (Horus, son of Isis). 69.

Harsomtus Hellenized form of the Egyptian Harsamtawy (Horus who unites the two lands). In the city of Dendara, this god was a particular incarnation of Horus the child as god of kingship.

Hathor Translated as "house of Horus," Hathor's name refers to her oldest function as goddess of the sky, where the sun's journey took place. She was probably the Egyptian incarnation of a very old symbolic theme—the sun disc between the horns of a cow—widespread from the Nile to the Sahara. In fact, the goddess was usually represented as a cow or with a human face and the ears of a cow. That animal was the nurse par excellence, since it produced milk. Hathor was thus the goddess of maternity and, moving up the chain of causality, the goddess of love. It was she who inspired love in young people. She was also the goddess of the feast and drunkenness, which are associated with love. Secondarily, the function of destructive fury was attributed to her, as to the majority of goddesses. She was also the funerary goddess of the west. Among her many cult sites, let us note Memphis, where she was "lady of the sycamore," and Dendara, where her temple is in a remarkably good state of preservation. 24, 26, 30, 31, 36, 43, 54, 68, 69, 71, 83, 84, 93, 106, 158, 169, 173.

Heka Personification of magical powers. 45.

Hermuthis Greek form of the Egyptian name Renenutet. Cobra goddess, who was considered a good spirit because she was the lady of granaries and food.

Heryshef (Hellenized form, Arsaphes) Ram god, worshiped in Herakleopolis Magna in the southern part of Faiyum. There, the animal represents both fertility and also the monarchy because of the majestic way it wears its horns like a crown. Hence the frequent epithet "god of the two lands," "ruler of the two banks." 34, 54.

Horus Falcon god, whose name is formed from the verb her, "to be above." Fundamentally, Horus represents the assertion of superiority, both physical and social. His physical superiority is evident in his role as god of the sun, toward which the falcon rises ineluctably in its imperious flight. The god manifests himself in several syncretistic forms: Horus-Ra, Ra-Horakhty, or simply Horakhty (Horus of the two horizons), that is, the opposite poles of the celestial journey of the sun. He also manifests himself as Horemakhet (Horus in the horizon) or as Haroeris, not to mention the deities linking the sky and the moon, such as Horus-Khenty-Irty in Letopolis or Horus-Merti in

Pharbaitos. In terms of social superiority, the king was a manifestation of Horus as of the predynastic period, and ideology perpetuated that expression of supremacy, which was at the very heart of the pharaonic role.

In the myth of Osiris, Horus symbolized more specifically the dynamic principle through which a state of inferiority contained the potential for a superiority to come. In fact, the young child, posthumous son of Osiris, finally transcended his weakness to become victorious.

Several divine forms crystallized around this myth. Harendotes, Hellenized form of Hornedjitef (Horus avenger of his father), Harsiesis, Horus, son of Isis), and above all Harpocrates (Horus the child). Harsomtus is a synthesis of the Horus of Osirian myth and of the Horus who is god of the monarchy.

The cults of Horus were widespread throughout Egypt. He was worshiped in cities such as Edfu and Nekhen from the beginnings of pharaonic civilization; in addition, his cults proliferated when local gods were reinterpreted, as was the case for Horus-Khenty-khety in Athribis, for example. 12, 20, 34, 43, 49, 54, 55, 58, 60, 63, 66, 71, 73, 83, 86, 123, 126, 137, 153, 156, 158.

Hu Personification of the demiurge's creating word; 45.

Isis A sky goddess, who owed her popularity to her dual role in the myth of Osiris. First, she was the model wife who conducted a relentless quest to find her husband's body parts, which Seth had scattered. Then, she performed the necessary funerary rites on the recomposed cadaver and perpetuated her husband through the son she conceived by him posthumously. Second, Isis was a model mother who saved her son from Seth's persecution by hiding him in the marshes of Chemmis. She tended to Horus continually so that he would reach maturity despite the thousands of dangers (primarily scorpions) that threatened him. It is true Isis was well equipped for the task, since she was an expert magician, who did not hesitate to use her art against the god Ra in person. 24, 25, 28, 32, 35, 52, 58, 64, 69, 73, 78, 119, 123, 136, 153, 156, 158.

Khenty-khety Crocodile god of the city Athribis in Middle Egypt, reinterpreted as Horus and Osiris under the names Horus-Khenty-khety and Osiris-Khenty-khety. 54, 60, 71.

Khepri The name, which means "he who comes into existence," is derived from a verb written with the hieroglyph for the scarab beetle. Representing the rising sun, this god thus has the scarab beetle as its face or as its headdress. 27, 45, 73.

Khnum A god that took the form of a ram, its horns extending horizontally from either side of the head. Khnum had cults in the Memphite plain, in Middle Egypt at Hypselis, on the east bank in Herur (located in Roman Antinous), and much farther south, in Esna and especially Elephantine, just beyond the First Cataract. This last site perhaps accounts for his function as lord of waters. Khnum was primarily a creator god, however, who modeled the primordial egg and living beings, even the pharaoh, on his potter's wheel. 34, 54, 69, 73, 163.

Khonsu Originally a moon god, Khonsu was prone to sudden and violent outbursts. His name means "he who crosses," probably an allusion to the moon's journey across the sky. The damage caused by his "massacres" are the subject of a particular notice in a medical treatise, which is astonishing because in our times the moon has peaceful and agreeable connotations. During the New Kingdom, Khonsu was integrated into the Theban triad as the son of Amun and Mut. His temple is well preserved in the southern part of the walled city of Karnak. He was worshiped there, particularly under the name Khonsu in Thebes-*neferhotep*. Neferhotep was an epithet, and later the name of a god of Upper Egypt, probably meaning "whom it is good to appease." Khonsu was usually represented at Karnak as a child wearing the moon disc on his head. 73, 152.

Maat Personification of both the cosmic and social orders set in place by the demiurge. The pharaoh was responsible for its maintenance before the gods. Thus, the rite par excellence that the pharaoh performed on their behalf was the offering of the Maat, represented by a statuette of a woman wearing an ostrich plume. 45, 86, 88.

Mahes The name, whose Hellenized form is Miusis, means "wild lion." Mahes was the lion god of Leontopolis in the eastern Delta.

Meretseger Her name means "she who loves silence." Cobra goddess haunting the "peak of the West," the rocky mountaintop that dominates the Theban necropolis, one of the best-loved deities of royal tomb workers. 24, 69.

Min God of fertility. His principal cults were located in Upper Egypt, particularly in Akhmim ("Panopolis" in Greek because it was identified with the god Pan) and in Koptos, a city from which expeditions to the Arabian desert and the Red Sea began. Thus, Min was also the tutelary deity of desert regions. He was represented as ithyphallic, wearing a close-fitting garment, an aspect he shared with Amun. 54, 60, 69.

Montu A deity who took the form of a falcon, Montu

was worshiped primarily in the Theban region. He was the unsuccessful rival of Amun for supremacy over Thebes. Montu thrived, nonetheless, not only in his temple in Karnak, north of the temple of Amun, but also in Tod, Medamud, and Armant. Montu was the national god of war. 58, 68, 69.

Mut A goddess of war who was promoted to Amun's wife, Mut had a temple at Karnak, south of her husband's, and a sacred lake called Asheru, which was shaped like a crescent and associated with cults of lion goddesses. 32, 54, 74, 171, 181.

Neith Archer goddess of Sais in the Delta and of Esna in Upper Egypt. Her theology presents her as a form of the primeval ocean. Her sacred animal was the perch (*lates*). 35, 38, 43, 79.

Nekhbet Vulture goddess whose cult was situated at the modern site of Elkab, opposite Hierakonpolis (local deity, Horus). During the Predynastic Era, Elkab was the capital of a kingdom. Hence, in the pharaonic era, Nekhbet of Upper Egypt was one of two tutelary goddesses of the monarchy, sharing her position with the cobra goddess Wadjyt of Buto in Lower Egypt. 12, 25, 32.

Nephthys Sister of Osiris, Seth, and Isis, she assisted the latter in mourning Osiris and presiding over his funeral. 35, 69, 78.

Nun Primeval dark, stagnant ocean in which the demiurge suddenly became aware of himself and shook off his torpor to create the world. By metonymy, Nun is often called the "father of gods." 75, 79, 82, 83, 86.

Nut Sky goddess, represented as a woman arching over her husband, Geb, god of the earth. Nut swallows the sun and stars in the evening and gives birth to them in the morning. Another means to express that cosmic appetite was her depiction as a sow. On the underside of sarcaphagus lids she is rendered as a woman, thus suggesting that the sarcophagus was considered a microcosm. The deceased is protected from the outside by the sky goddess, just as the world is protected from the surrounding nonbeing. 24, 25, 38, 78, 114.

Onuris Hellenized form of Egyptian Inhert (he who brings back the distant one), an allusion to Onuris's role in the myth of the eye of the sun. Onuris worked to bring back to Egypt the goddess of the eye of Ra, who had fled to Nubia. Onuris had two principal cult sites, Thinis in Middle Egypt and Sebennytos in Lower Egypt. 69.

Osiris One of ancient Egypt's most important deities,

Osiris owed his renown to the myth, with its countless variants, about his murder by his brother, Seth. Osiris's body was cut into pieces and scattered across Egypt. Osiris's wife, Isis, collected the parts and recomposed the macabre puzzle into a cadaver. The body's reproductive powers persisted long enough for Isis to conceive a son, Horus, who was called upon to avenge his father and reclaim his throne.

A fundamental concept of Egyptian thought lay behind this myth, namely, that death is only an unavoidable phase in the biological cycle and leads to rebirth, provided that necessary precautions are taken. As a result, Osiris is the god of the dead who lives in the underworld. Osiris is also the god of vegetation: plants wither only to germinate anew. He is lord of the Nile, which, fed by humors emanating from the decomposition of his body, produces the regenerative inundation. Osiris is also a lunar god because the waning moon is replaced by a new moon. Osiris is even the god of the sun during its nocturnal phase because that temporary disappearance brings on a new sunrise.

In ancient times, the cult of Osiris undoubtedly took root in Busiris, where it supplanted the cult of the god Andjety, then spread to Abydos, where Osiris was assimilated with Khenty-imentiu, "chief of the westerners." It also took root in Memphis, where he was assimilated to Ptah-Sokar, and then in all the necropoleis in Egyptian territory. In the Late Period, the religious fervor surrounding Osiris was so great that every local cult had its own set of Osirian beliefs, which were illustrated and codified in sanctuaries and rituals. These local cults were relatively autonomous. 49, 51, 68, 69, 70, 73, 78, 106, 111, 113, 114, 119, 120, 123, 137, 143, 148.

Ptah Ptah was represented as a mummy, bearded, wearing a skullcap, and holding a scepter. Probably a god of craftsmen and skilled labor, Ptah had his major cult site at Memphis. That association explains his demiurgic role. According to a cosmogonic tradition in a famous text, Ptah was the "stone of Memphis theology" who created the world by thought, then by realizing that thought in an oral formulation. Because Memphis grew during the New Kingdom, Ptah became one of the great national gods. Thus, he had a temple inside the city walls of Karnak and sanctuaries on the west bank of Thebes and in Abydos. As a creator god, Ptah—often in the form Ptah-Tatjenen through his assimilation with a god of the earth responsible for the world's origin—was the guarantor of kingship. He was also identified with Sokar early on, a funerary god of the Memphis region, and by this very fact with Osiris, in the syncretistic form Ptah-Sokar-Osiris. 52, 54, 63, 68, 69, 79, 163, 168, 177, 179.

Ra The primary solar deity. His name means "sun"

in Coptic, and the hieroglyph of his name is used for both the word "day" and a determiner in notions of time. His major cult was in Heliopolis, and his prestige was such that a number of local theologies manifested the solar character of their deity by a syncretistic designation, such as Amun-Ra, Horus-Ra, Khnum-Ra, Montu-Ra, Shu-Ra, and Sobek-Ra. 43, 45, 52, 58, 68, 69, 73, 77, 83, 97, 106, 114, 119, 163, 168, 169, 180.

Satis Goddess of Elephantine, Satis wore the white crown adorned with two antelope horns. She was integrated into a local triad alongside Khnum and Anuket. 54, 60, 69, 163.

Sekhmet (Hellenized form, Sakhmis) Sekhmet's name means "she who is powerful": it is obviously programmatic, since this lion goddess represents the savage power the animal unleashes in her attacks. That power was put to the service of the created world in the many causes she had to defend. Identified with the eye of Ra, Sekhmet ferociously quashed the human revolt in the long-forgotten past, when the sun god reigned on earth. When the pharaoh replaced the sun god on earth, Sekhmet put herself in the king's service, lending her destructive power to his *uraeus* or crowns and participating with ferocious joy in the slaughter of enemy tribes. She was also the creator's armed agent when he punished his creation. The evil actions of men were listed on a registry, and the punishments related to them entrusted to Sekhmet. She divided them up among her cohorts, the "slaughterers," who brought pestilence, plague, and illness in accordance with the calendar. Although she unleashed them especially in times of transition, in particular during the five "epagomenal" days marking the passage from one year to the next, she also reserved a certain amount of pain for each day. That explains the hundreds of statues erected by Amenhotep III representing two forms of the goddess for every day of the year. 24, 34, 38, 54, 156, 168, 184.

Selkis (Hellenized form of the Egyptian Serket) A goddess represented as a woman with nepid (benign water scorpion) on her head, Selkis was a protector from scorpions. One of the terms designating the magician responsible for protecting against these creatures was "conjurer of Selkis." 35.

Seshat Goddess of writing and architecture; her name is related to a verb meaning "to write." She had a composite emblem made up of a rosette and a crescent, which perplexed not only Egyptologists but the ancient Egyptians themselves, who had lost its original meaning. It was reinterpreted as an epithet for the goddess, Sefkhet-abwy. 59.

Seth The roles of this god were as curious as his appearance: a fantastic animal with a long and tapered muzzle. Seth represented the troubling destructive powers of the desert. He was fundamentally a destroyer, incarnating disorder intrinsic within all being and necessary for its dynamic. His abilities serve the cause of righteousness when, in the bow of the solar bark, he used them to annihilate the menacing snake Apophis. Seth was destined to play the role of obligatory troublemaker in the originally lunar myth of the eye of Horus. He damaged that eye, and in retaliation, Horus tore off his testicles. That incident explains the cycle of the moon, which periodically moves from the invisible to the visible. The waning phase can be attributed to the disorder inherent in creation, the waxing phase to the neutralization of disorder. But it was the myth of Osiris that offered Seth his most spectacular role. He was both the murderer of Osiris, his brother, and the relentless persecutor of Horus, sired posthumously by Osiris. Seth subjected Horus to every ordeal imaginable, even drawing him into a homosexual relationship. But in the end, he could not prevent him from recovering his father's throne.

Seth had cults across Egypt, the most important in the city of Kom Ombo in Upper Egypt and in Avaris in the eastern Delta. The Nineteenth Dynasty originated in Avaris, and two of its pharaohs bore the name Seth. Seth was raised to the rank of national deity next to Amun, Pre, and Ptah. But the infatuation with his evil side from the Osirian myth sealed his fate from the Third Intermediate Period onward. Seth was systematically identified with evil and foreign oppressors, his representations were mutilated, his name proscribed, and his cults banished or absorbed in religious syntheses. 34, 43, 49, 55, 60, 68, 69, 73, 78, 86, 123, 137.

Shu In the Heliopolitan cosmogony, Shu held a privileged place since, with his sister Tefnut, he formed the first couple created by the demiurge Atum. Shu represented sexual difference and the principle of differentiation in creation. It was he who stood up to separate the sky from the earth. He was the light that dawned in the space thus constituted, and, quite simply, the principle of life. Several local theologies merged their deities with Shu; hence there was Onuris-Shu, Khonsu-Shu, Khnum-Shu, Thoth-Shu, among others. 69, 73, 75, 78, 79, 82.

Sia Personification of the creator god's perception. 45.

Sobek (Hellenized form, Suchos) The most popular of the crocodile gods, whose cults were scattered across Egypt. The most important were in the Faiyum, a depression where a tributary of the Nile empties into a lake of brackish water. One can easily imagine how a god who manifested himself as an aquatic monster measuring

more than 19⅔ feet (6 meters) in length was fundamentally a lord of waters. The personality of Sobek was enriched, however, through assimilations with other deities. In the Middle Kingdom, his supremacy over the fauna of the rivers and lakes made him a form of Horus, under the name Sobek of Shedyet (Crocodilopolis, capital of Faiyum) or Horus-who-resides-in-Shedyet. In very ancient times, he was identified with Ra in the form Sobek-Ra; later, he was particularly valued as an accomplice or manifestation of the creator god, slaughtering anyone who attempted to oppose him in the primeval waters. 14, 17, 34, 58, 71, 73, 84, 169.

Sokar (or Sokaris) Originally the god of craftsmen, Ptah became god of the Memphis necropolis in the syncretistic form Ptah-Sokar, Sokar-Osiris, and Ptah-Sokar-Osiris. Depicted in human or hawk-headed form, he seemed especially to represent the emergence of the sun and moon from the earth. During the New Kingdom, his cult was marked by a procession around the city walls and by the hauling of his sacred bark (the *henu*), which was transferred to Thebes. There it was integrated into funerary beliefs, and more particularly into the complex ritual of the month of Choiak. 21.

Sopdu Sopdu's name, which means "pointed one," evokes the sharp talons of the hawk, which was his usual form. His warlike nature corresponded to the location of his principal province, the Wadi Tumilat, which was one of the passageways between Egypt and Asia. It was thus a borderland to be entrusted to a deity capable of repelling invaders. 24, 60, 123.

Tanen/Tatjenen The variation in the name of this god is significant. It suggests the dynamic process by which the "sunken land" (*Ta nen*), undifferentiated before creation, became the "risen land" (*Ta tenen*) at the birth of the world. This eminently chthonic god was assimilated with Ptah and Osiris.

Tefnut Female counterpart of Shu and thus the foremost female representation after the demiurge created sexual difference, Tefnut was identified with the eye of the sun, "the distant one." She fled her master, going far into the desert regions of eastern Nubia. As daughter of the demiurge, Tefnut worked to keep her father's sexual desire constantly awakened, since that urge was the origin of creation and the condition for its functioning. Thus, Tefnut was identified with Maat. 75, 78, 82.

Thoeris Hellenized form of the Egyptian Taweret, "the corpulent one." Hippopotamus goddess, protector of women in childbirth. 34, 69.

Thoth Represented either as an ibis or as a baboon, Thoth was primarily responsible for the quantifiable and codifiable. He was the one who divided reality into discrete units. God of the moon, Thoth ensured the regularity of its cycle by reconstituting the eye of Horus that had been mutilated by Seth. Responsible for periodization, Thoth inscribed the years of the pharaoh's reign on the *ished* tree. He controlled calculation, metrology, and the basic unit of length, the cubit, which was the regular gait of the ibis. Lord of the word and of its visual codification in writing, Thoth was the scribe of the gods, especially in the famous scene of the "judgment of the dead." He was tutelary deity of scribes, supposedly the original transcriber of all the sacred writings. Thoth's role as scholar and magician, particularly developed in Ptolemaic and Roman traditions. The archetype of the vizier or prime minister, Thoth oversaw records and judicial procedures. His principal cult was in Hermopolis Magna, a city in Middle Egypt, well-known in modern times for its ibis necropolis. Thoth was also the major god of Hermopolis Parva in the eastern Delta. He had several cult sites in Nubia, including the city of Pnubs, because myth made him one of the gods who brought back to Egypt the eye of the sun, which had been exiled in the southern regions. 24, 32, 45, 48, 49, 59, 68, 69, 86, 137, 156, 168, 180.

Wadjyt (Hellenized form, "Uto") Cobra goddess of the city of Buto in the northern Delta, an ancient capital from the early dynastic period. The *uraeus* spitting fire at the pharaoh's enemies, she was elevated to the goddess of the monarchy and symbolized Lower Egypt in its union with Upper Egypt, which was represented by Nekhbet. 34, 66, 150.

Wepwawet This name, whose Hellenized form is "Ophaïs," means "opener of the ways." It originally designated a standard depicting a canine (dog/wolf/jackal), which was brandished at the head of an army column or of a procession. Wepwawet's bellicose character was placed in the service of Osiris. He became Osiris's son in the ceremonies of Abydos. In addition, Wepwawet was the principal god of Asyut in Middle Egypt and of its necropolis, Raqerret. 180.

Annotated Bibliography

Most of the monuments that have come down to us had a more or less direct religious purpose. This is simply because the ancient Egyptians built such monuments to last, using materials less perishable than those used for objects and buildings of everyday life. Is it any wonder, then, that the bibliography relating to Egyptian religion is vast? Since exhaustivity is clearly out of the question, I have confined myself to choosing publications that are the most significant in their field, the most recent, and, as much as possible, the most accessible. In principle, only books are listed, though I did not hesitate to mention articles when the state of research required it.

Research Tools

Readers wishing for further knowledge on the subject may consult W. Hovestreydt and L. M. J. Zonhoven, *Annual Egyptological Bibliography* (Leiden, 1947–). The last volume appeared in 1997; it inventories publications for the year 1994. All Egyptological publications for the year are listed by topic, with a special section devoted to religion, as might be expected.

The sum of Egyptological knowledge is also available in the form of a scholarly encyclopedia, organized alphabetically, which treats all aspects and realia of pharaonic civilization and includes a detailed bibliography: *Lexikon der Ägyptologie*, 7 volumes, plus supplements (Wiesbaden, 1975–1992).

Detailed Reflections on Egyptian Religion and Analyses

I focus primarily on the work of three Egyptologists— J. Assmann, P. Derchain, and E. Hornung. Obviously, I cannot list all their writings, but here is a selection:

Assmann, J. *Ägypten: Theologie und Frömmigkeit einer frühen Hochkultur.* KohlhammerUrban-Taschenbücher 366. Mainz, 1984.

Derchain, P. "La religion égyptienne." In *Histoire des religions I*, edited by H. C. Puech. Encyclopédie de la Pléiade, 29. Paris, 1970, pp. 63–140.

———. Various articles in *Dictionnaire des mythologies*, vols. 1–2. Edited by Y. Bonnefoy. Paris, 1981.

———. "Der ägyptische Gott als Person und Function." In *Aspekte der spätägyptischen Religion*, edited by W. Westendorf. Göttinger Orientforschungen, 4. Reihe: Ägypten, 9. Wiesbaden, 1979, pp. 43–45.

Hornung, E. *Conceptions of God in Ancient Egypt: The One and the Many.* Translated by J. Baines. Ithaca, 1982.

———. L'esprit des pharaons. Paris, 1996.

Surveys

Bonnet, H. *Reallexicon der ägyptischen Religionsgeschichte.* Berlin, 1952.

Dunand, F., and C. Coche-Zivie. *Dieux et hommes en Égypte, 3000 av. J.-C.—395 apr. J.-C.: anthropologie religieuse.* Paris, 1991. A book designed for use at the university level, perfectly suited to its objective.

Erman, A. "La religion des égyptiens." In *La Civilisation Égyptienne.* Translated by Charles Mathieu, edited by A. Erman and H. Ranke. Paris, 1952. An old book, but still valuable for the volume of facts presented.

Morenz, S. *Egyptian Religion.* Translated by Ann E. Keep. Ithaca, 1973. The religious phenomenon from the partial but stimulating perspective of a theologian and Egyptologist.

Quirke, S. *Ancient Egyptian Religion.* London, 1992. A very clear overview, richly illustrated with objects from the British Museum.

Religious Thought and the History of Ideas

Assmann, J. *Zeit und Ewigkeit im alten Ägypten: Ein Beitrag zur Geschichte der Ewigkeit.* Abhandlung der Heidelberger Akademie der Wissenschaften, phil.-hist. Klasse, 1. Heidelberg, 1975.

———. "Denkformen des Endes in der Altägyptichen Welt." In *Das Ende: Figuren einer Denkform*, edited by K. Stierle and R. Warning. 1996, pp. 1–31. Eschatology.

———. *Egyptian Solar Religion in the New Kingdom: Re, Amun and the Crisis of Polytheism.* Translated by Anthony Alcock. London, 1995.

———. *Maât, l'Egypte pharaonique et l'idée de justice sociale: Conférences.* Paris, 1989.

Assmann, J., and D. Hellholm, eds. *Apocalypticism in the Mediterranean World and the Near East.* Proceedings of the International Colloquium on Apocalypticism, Uppsala, August 12–17, 1979. Tübingen, 1983. Eschatology and prophecy.

Englund, G., ed. *The Religion of the Ancient Egyptians: Cognitive Structures and Popular Expressions.* Acta Universitatis Upsaliensis Boreas, 20. Uppsala, 1989.

Hornung, E. *Geschichte als Fest: Zwei Vorträge zum Geschichtsbild der frühen Menscheit.* Darmstadt, 1966.

Otto, E. *Das Verhältnis von Rite und Mythus im Ägyptischen.* Heidelberg, 1958.

———. *Wesen und Wandel der ägyptischen Kultur.* Verständliche Wissenschaft 100. Berlin and New York, 1960.

Religions en Égypte hellénistique et romaine: Colloque de Strasbourg 16–18 mai 1967. Paris, 1969. Writings from the Centre d'Etudes Supérieures de Strasbourg, specializing in the history of religions.

Vernus, P. "La grande mutation idéologique du Nouvel Empire: Une nouvelle théorie du pouvoir politique: Du démiurge face à sa création." *Bulletin de la Société d'Égyptologie de Genève 19* (1995): 69–95.

———. *Essai sur la conscience de l'Histoire dans l'Égypte pharaonique.* Bibliothèque de l'École des Hautes Études Sciences historiques et philologiques 132. Paris, 1995.

Yoyotte, J. "La pensée préphilosophique en Égypte." In *Histoire de la philosophie, 1-Orient-Antiquité-Moyen âge: Encyclopédie de la Pléiade,* edited by B. Parain. Paris, 1970, pp. 1–23.

Cosmogonies

Allen, J. *Genesis in Egypt: The Philosophy of Ancient Egyptian Creation Accounts.* Yale Egyptological Studies 2. New Haven, 1988. A remarkable combination of insightful summaries and of translated and glossed texts.

Bickel, S. *La cosmogonie égyptienne avant le Nouvel Empire.* Orbis Biblicus et Orientalis 134. Freiburg, 1994. An excellent study, which filled a regrettable gap on the subject.

Sauneron, S., and J. Yoyotte. *La naissance du monde selon l'Égypte ancienne.* Sources Orientales 1. Paris, 1959, pp. 17–91. A very helpful presentation, which has lost none of its interest.

Schlögl, H. *Der Sonnengott auf der Blüte: Eine ägyptische Kosmogonie des Neuen Reiches.* Aegyptiaca Helvetica 5. Basel and Geneva, 1977. The emphasis is on a particular cosmogonic theme, one that took on great importance during the Late Period.

The Pantheon and Myths

Assmann, J. *Ägyptische Hymnen und Gebete.* Zurich and Munich, 1975.

Baines, J. *Fecundity Figures: Egyptian Personification and the Iconology of a Genre.* Warminster, 1985.

Begelsbacher-Fischer, B. L. *Untersuchungen zur Götterwelt des Alten Reiches in Spiegel der Privatgräber der IV. und V. Dynastie.* Orbis Biblicus et Orientalis 37. Freiburg and Göttingen, 1981.

Brunner-Traut, E. *Gelebte Mythen: Beiträge zum altägyptischen Mythos.* 3d ed. Darmstadt, 1988.

Cambefort, Y. *Le scarabée et les dieux.* Paris, 1994.

Derchain, P. *Mythes et dieux lunaires en Egypte.* Sources Orientales 5. Paris, 1962.

Desroches Noblecourt, C. *Amours et fureurs de La Lointaine: Clés pour la compréhension de symboles égyptiens.* Paris, 1995.

Franco, I. *Petit dictionnaire de mythologie égyptienne.* Paris, 1993.

———. *Mythes et dieux: Le souffle du soleil.* Paris, 1996.

Gamer-Wallert, I. *Fische und Fischkulte im Alten Ägypten.* Ägytologische Abhandlungen 21. Wiesbaden, 1970.

Griffiths, J. Gwyn. *The Conflict of Horus and Seth from Egyptian and Classical Sources: A Study in Ancient Mythology.* Liverpool, 1960.

Hornung, E. *Der ägyptische Mythos von der Himmelskuh: Eine Ätiologie des Unvollkommenen.* Orbis Biblicus et Orientalis 46. Freiburg, 1982.

Luft, U. *Beiträge zur Historisierung der Götterwelt und der Mythenschreibung.* Studia Aegyptiaca 4. Budapest, 1978.

Meeks, D. *Génies, anges et démons en Égypte.* Sources Orientales 8. Paris, 1971.

Meeks, D., and C. Favard-Meeks. *Daily Life of the Egyptian Gods.* Translated by G. M. Goshgarian. Ithaca, 1996.

Schoske, S., and D. Wildung. *Gott und Götter im Alten Ägypten.* Mainz, 1992. The Egyptian pantheon illustrated with a collection of statuettes.

Stadelmann, R. *Syrische-Palästinenische Gottheiten in Ägypten.* Probleme der Ägyptologies. Leiden, 1967.

Traunecker, C. *Les dieux de l'Égypte.* Paris, 1992.

Vittmann, G. *'Riesen' und riesenhafte Wesen in der Vorstellung der Ägypten.* Veröffentlichungen der Institute für Afrikanistik und Ägyptologie der Universität Wien 71. Vienna, 1995.

Local Cults

Baines, J., and J. Malek. *Atlas of Ancient Egypt.* New York, 1980. Inventory of sites and cities possessing archaeological remains, almost all of them religious in aim.

Beinlich, H. *Das Buch vom Fayum: Zum religiösen Eigenverständnis einer ägyptischen Landschaft.* Ägyptologische Abhandlungen 51. Wiesbaden, 1991. Scholarly edition of a monograph on the theology of Faiyum.

Cauville, S. *Essai sur la théologie du temple d'Horus à Edfou.* Bibliothèque d'Études 102. Cairo, 1987.

Derchain-Urtel, M.-T. *Priester im Tempel: Die Rezeption der Theologie der Tempel von Edfu und Dendera in den Privatdokumenten aus ptolemäischer Zeit.* Göttinger Orientforschungen IV Reihe, Ägypten 19. Wiesbaden, 1989.

Goyon, J.-C. *Les dieu-gardiens et la genèse des temples (d'après les textes égyptiens de l'époque gréco-romaine): Les soixante d'Edfou et les soixante-dix-sept dieux de Pharbaethos.* Bibliothèque d'Etudes 93. Cairo, 1985.

Gutbub, A. *Textes fondamentaux de la théologie de Kom Ombo.* Bibliothèque d'Études 47. Cairo, 1973.

Kees, H. *Ancient Egypt: A Cultural Topography.* Edited by T. G. H. James; translated by Ian F. D. Morrow. London, 1961. Description of cult traditions by region for a general audience.

———. *Der Götterglaube im alten Ägypten.* 3d edition. Berlin, 1977. Basic survey of cult topography.

Reymond, E. A. E. *The Mythical Origin of the Egyptian Temple.* New York, 1969. The theology of Edfu exclusively.

Sauneron, S. *Villes et légendes d'Egypte.* Bibliothèque d'Études, 90, 2d ed. Cairo, 1983.

Traunecker, C. *Coptos: Hommes et dieux sur le parvis de Geb.* Orientalia Lovaniensia Analecta 43. Louvain, 1992.

Vandier, J. *Le papyrus Jumilhac.* Paris, 1961. Scholarly edition of a mongraph on the theology of the nome of Cynopolis, a fundamental document on local theologies.

Vernus, P. *Athribis: Textes et documents relatifs à la géographie, aux cultes, et à l'histoire d'une ville du Delta égyptien à l'époque pharaonique.* Bibliothèque d'Études 74. Cairo, 1978.

Yoyotte, J. "Héra d'Héliopolis et le sacrifice humain." *Annuaire de l'École Pratique des Hautes Études Ve section— Sciences religieuses,* 89. Paris, 1980–81, pp. 31–102. Textual archaeology of a local cult tradition, a model of insightful scholarship.

Zivie, A. P. *Hermopolis et le nome de l'Ibis: Recherches sur la province du dieu Thot en Basse Egypte.* Bibliothèque d'Études 66. Cairo, 1975.

Monographs on Particular Gods

Atum

Myśliwiec, K. *Studien zum Gott Atum.* Hildesheimer Ägyptologische Beiträge 5. Hildesheim, 1978.

Hathor

Derchain, P. *Hathor Quadrifons: Recherches sur la syntaxe d'un mythe égyptien.* Nederlands Historisch, Anchaeologisch Instituit in het Nabije Oosten, Uitgaven 28. Istanbul, 1972.

Isis

Münster, M. *Untersuchungen zur Göttin Isis vom Alten Reich bis zum Ende des Neuen Reiches.* Münchner Ägyptologische Studien 11. Munich, 1968.

Meret

Guglielmi, W. *Die Göttin Mr.t. Entstehung und Verehrung einer Personifikation.* Probleme der Ägyptologie, 7. Leiden, 1991.

Min

McFarlane, A. *The God Min to the End of the Old Kingdom.* The Australian Centre for Egyptology, Studies, 3. Sydney, 1995.

Nehmetaway

Parlebas, J. *Die Göttin Nehmet-awaj.* Kehl, 1984.

Neith

El Sayed, R. *La déesse Neith de Saïs.* Bibliothèque d'Études 86. Cairo, 1982.

Osiris

Beinlich, H. *Die "Osirisreliquien": Zum Motiv der Körperzergliederung in der altägyptischen Religion.* Ägyptologische Abhandlungen 42. Wiesbaden, 1984.

Cauville, S. *La théologie d'Osiris à Edfou.* Bibliothèque d'Études 91. Cairo, 1983.

Chassinat, E. *Le mystère d'Osiris au mois de Khoiak I.* Cairo, 1966.

Koemoth, P. *Osiris et les arbres: Contribution à l'étude des arbres sacrés de l'Egypte ancienne.* Aegyptiaca Leodiensia 3. Liège, 1994.

Reshef

Fulco, W. J. *The Canaanite God Rešep.* American Oriental Society, American Oriental Series, 8. New Haven, 1976.

Satet

Valbelle, D. *Satis et Anoukis.* Mainz, 1981.

Sekhmet

Germond, P. *Sekhmet et la protection du monde.* Aegyptiaca Helvetica 9. Paris, 1981.

Känel, F. von. *Les prêtres-ouâb de Sekhmet et les conjurateurs de Serket.* Bibliothèque de l'École des Hautes Études— Sciences religieuses 87. Paris, 1984.

Seth

te Velde, H. *Seth, God of Confusion: A Study of His Role in Egyptian Mythology and Religion.* Probleme der Ägypto- logie 6. Repr. Leiden, 1977.

Shay

Quaegebeur, J. *Le dieu égyptien Shaï dans la religion et l'onomastique.* Orientalia Lovanensia Analecta 2. Louvain, 1975.

Sopdu

Schumacher, I. *Der Gott Sopdu: der Herr der Fremdländer.* Orbis Biblicus et Orientalis 79. Freiburg and Göttingen, 1988.

Sokar

Graindorge-Héreil, C. *Le dieu Sokar à Thèbes au Nouvel Empire.* Göttinger Orientforschungen, 4 Reihe: Ägypten, 28. Wiesbaden, 1994.

The Sphinx of Giza

Zivie-Coche, C. *Sphinx! Le père la terreur.* Paris, 1997.

Tatjenen

Schlögl, H. A. *Der Gott Tatenen.* Orbis Biblicus et Orientalis 29. Freiburg and Göttingen, 1980.

Tjanenet

Derchain-Urtel, M.-T. *Synkretismus in ägyptischer Ikonographie. Die Göttin Tjenenet.* Wiesbaden, 1979.

Thoth

Derchain-Urtel, M.-T. *Thot, à travers ses épithètes dans les scènes d'offrandes des temples d'epoque gréco-romaines.* Rites égyptiens 3. Brussels, 1981.

Deified Men

Demaree, R. J. *The Akh ikr n r[ayin] Stelae: On Ancestor Worship in Ancient Egypt.* Egyptologische Uitgaven 3. Leiden, 1983.

Franke, D. *Das Heiligtum des Heqaib auf Elephantine.* Studien zur Archäologie und Geschichte Altägyptens 9. Heidelberg, 1994.

Wildung, D. *Die Rolle ägyptischer Könige im Bewusstsein ihrer Nachwelt,* 1. Münchner Ägyptologische Studien 17. Munich, 1969.

———. *Egyptian Saints: Deification in Pharaonic Egypt.* New York, 1977.

———. *Imhotep und Amenhotep: Gottwerdung im alten Ägypten.* Münchner Ägyptologische Studien 36. Munich and Berlin, 1977.

The Religious Monarchy

Derchain, P. "Le rôle du roi dans le maintien de l'ordre cosmique." In *Le pouvoir et le sacré*. Annales du Centre d'Étude des Religions, 1. Brussels, 1962.

Frankfort, H. *Kingship and the Gods. A Study of Ancient Near Eastern Religion as the Integration of Society and Nature.* Chicago, 1948.

O'Connor, D., and D. P. Silverman, eds. *Ancient Egyptian Kingship.* Probleme der Ägyptologie, 9. Leiden, New York, 1995.

Posener, G. *De la divinité du pharaon.* Cahiers de la Société Asiatique 15. Paris, 1960.

Shirun-Grumach, I. *Offenbarung, Orakel und Königsnovelle.* Ägypten und Altes Testament 24. Wiesbaden, 1993.

The Temple and the Divine Cult

Alliot, M. *Le culte d'Horus à Edfou au temps des Ptolémées.* Bibliothèque d'Études 20. Cairo, 1954.

Cauville, S. *Dendera.* Bibliothèque générale 12. Cairo, 1990.

———. *Edfou.* Bibliothèque générale 6. Cairo, 1984.

Daumas, F. *Les mammisi des temples égyptiens.* Annales de l'Université de Lyon 32. Paris, 1958.

David, R. *A Guide to Religious Ritual at Abydos.* 1981.

Derchain, P. *Les sacrifices de l'oryx.* Rites Égyptiens 1. Brussels, 1962.

Desroches-Noblecourt, C., and C. Kuentz. *Le petit temple d'Abou Simbel: "Nofertari pour qui se lève le dieu-soleil."* Centre de Documentation et d'Études sur l'Ancienne Égypte 1–2. Cairo, 1968.

Fairman, H. W. "Worship and Festivals in an Egyptian Temple." *Bulletin of the John Rylands Library* 37 (1954): 163–203.

Fairman, H. W. *The Triumph of Horus: The Oldest Play in the World.* London, 1974.

Rhyiner, M. L. *L'offrande du lotus dans les temples égyptiens de l'époque tardive.* Rites Égyptiens 6. Brussels, 1968.

———. *La procession des étoffes et l'union avec Hathor.* Rites Égyptiens 8. Brussels, 1995.

Sauneron, S. *The Priests of Ancient Egypt.* Translated by Ann Morrissett. London and New York, 1960.

———. *Les fêtes religieuses d'Esna aux derniers siècles du paganisme.* Cairo, 1962.

Verhoeven, U., and P. Derchain. *Le voyage de la déesse libyque: Ein Text aus dem "Mutritual" des Pap. Berlin 3053.* Rites Égyptiens 5. Brussels, 1985.

Winter, E. *Untersuchungen zu den ägyptischen Tempelreliefs der griechisch-römischen Zeit.* Akademie der Wissenschaften, phil.-hist. Kl. Deukschuften, 98. Vienna, 1968.

The Amarna Heresy

There are three in-depth studies to aid in understanding the most famous episode in the religious history of ancient Egypt:

Allen, J. "The Natural Philosophy of Akhenaten." In *Religion and Philosophy in Ancient Egypt*, edited by W. K. Simpson. Yale Egyptological Studies 3. New Haven, 1989, pp. 89–101.

Assmann, J. *Akhanyati's Theology of Light and Time.* Proceedings of the Israel Academy of Sciences and Humanities, vol. 7, no. 4. Jerusalem, 1992.

Hornung, E. *Echnaton: Die Religion des Lichtes.* Zurich, 1995.

The following survey is still very original and stimulating:

Redford, D. B. *Akhenaten: The Heretic King.* Princeton, 1984.

On the reconstitution of the dismantled temples of Akhenaten, see:

Verginieux, N., and M. Gondran. *Aménophis IV et les pierres du soleil: Akhénaton retrouvé.* Paris, 1997.

Aldred, C. *Akhenaten, King of Egypt.* London, 1988.

For the famous hymns to Aten, see, among others:

Grandet, P. *Hymnes de la religion d'Aton.* 1995.

Niccaci, A. "La lode del creatore: l'inno egiziano di Aton, la tradizione biblica." In *Bogoslovoskka Smotra Ephemerides theologicae zagrabienses.* Zagreb, 1994, pp. 137–59.

Funerary Beliefs

Aubert, J.-F., and L. Aubert. *Statuettes égytiennes: Chaouabtis Ouchebtis.* Paris, 1974.

Bolshakov, A. *Man and His Double in Egyptian Theology of the Old Kingdom.* Ägypten und Altes Testament 37. Wiesbaden, 1997.

Dunand, F., and R. Lichtenberg. *Mummies: A Voyage through Eternity.* Translated by Ruth Sharman. 1991.

Edwards, I. E. S. *The Pyramids of Egypt.* Rev. ed. Harmondsworth, 1985.

Franco, I. *Rites et croyances d'éternité.* Paris, 1993.

Goyon, J.-C., and P. Josset. *Un corps pour l'éternité: Autopsie d'une momie.* Paris, 1988.

Grieshammer, R. *Das Jenseitsgericht in den Sargtexten.* Ägyptologische Abhandlungen 20. Wiesbaden, 1970.

Hornung, E. *Die Nachtfahrt der Sonne: Eine altägyptische Beschreibung des Jenseits.* Munich, 1991.

Lauer, J.-P. *Le mystère des pyramides.* Paris, 1974.

Leblanc, C. *Ta Set Neferou: Une nécropole de Thèbes-ouest et son histoire.* Cairo, 1989.

Leca, A.-P. *The Cult of the Immortal: Mummies and the Ancient Egyptian Way of Death.* Translated by Louise Asmal. London, 1979.

Schneider, H. D. *Shabtis: An Introduction to the History of Ancient Egyptian Funerary Statuettes with a Catalogue of the Collection of Shabtis in the National Museum of Antiquities at Leiden.* 3 vols. Leiden, 1977.

Stadelmann, R. *Die grossen Pyramiden von Giza.* Graz, 1989.

Yoyotte, J. *Le jugement des morts.* Sources Orientales 4. Paris, 1961.

Žabkar, L. *A Study of the Ba Concept in Ancient Egyptian Texts.* Studies in Ancient Oriental Civilization 34. Chicago, 1968.

Funerary Texts

Barguet, P. *Le livre des morts des anciens égyptiens.* Littératures anciennes du Proche-Orient 1. Paris, 1967.

————. *Les textes des sarcophages égyptiens du Moyen Empire.* Littératures anciennes du Proche-Orient 12. Paris, 1986.

Faulkner, R. O. *The Ancient Egyptian Pyramid Texts.* 2 vols. Oxford, 1969.

————. *The Ancient Egyptian Coffin Texts.* 3 vols. Warminster, 1973–78.

Goyon, J.-C. *Rituels funéraires de l'ancienne Égypte.* Paris, 1972.

Herbin, F. *Le livre de parcourir l'éternité.* Orientalia Loveniensia Analecta 58. Louvain, 1994.

Hermsen, E. *Die zwei Wege des Jenseits: Das altägyptische Zweigebuch und seine Topographie.* Orbis Biblicus et Orientalis 112. Freiburg and Göttingen, 1991.

Hornung, E. *Ägyptische Unterweltsbücher.* Zurich and Munich, 1972.

————. *Das Totenbuch der Ägypter.* Zurich, 1979.

————. *Altägyptische Jenseitsbücher: Ein einführender Überblick.* Darmstadt, 1997.

Jacq, C. *Le voyage dans l'autre monde selon l'Égypte ancienne: Épreuves et métamorphoses du mort d'après les Textes des Pyramides et les Textes des Sarcophages.* Monaco, 1986.

Willems, H., ed. *The World of the Coffin Texts.* Proceedings of the Symposium Held on the Occasion of the 100th Birthday of Adriaan de Buck, Leiden, December 17–19, 1992. Egyptologische Uitgaven 9. Leiden, 1996.

Personal Piety

This aspect of religion has attracted much less attention from Egyptologists than have funerary beliefs. Apart from the insights—brief, unfortunately—in wide-ranging works, the bibliography on the subject is dispersed in studies with a narrow focus.

Assmann, J. "Eine Traumoffenbarung der Göttin Hathor: Zeugnisse 'persönlicher Frömmigkeit' in thebanischen Privatgräbern der Ramessidenzeit," *Revue d'Egyptologie* 30 (1978): 22–50. Publication of an unusual inscription.

Baines, J. "Practical Religion and Piety." *Journal of Egyptian Archaeology* 73 (1987): 79–98.

————. "Society, Morality, and Religious Practice." In *Religion in Ancient Egypt: Gods, Myths, and Personal Practice,* edited by B. E. Shafer. Ithaca, 1991, pp. 123–200. An excellent overview, enriched by the author's strong background in religious anthropology.

Bourghouts, J. "Divine Intervention in Ancient Egypt and Its Manifestation." In *Gleanings from Deir el-Medina,* edited by R. J. Demaree and J. J. Janssen. Egyptologische Uitgaven, 1. Leiden, 1982, pp. 1–70.

Brunner, H. *Das Hörende Herz: Kleine Schriften zur Religion- und Geistesgeschichte Ägyptens.* Orbis Biblicus et Orientalis 80. Freiburg and Göttingen, 1988. Many of the pieces collected in this work touch on the subject.

Clère, J. J. *Les chauves d'Hathor.* Orientalia Lovaniensia Analecta 63. Louvain, 1995. A curious body of statues resulting from the quest for intercessors.

Durisch, N. "Cultes des canidés à Assiout: Trois nouvelles stèles dédiées à Oupouaout." BIFAO 93 (1993): 205–21.

Görg, M. "'Persönliche Frömmigkeit' in Israel und Ägypten." In *Fontes atque Pontes: Eine Festgabe für Hellmut Brunner.* Edited by Manfred Görg. Ägypten und Alten Testament 5. Wiesbaden, 1983, pp. 162–85.

Griffiths, Gwyn J. "Intimations in Egyptian Non-royal Biography of a Belief in Divine Impact on Human Affairs." In *Pyramid Studies and Other Essays Presented to I. E. S. Edwards,* edited by John Baines, T. G. H. James, Anthony Leahy, and A. F. Shore. London, 1988, pp. 91–102.

Guglielmi, W. "Zur Bedeutung von Symbolen der persönliche Frömmigkeit: Die verschiedenfarbigen Ohren und das Ka-Zeiche." ZÄS 118 (1991): 116–27.

Guglielmi, W., and Johanna Dittmar. "Anrufungen der persönlichen Frömmigkeit auf Gans- und Widder-Darstellungen des Amun." Festschrift für Emma Brunner-Traut. 1992, pp. 119–42.

Kruchten, J.-M. "Profane et sacré dans le temple égyptien: Interrogations et hypothèses à propos du rôle et du fonctionnement du temple égyptien." *Bulletin de la Société d'Egyptologie de Genève* 21 (1997): 23–37.

Pamminger, P. "Magistrale Intervention: Der Beamte als Mittler." *Studien zur Altägyptische Kultur* 23 (1996): 281–304.

Pinch, G. *Votive Offerings to Hathor.* Oxford, 1993.

Sadek, A. *Popular Religion in Egypt during the New Kingdom.* Hidelsheimer Ägyptologische Beitrage 27. Hildesheim, 1978. Compilation of fundamental data.

Vernus, P. "Le dieu personnel dans l'Egypte pharaonique." *Colloques d'Histoire des Religions organisés par la Société Ernest Renan Société française d'Histoire des Religions.* 1977, pp. 143–57. Overviews.

————. "Littérature et autobiographie: Les inscriptions de s[aleph]-mwt surnommé kyky." RdE 30 (1978): 115–46. Publication of an unusual inscription.

Yoyotte, J. *Les pélérinages dans l'Egypte ancienne.* Sources Orientales 3. Paris, 1960, pp. 18–74.

Magic

Borghouts, J. "The Magical Texts of Papyrus Leiden I 348." *OMRO* 51. (1970): 1–248. Publication of a magical papyrus of foremost importance. The entire volume consists of this one article.

————. *Ancient Egyptian Magical Texts.* Nisaba, 9. Leiden, 1978. Translation of the primary magical texts.

Koenig, Y. *Magie et magiciens dans l'Égypte antique.* Paris, 1994. Excellent overview of the various aspects of magic.

Ritner, R. *The Mechanics of Ancient Egyptian Magical Practice.* Studies in Ancient Oriental Civilization 54. Chicago, 1993. A study oriented more particulary toward the material procedures of magic.

Sauneron, S. *Le monde du magicien égyptien.* Sources Orientales 7. Paris, 1966, pp. 27–65. Description of the basic principles of magical thought.

The Delta and Middle Egypt

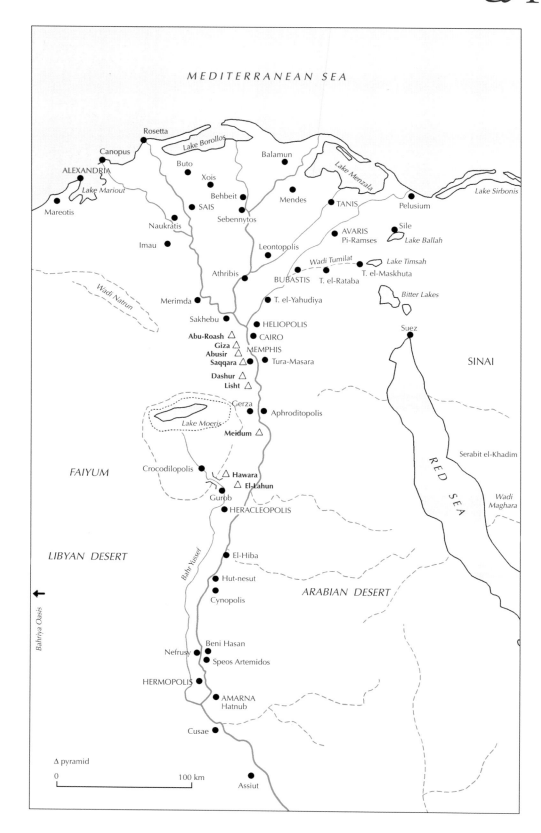

MEDITERRANEAN SEA

Rosetta

Canopus

Lake Borollos

ALEXANDRIA

Buto

Balamun

Lake Menzala

Lake Marioul

Xois

Lake Sirbonis

Mareotis

Behbeit

Mendes

TANIS

Pelusium

SAIS

Naukratis

Sebennytos

AVARIS
Pi-Ramses

Sile

Lake Ballah

Imau

Leontopolis

Wadi Tumilat

Lake Timsah

Athribis

BUBASTIS

T. el-Rataba

T. el-Maskhuta

Wadi Natrun

Merimda

T. el-Yahudiya

Bitter Lakes

Sakhebu

HELIOPOLIS

Abu-Roash △ CAIRO

Suez

Giza △ MEMPHIS

Abusir △

Saqqara △

Tura-Masara

SINAI

Dashur △

Lisht △

Gerza

Aphroditopolis

Lake Moeris

Meidum △

Serabit el-Khadim

FAIYUM

Crocodilopolis

△ **Hawara**

△ **El-Lahun**

Gurob

RED SEA

Wadi
Maghara

HERACLEOPOLIS

LIBYAN DESERT

Bahr Yussef

El-Hiba

Hut-nesut

ARABIAN DESERT

Cynopolis

Bahriya Oasis

Beni Hasan

Nefrusy

Speos Artemidos

HERMOPOLIS

AMARNA
Hatnub

Cusae

△ pyramid

0 100 km

Assiut

Upper Egypt and Lower Nubia

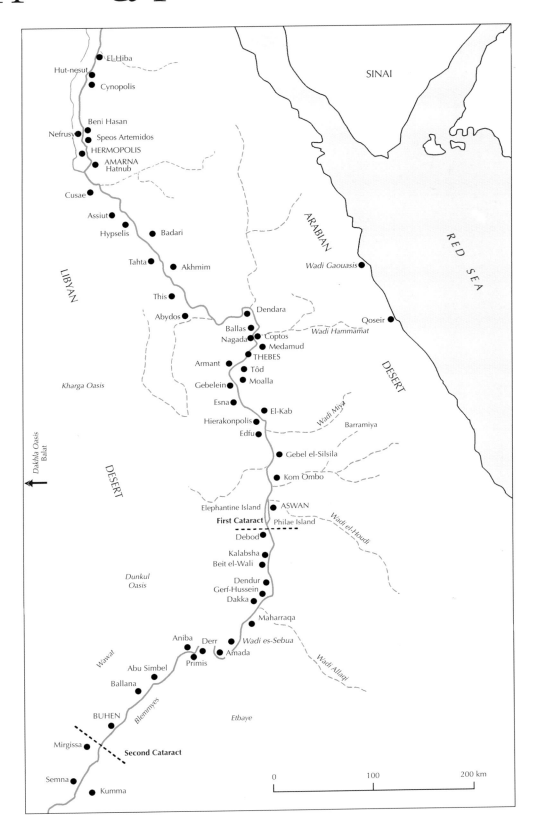

El-Hiba
Hut-nesut
Cynopolis

SINAI

Beni Hasan
Nefrusy
Speos Artemidos
HERMOPOLIS
AMARNA
Hatnub

Cusae

Assiut

Hypselis
Badari

Tahta
Akhmim

Wadi Gaouasis

RED SEA

ARABIAN

This
Abydos
Dendara

Ballas
Nagada
Coptos
Medamud
THEBES
Armant
Tôd
Gebelein
Moalla

Esna
El-Kab
Hierakonpolis
Edfu

Qoseir

Wadi Hammamat

DESERT

Kharga Oasis

Wadi Miya
Barramiya

LIBYAN

Gebel el-Silsila
Kom Ombo

Elephantine Island
ASWAN
First Cataract
Philae Island
Debod

Wadi el-Houdi

Dakhla Oasis
Balat

Kalabsha
Beit el-Wali

Dunkul
Oasis

Dendur
Gerf-Hussein
Dakka

DESERT

Maharraqa

Aniba
Derr
Wadi es-Sebua
Primis
Amada

Wadi Allaqi

Wawat

Abu Simbel
Ballana

BUHEN
Blemmyes

Etbaye

Mirgissa
Second Cataract

Semna
Kumma

0 100 200 km

Chronology

4000 B.C.–3000 B.C.	*Predynastic Era* Nagada Period 1 to 3
3000 B.C.–2635 B.C.	*Archaic Period* Dynasties 1 through 2
2635 B.C.–2140 B.C.	*Old Kingdom* Dynasties 3 through 6
2140 B.C.–2022 B.C.	*First Intermediate Period* Dynasty 7 through the first half of the 11th Capital at Memphis, Dynasties 7 through 8 Period of intermittent civil war between two rival dynasties, Lower and Middle Egypt controlled by royal court at Herakleopolis, Dynasties 9 through 10 Upper Egypt controlled by royal court at Thebes, first half of the 11th Dynasty Reunification of Upper and Lower Egypt occurs in second half of 11th Dynasty
2022 B.C.–1650 B.C.	*Middle Kingdom* Second half of the 11th Dynasty through the 13th Dynasty
1650 B.C.–1539 B.C.	*Second Intermediate Period* Dynasties 14 through 17
1539 B.C.–1080 B.C.	*New Kingdom* Dynasties 18 through 20
1080 B.C.–660 B.C.	*Third Intermediate Period* Dynasties 21 through 25
660 B.C.–330 B.C.	*Late Period* Dynasties 26 through 30
330 B.C.–30 B.C.	*Ptolemaic Period* Controlled by Greek rulers residing at Alexandria
30 B.C.	*Roman Era*

List of Illustrations

to Twentieth Dynasty. Kunsthistorisches Museum, Ägyptisch-orient Sammlung, Vienna, Austria.

p. 42 Baboons worshiping the sun disk. Bronze statuette. H: 3 1/8 in. (7.9 cm). Late Period, tenth to sixth century B.C. Musée du Louvre, Department of Egyptian Antiquities, Paris.

p. 43 Ichneumon, a kind of mongoose. Statuette in green slate. Sixth to fourth century B.C. Kunsthistorisches Museum, Ägyptisch-orient Sammlung, Vienna, Austria.

p. 44 Statue in the round of a baboon, located at the main entrance of the Temple of Thoth. Stone. Second Intermediate Period. Hermopolis, Egypt.

pp. 46–47 View of Luxor, Egypt.

p. 48 Ibis. Wood statuette. Private collection.

p. 49 The god Bes. Statuette in terra-cotta. New Kingdom. Musée du Louvre, Department of Egyptian Antiquities, Paris.

p. 49 Harpocrates or Horus the child riding a donkey. Private collection.

p. 49 Ibis beak. Bronze. Sixth century B.C. Kunsthistorisches Museum, Ägyptisch-orient Sammlung, Vienna, Austria.

p. 50 Ram god. Amulet in blue faience. H: 1 1/2 in. (3.8 cm). Saite Period. Private collection.

p. 50 Duck. Setting of a chrysoprase ring inscribed with the name of Princess Neferura, daughter of Hatshepsut and Thutmose III. 11/16 x 7/16 in. (1.7 x 1.1 cm). Private collection.

p. 51 Coiled snake. Cover of a mummy box for a snake. Bronze. L: 4 3/4 in. (12 cm). Twenty-sixth Dynasty. Kunsthistorisches Museum, Ägyptisch-orient Sammlung, Vienna, Austria.

p. 52 The god Amun. Bas-relief in the Temple of Beit el-Wali, Nubia, Egypt.

p. 53 Isis. Bas-relief from the Temple of Isis. Ptolemaic Period. Philae Island, Egypt.

p. 54 Jumelle vase. Brownish red terra-cotta with white pattern. Naqada I Period, Predynastic Era, early fourth millennium B.C. Staatliche Museen, Ägyptisches Museum, Berlin, Germany.

p. 55 Ram drawn on an ostracon. Limestone. H: 5 7/8 in. (15 cm). Musée du Louvre, Department of Egyptian Antiquities, Paris.

p. 55 Horus and Seth. Bas-relief on the side of a seat of a statue of Sesostris I (1971–1928 B.C.). Archaeological Museum, Cairo, Egypt.

pp. 56–57 Farming along the Nile.

p. 58 So-called concubine statuettes. Blue faience. H: 5 7/16 in. (13.8 cm) and 4 13/16 in. (12.2 cm). New Kingdom. Musée du Louvre, Department of Egyptian Antiquities, Paris.

p. 59 The goddess Seshat. Copper alloy. H: 6 1/4 in. (15.9 cm). Musée du Louvre, Department of Egyptian Antiquities, Paris.

p. 60 Harpocrates (Horus the child) in a lotus flower. Ivory. Tenth to sixth century B.C. Israel Museum (IDAM), Jerusalem, Israel.

p. 61 Harpocrates. Sculpted wood. Ptolemaic Period. Kunsthistorisches Museum, Ägyptisch-orient Sammlung, Vienna, Austria.

p. 62 Harpocrates, Ibis, Horus. Group in bronze. Twenty-sixth Dynasty. Kunsthistorisches Museum, Ägyptisch-orient Sammlung, Vienna, Austria.

p. 63 Imhotep. Statuette in copper alloy. H: 5 1/8 in. (13 cm).

Ptolemaic Period. Musée du Louvre, Department of Egyptian Antiquities, Paris.

p. 64 Pharaoh Akhenaten. Colossal statue in stone from Karnak. H: 60 1/4 in. (153 cm). Archaeological Museum, Cairo, Egypt.

p. 65 Isis brandishing a sistrum. Bas-relief in a chapel of the hypostyle hall of the Temple of Abydos. 1305–1196 B.C. Abydos, Egypt.

p. 67 Horus and the pharaoh Horemheb. Limestone. New Kingdom, Eighteenth Dynasty. Kunsthistorisches Museum, Ägyptisch-orient Sammlung, Vienna, Austria.

p. 68 "Epsilon" ax. Bronze. Middle Kingdom. Musée du Louvre, Department of Egyptian Antiquities, Paris.

p. 69 Embalmer's knife. Bronze. New Kingdom. Musée du Louvre, Department of Egyptian Antiquities, Paris.

p. 70 Head of an Osirid pillar. Polychrome stone. Early Eighteenth Dynasty. Museo Egizio, Turin, Italy.

p. 70 Two unguent vases carried by servants, one Nubian, the other Asian. New Kingdom. Left: Nubian in limestone. H: 4 1/2 in. (11.5 cm). Right: Asian in alabaster. H: 4 1/2 in. (11.5 cm). Musée du Louvre, Department of Egyptian Antiquities, Paris.

p. 71 Instrument in the "Opening of the Mouth" ritual. Alabaster. Tenth to sixth century B.C. Musée du Louvre, Department of Egyptian Antiquities, Paris.

p. 72 Triad of Isis, Osiris, and Horus. Gold and lapis lazuli jewelry. H: 3 9/16 in. (9 cm). Twenty-second Dynasty, 945–745 B.C. Musée du Louvre, Department of Egyptian Antiquities, Paris.

p. 74 Sety I, Amun, and Mut. Stone stele. Thirteenth century B.C. Archaeological Museum, Istanbul, Turkey.

p. 75 Circular libation table. Thirtieth Dynasty. Museo Egizio, Turin, Italy.

p. 76 Rameses II hunting as a child. Bas-relief in limestone. New Kingdom, Nineteenth Dynasty. Musée du Louvre, Department of Egyptian Antiquities, Paris.

p. 77 Haroeris recording his jubilees. Bas-relief in the Temple of Sobek and Horus. Ptolemaic Period. Kom Ombo, Egypt.

p. 78 Incense burner. Wood. L: 14 7/16 in. (36.7 cm). Second to first millennium B.C. Musée du Louvre, Department of Egyptian Antiquities, Paris.

p. 79 Incense burner. Wood and faience. Eighteenth Dynasty, 1580–1314 B.C. National Maritime Museum, Haifa, Israel.

pp. 80–81 Sacred Lake, Temple of Karnak, Egypt.

p. 82 Situla. Bronze. Staatliche Museen, Ägyptisches Museum, Berlin, Germany.

p. 83 Sistrum. Bronze. New Kingdom. Musée du Louvre, Department of Egyptian Antiquities, Paris.

p. 84 Small Temple of Hathor. Thirteenth century B.C. Kalabsha, Nubia.

p. 85 Colonnade of the Temple of Sobek and Haroeris. Ptolemaic Period. Kom Ombo, Egypt.

p. 87 Sphinx of Menkheperra. Decorative element on a bronze religious object. H: 3 1/16 in. (7.8 cm). L: 1 1/8 in. (2.85 cm). Twenty-first Dynasty. Musée du Louvre, Department of Egyptian Antiquities, Paris.

p. 89 Two prisoners, one Nubian, one Asian, painted on the soles of shoes. New Kingdom, 1554–1080 B.C. Drovetti Collection, Museo Egizio, Turin, Italy.

pp. 90–91 Heads of prisoners of war: Nubian, Semite, and Ethiopian. Faience tiles from the palace of Rameses III.

Twentieth Dynasty. Kunsthistorisches Museum, Ägyptisch-orient Sammlung, Vienna, Austria.

p. 92 Wings of a goddess protecting a pharaoh. Wood. H: 7 7/8 in. (20 cm). Twenty-sixth Dynasty. Kunsthistorisches Museum, Ägyptisch-orient Sammlung, Vienna, Austria.

pp. 94–95 Sacred Lake of the Temple of Hathor. Ptolemaic Period, 332–330 B.C. Dendara, Egypt.

pp. 96–97 Talatat blocks of sandstone or limestone from religious buildings built under the reign of Akhenaten in Karnak. Above on page 96: Three girls carrying fans. About 1360 B.C. Sammlung Ägyptischer Kunst, Munich, Germany. Below: Prayer to the god Aten. Relief from Amarna. H: 7 1/16 in. (18 cm). New Kingdom, 1340 B.C. Archaeological Museum, Cairo, Egypt. Page 97: Block of limestone from the Sanctuary of Aten built by Akhenaten in Karnak. H: 8 7/16 in. (21.5 cm). New Kingdom, 1350 B.C. Franco-Egyptian Center, Karnak, Egypt.

p. 98 Akhenaten followed by his wife Nefertiti. Bas-relief from Amarna. 41 5/16 x 19 11/16 in. (105 x 50 cm). New Kingdom, c. 1350 B.C. Archaeological Museum, Cairo, Egypt.

p. 100 Artificial mummy. Painted wood and fabric. New Kingdom, Nineteenth Dynasty. Staatliche Museen, Ägyptisches Museum, Berlin, Germany.

p. 101 Tutankhamun. Life-size statue placed in the antechamber to the funerary chamber. Wood coated with black resin and plated with gold leaf, eyes inlaid with limestone and obsidian. 1342 B.C. Valley of the Kings, Thebes. Archaeological Museum, Cairo, Egypt.

p. 103 Usekh necklace. Ptolemaic Period, about 100 B.C. Staatliche Museen, Ägyptisches Museum, Berlin, Germany.

pp. 104–105 Temple of Queen Hatshepsut and Pharaoh Thutmose III. Eighteenth Dynasty. Deir el-Bahri, Egypt.

p. 106 Funerary procession. Limestone bas-relief. 1320 B.C. Staatliche Museen, Ägyptisches Museum, Berlin, Germany.

p. 107 Osiris, followed by Hathor, facing Ra-Horakhty, followed by Amenhotep III. Limestone stele. New Kingdom. Drovetti Collection, Museo Egizio, Turin, Italy.

p. 107 Osiris and Ra-Horakhty back to back. Limestone stele. New Kingdom, Nineteenth Dynasty. Staatliche Museen, Ägyptisches Museum, Berlin, Germany.

p. 108 Detail of a procession of dignitaries. Limestone bas-relief. New Kingdom, Eighteenth Dynasty, about 1320 B.C. Staatliche Museen, Ägyptisches Museum, Berlin, Germany.

p. 109 Funerary stele from the Sanctuary of Osiris in Abydos. 13 3/4 x 28 3/8 in. (35 x 72 cm). Middle Kingdom, Twelfth Dynasty. Kunsthistorisches Museum, Ägyptisch-orient Sammlung, Vienna, Austria.

p. 110 Wall paintings from a tomb. Above: Sacrifice of an ox. First Intermediate Period, beginning of Middle Kingdom. Museo Egizio, Turin, Italy. Below: Offering of a beef flank. Painted relief from a tomb in Saqqara. Fifth to Sixth Dynasty. Sammlung Ägyptischer Kunst, Munich, Germany.

p. 112 Episode in the nocturnal journey of the sun.

p. 113 Triumphant phase of the sunrise greeted by gods. Details of the sarcophagus of a royal scribe found in Saqqara. Basalt. Ptolemaic Period. Kunsthistorisches Museum, Ägyptisch-orient Sammlung, Vienna, Austria.

p. 115 *Shabti* box. Painted wood. Ramesside Era. Musée du Louvre, Department of Egyptian Antiquities, Paris.

p. 115 Mythological map of the sky. Painting on the ceiling of the Tomb of Rameses VI. Twentieth Dynasty. Valley of the Kings, Biban el-Muluk, Thebes, Egypt.

pp. 116–117 Left: Three *shabtis*. Faience, painted wood, and painted limestone. Right: Three figurines of Osiris. Painted wood. About 600 B.C. Staatliche Museen, Ägyptisches Museum, Berlin, Germany.

p. 118 The daily course of the sun. Manuscript from the Book of the Dead by Khonsmose. Papyrus. Third Intermediate Period, Twenty-first Dynasty.

p. 118 Anubis and the mummy of a dead man. Manuscript from the Book of the Dead. Papyrus. Third Intermediate Period, Twenty-first Dynasty. Kunsthistorisches Museum, Ägyptisch-orient Sammlung, Vienna, Austria.

p. 119 Osiris bed from Thebes. 2 3/4 x 5 1/8 x 9 7/16 in. (7 x 13 x 24 cm). New Kingdom, Seventeenth to Nineteenth Dynasty. Dagon Agricultura Collection, Haifa, Israel.

pp. 120–121 Wall paintings in the Tomb of Sennutem. Left: Osiris. Right: Anubis. Early Ramesside Era, Eighteenth Dynasty. Deir el-Medina, Thebes, Egypt.

pp. 122–123 Women bearing offerings. Wood. H: 24 7/8 in. (63.2 cm) and 19 9/16 in. (49.7 cm). Middle Kingdom. Musée du Louvre, Department of Egyptian Antiquities, Paris.

p. 124 Above: Funerary mask. Wood. Third Intermediate Period. Musée du Louvre, Department of Egyptian Antiquities, Paris.

p. 124 Left: Painted sculpture called the "Salt head." Limestone. Old Kingdom, Fourth to Fifth Dynasty. Musée du Louvre, Department of Egyptian Antiquities, Paris.

p. 124 Right: Sculpture of a so-called reserve head from a tomb in Giza. Limestone. About 2450 B.C. Old Kingdom, Fourth Dynasty. Kunsthistorisches Museum, Ägyptisch-orient Sammlung, Vienna, Austria.

p. 125 Breastplate masks of women. Painted plaster. Above: About A.D. 50. Staatliche Museen, Ägyptisches Museum, Berlin, Germany. Below: Roman Era. H: 13 3/8 in. (34 cm). L: 24 3/8 in. (62 cm). Musée du Louvre, Department of Egyptian Antiquities, Paris.

p. 127 The pyramids of Pharaohs Khufu and Khaefre. Giza, Egypt.

pp. 128–129 Faiyum funerary portraits. Wood painted using the encaustic technique. Page 128: Young man. 14 3/16 x 7 11/16 in. (36.1 x 19.5 cm). Roman Era, middle of fourth century. Page 129: Young woman. 25 3/16 x 8 9/16 in. (63.9 x 21.7 cm). Roman Era, third century. Kunsthistorisches Museum, Antikensammlung, Vienna, Austria.

p. 130 Gold funerary mask of Khaemwaset, son of Rameses II. H: 11 1/4 in. (28 cm). About 1290–1224 B.C. Musée du Louvre, Department of Egyptian Antiquities, Paris.

p. 130 Funerary mask. Painted cardboard, linen, and gold leaf. Greco-Roman Era, c. A.D. 50. Staatliche Museen, Ägyptisches Museum, Berlin, Germany.

p. 132 Sennefer, governor of Thebes, receiving an offering of fabric. Wall painting in the mortuary chapel. Eighteenth Dynasty. Thebes, Egypt.

p. 133 Nakht, dignitary hunting with a boomerang. Wall painting in the Mortuary Chapel of Nakht. Eighteenth Dynasty. Thebes, Egypt.